12/25/10
Ella + Colton
Merry Christmas
love
Nana + Poppy ♡

W9-AKT-994

Ella

Colton

# BİBLE

### STORİES

Nouum opus facere me cogis
ex ueteri. ut post exemplaria scriptu-
rarum toto orbe dispersa. quasi quidam arbi-
ter sedeam. & quia inter se uariant. quae sint
illa quae cum graeca consentiant ueritate de-
cernam. pius labor. sed periculosa praesumptio.
iudicare de ceteris. ipsum ab omnibus iudican-
dum. senis mutare linguam. & canescentem
mundum et ab initia retrahere paruulorum.
Quis enim doctus pariter uel indoctus. cum in manu
uolumen adsumpserit. et a saliua quam semel in-
bibit uideris discrepare quod lectitat. non statim
erumpat in uocem. me falsarium. me clamans esse
sacrilegum. qui audeam aliquid in ueteribus libris
addere mutare corrigere. Aduersus quam inui-
diam duplex causa me consolatur. quod et tu qui
summus sacerdos es fieri iubes. et uerum nonnge-

quod uariat. etiam in maledicorum testimonio
pene ex eo pla ri aquod codices. sin autem ueri
praetibus maledita uel a praesumptoribus inpe-
te queueroe qo de ueteri discipuli sputo testamento q
non quero quid aqui la quid symmachus sapiant. q
nauerunt. deni quo uno uel quo or testamento. q
literis edidit. hoc certe tecum innsos ermonedis

est adibenda respondeant quibus
originem reuertentes. eaque uel kui ti
tibus. aut addita sunt aut mutata core
uer sum. tertio gradu ad nos hus quep
At. Sit illa uera interpraetatio. quam a
heo. qui primus in iudea euangelium xp
de ponte que renus que p         praetermitto

di tasunt. Igitur hoc praesens praefatiuncula pol
emendata col latione. seduetere um que ne multum
tum mutare correctis. reliquam anere pateremur
ammonium indecem numeros ordinauit. sicut
iudici na uel solas int. eorum distinctione sco
ust aplus dixit. in aliqua minus putauerit aut addide
exemplum ceter e os quo que extim auerit thema dan

Mattheus marchus lucas Johannis. codi
molnpe rcium ii this tantum quae sensu
ariensis aepiscopus. alexandrinum
riosis uolueri tnosse. que Ne uangel
erroi noleuit. quam quod ne adere xli ut
ille qui hunum he quattuor primum le e
inm archo plura lucae ad quem mathei.

matthe o Johannis e tmarchi. et incetere sreliquorum
que nalis propriasunt Inue niantur. cum itaque cano
nes leg eris qui subiecti sunt. confusioni serrore sublato
cotimulu mhominut cetr tatinquitss u si g sfecta ueuit. nca non eprimo
concordiae. qua erauite matheus. marchus. lucas. Joh
annes.    nsecundo tres. m. mattheus. marchus. lu
cas.    ntertio tres. mattheus. lucas. Johannes.
nquario tres.    mattheus. marchus. Johannes. n
quinto duo. mattheus lucas.    nsexto duo. matthe
marchus.    nseptimo duo. mattheus. Johannes. nn
octa uo duo. marchus. lucas.    nnono duo. lucas
Johannes.    ndecimo. propria hunus quis que. qe
non habentur in alii s. edide runt. singuli euange
lii sa b huno incipien bus que ad finem libror um eis
par numerus in crescit. hic nigro color e praescrip
tus. subse b abet a lium ex minio. numerum discolo
rem. quiad decem hus que procedens. Indicat prior
inumerus inquo sitcanon e requirendus. Cum

# BIBLE
## STORIES

BY MARTINA DEGL'INNOCENTI
AND STELLA MARINONE

Abrams, New York

*Page 2:* School of Oviedo, *Letter from Saint Jerome to Pope Damasus and Prologue to the Four Gospels* miniature from a Bible, 9th century Cava dei Tirreni, Biblioteca della Badia

*Opposite:* Hans Thoma, *The Garden of Eden* 1896, Staatliche Kunsthalle, Hamburg

*Pages 8–9: Evangelia antehieronymiana* 6th–7th century, Brescia, Biblioteca Civica Queriniana

© M. Chagall by SIAE 2009

*Editorial direction:* Virginia Ponciroli
*Editor:* Studio Zuffi
*Graphic direction:* Dario Tagliabue
*Layout:* Elena Brandolini
*Picture research direction:* Elisa Dal Canto
*Picture research:* Simona Pirovano
*Technical direction:* Lara Panigas
*Quality control:* Giancarlo Berti
*English translation:* Rosanna M. Giammanco Frongia, Ph.D.
*English-language typesetting:* William Schultz

Library of Congress Control Number: 2009940861
ISBN: 978-0-8109-8996-2

ABRAMS
THE ART OF BOOKS SINCE 1949

115 West 18th Street
New York, NY 10011
www.abramsbooks.com

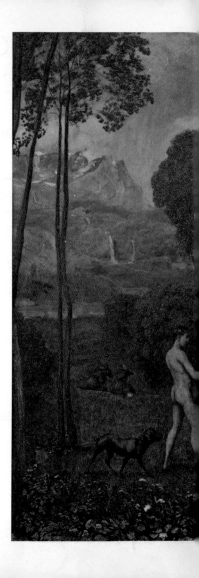

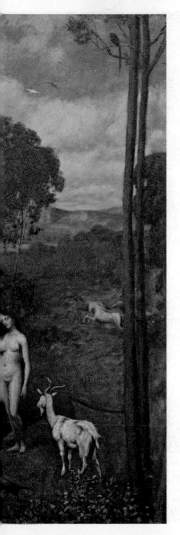

# Contents

# Introduction

"Thou shalt not make unto thee any graven image, or any likeness of any thing that is in heaven above, or that is in the earth beneath, or that is in the water under the earth." (Ex 20:4)

Given the sheer number of images inspired by the vast power that the Bible has exerted on the artistic imagination, one might wonder how the above verse from Exodus, the first commandment that God gave to man, fits into the picture. From this ancient biblical ban on expressing faith through images, we have come, after several millennia, to accept the full legitimacy, unique to Christianity, of icons as aids to worship. Thus the Bible has become the great iconographic codex of Western culture, the most illustrated book of all time.

Still, even with all the biblical images offered by the visual landscape that surrounds us, we often fail to grasp their symbolism. In trying to explain this loss, the great semiotics scholar Umberto Eco asks why "our young people learn everything about Homer, but nothing about Moses."

To help recapture this knowledge, we have designed this book to match passages from the Bible with their representations. Words have been linked to their images, exposing the deep bond that unites verse and brush. The book opens with an introductory section that briefly covers the history of the Book, the etymology of key words, and the structure of the Bible, concluding with an excursus on the relationship between the Word and the silver screen. Then we begin to leaf through the pages of the Bible, choosing episodes that follow the order of its many parts, from Genesis to Revelation. From the Creation to the Resurrection of the dead, the paintings, sculptures, illuminations, and stained-glass windows guide readers to discover the roots of their cultural landscape.

Sometimes, the collective imagination associates a passage with a

famous image (such as Michelangelo's *Creation of Adam*), making it difficult or impossible to extricate the story from that context. Other times, words in illuminated Bibles have been decorated using unique techniques, compositions, or styles, offering yet another layer of imagery. Artists have often departed from literal representations to draw on other traditions.

While we have included some of these creative works, most of the art reproduced here is faithful to the sacred narrative. The illustrations include lovely miniatures—the *incipit* pages of books from the Scriptures—to show how the Bible has been decorated and embellished with symbolic renditions of the letters themselves.

Recurring episodes are covered only once, though we have included all the biblical references to each episode. In particular, we have treated the Gospel episodes as one continuous narrative of the life of Jesus, drawing from one or more of the four Gospels and pointing out any discrepancy or coincidence.

Some passages that are highly anecdotal or narrative in style have inspired artists more than other more poetic or didactic ones. For this reason, although we tried to include all the books of the Catholic Bible, we have preferred to focus on the more narrative ones. Our choice was also dictated by the importance that some events have played in the history of the Old and New Covenants.

The Supplements section has a useful map of the Middle East that identifies the places where the main events unfolded. There is also a basic chronology to help the reader navigate the complexity of biblical history, a list of abbreviations, and an index of episodes and artists. This book renders an interweaving of art, history, and faith in the pages of the world's most famous book.

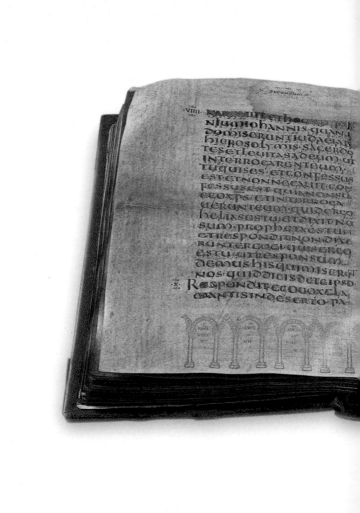

# Words and Images

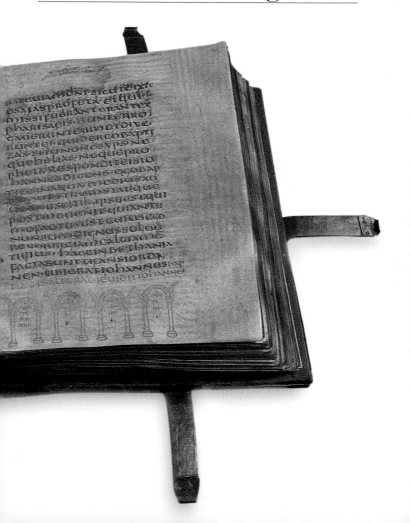

# Words from the Bible

The word "Bible" is derived from the Greek *biblìa*, the plural of *biblìon*, which in turn is the diminutive form of *býblos*, or "book." By "Bible" we mean the sacred Book, subdivided into the Old and the New Testaments. The early Christian theologian Tertullian (AD 160–230) first used the Latin word *testamentum*, "testament," referring to the book of the Covenant, translated from the Greek term *diatheke*, in turn derived from the ancient Hebrew word *berith*, "covenant," or more precisely, "instructions about the last wishes." In antiquity the word *biblìon* denoted a rolled-up book or scroll, usually made of strips of papyrus, a material chosen for its light weight and suppleness. At the time, very few texts were illustrated or decorated. Over time, the scroll gave way to the codex, a more modern type of bound book. This Latin term originally denoted a two-leaved wood tablet or diptych, coated on the inside with a layer of wax, inscribed using a stylus. Later, the diptych became a set of single pages with the same format, a book designed to be leafed through instead of unrolled.

*Diptych with Adam Naming the Animals and Miracles of Saint Paul*
early 5th century
Museo Nazionale del Bargello, Florence

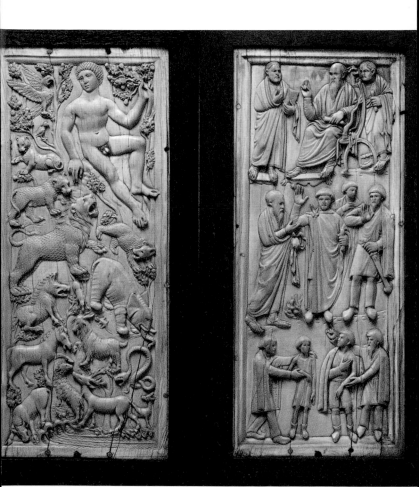

# The Origins of the Bible

From the beginning, both the Hebrew scriptures and the New Testament were handed down orally, a tradition that continued even after they began to be written down. In 1000 BC, when the kingdoms of Judah and Israel arose, their kings ordered that the ancestral tales of their peoples be put in writing. The pivotal moment in defining the worship of Yahweh as the "religion of the Book" came during the Babylonian captivity. Enslaved and taken to Babylon by force, the Hebrew people took with them the scrolls from the royal archives of Jerusalem. These texts were not yet considered sacred; thus in studying and commenting on them, sometimes the scribes added passages to adapt them to their enslaved condition. Drawing from these disparate Israelite and Judaic traditions, historians in the eighth century BC began to write a unified narrative that has become the core of the Hebrew Bible. In fact, they merged texts from the south (the kingdom of Judah), generally indicated by scholars with the letter "J" because they refer to God as "Yahweh" (also spelled "Jehovah"), and from the north (the kingdom of Israel), identified with "E" because they refer to God by the more formal name of "Elohim." The texts of the prophets and the Psalms, written during the Babylonian captivity, were also included.

*The Ishtar Gate* (reconstruction)
late 1930s; original *c.* 575 BC
Pergamon Museum, Berlin

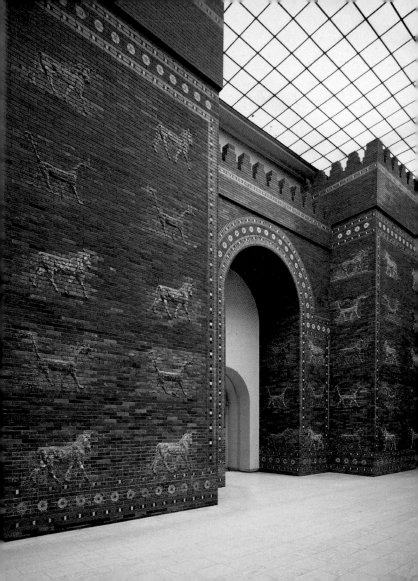

# The Hebrew Bible

The entire Hebrew Bible is also known as *Tanakh*, an acrostic of the initials of its three divisions: the *Torah* or "law," which incorporates the "E" and "J" traditions; the *Neviim* or "prophets," composed during the Babylonian exile; and the *Kethuvim* or "writings," miscellaneous books dating after the exile. The Torah is also known today as the Pentateuch, from the Greek *pentàteychos*, which means "five books"; the Jewish tradition holds that they record the word of God as revealed directly to Moses. The *Sepher Torah* or "Book of Law" is a parchment scroll kept in every synagogue that contains the Pentateuch. It is usually rolled up in a cloth and kept inside a sacred casket on a wall that faces Jerusalem. The official text of the Hebrew Bible was finalized between the seventh and tenth centuries AD, although several more ancient versions still exist.

English School
*Torah Scroll*
1765
Jewish Museum, London

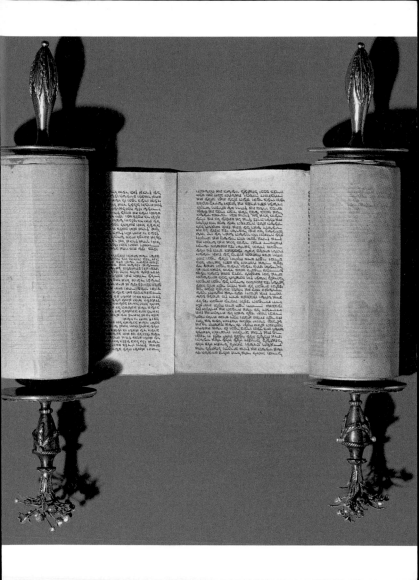

# The Septuagint

In ancient times, Alexandria in Egypt was home to a large Hebrew community whose members could not read the Torah because their language was Greek; in fact, by that time Hebrew was slowly disappearing even in Palestine, where it was being replaced by Aramaic. For this reason, in the third century BC a group of Alexandrian Jews decided to translate the Torah into Greek. This initiative is tied to a legend (handed down in the Letter of Aristeas from the end of the second century BC) that recounts how Ptolemy Philadelphus (285–47 BC), king of Egypt, upon the suggestion of his librarian Demetrius of Phaleron, ordered the translation so that it could be added to the famous library of Alexandria. It is said that seventy-two Jewish scholars were sent by the high priest of Jerusalem to Alexandria specifically for this task. This legendary feat—which contains a kernel of truth, namely the intention to complete the library's law section with the text of the Hebrew Law—came to be known as the Septuagint, or "Bible of the Seventy." In the Middle Ages, the Fathers of the Church used this translation, which became the only version of the Old Testament to be used throughout Christendom.

O. Von Corven
*Artistic Rendering of the Great
Library of Alexandria*
1880
Private collection

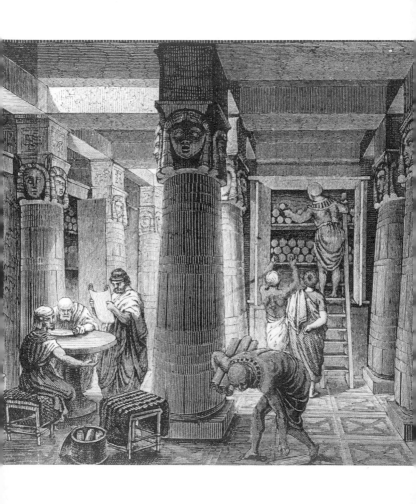

# The New Testament

The word "Gospel," from the Greek *eu-aggèlion*, or "good news," refers to the teachings of Jesus that brought the good news of the Redemption to the human race. Today, the word denotes specifically the texts that narrate the life of the Christ. The New Testament contains four of these Gospels, which from inception circulated anonymously, making it impossible to clearly identify their authorship, though it is customary to attribute them to the disciples Matthew, Mark, Luke, and John. Luke is also believed to be the author of the Acts of the Apostles, and John the author of Revelation. The first three Gospels date between AD 70 and 90 and are called "synoptic" because a synoptic, or summary, comparison of the three texts arranged side by side in parallel columns reveals many similarities in the narrative, in the sequence of the episodes, and sometimes even in the expressions used. The Gospel of John (dated to the close of the first century AD) differs from the other three in the chronology of events described, and it is filled with personal impressions. In addition to the four Gospels, the New Testament also includes the Epistles of Paul; of these, some are signed and thus precede the Gospels (Paul of Tarsus died in Rome in about the year AD 67), while others were probably composed by disciples in his name, and still others are traditionally attributed to James, Peter, John, and Jude.

Master of the Four Elements
*The Evangelists,* 14th century
San Francesco, Lodi

# *The Christian Bible*

The Christian Bible is more than just the addition of some books (the New Testament) to the Hebrew scriptures (the Old Testament), since the Old Testament books, which are shared, take on different meanings depending upon their arrangement. Specifically, the Christian Old Testament draws upon the Septuagint and follows its order of the books as Pentateuch, historical books, wisdom books, and prophetic books. The prophets in particular are believed to have heralded the events of the New Testament, which provides continuity between God's First and Second Covenants with His people. Additionally, not all Christian Bibles contain the same number of books. The so-called "deuterocanonical" books (Tobit, Judith, parts of Esther, Maccabees, Wisdom, Baruch, parts of Daniel, and Ben Sira, also known as Sirach, Siracides, or Ecclesiasticus) not included in the Hebrew *Tanakh* are part of Catholic and Christian Orthodox, but not Protestant, tradition. Overall, the Christian Bible is a narrative that begins with the creation of the universe (Genesis) and concludes with the coming of the next world (Revelation).

Vincent Van Gogh
*Still Life with Bible*
1885
Van Gogh Museum, Amsterdam

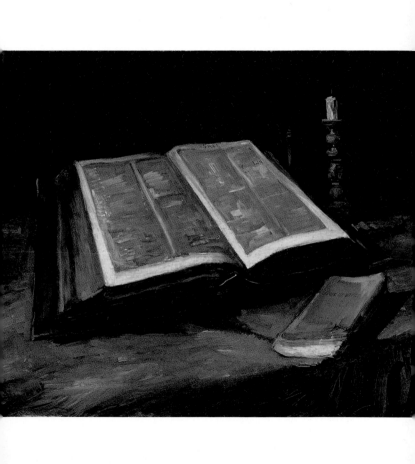

# The Languages of the Bible

The Old Testament books have been handed down in Hebrew, with the exception of two words in Genesis, a verse in Jeremiah, and parts of Daniel and Ezra (Gn 31:47; Jr 10:11; Dn 2:4–7, 28; Ezr 4:6–6:18 and 7:12–26) that were written in Aramaic, the native language of the area roughly corresponding to today's Syria. Aramaic was the common tongue in Roman Palestine, since Hebrew had for a long time been restricted to liturgical use. Even Jesus, as he expired, spoke in Aramaic when he cried, "My God, my God, why hast thou forsaken me?" (Mt 27:47; Mk 15:34) In Genesis (11:1), it is said that at the beginning only one tongue was spoken on Earth; Jewish tradition holds that this language was Hebrew, and that it will again be the only spoken language in the messianic era, when God speaks to His peoples in a pure tongue. The construction of the Tower of Babel resulted in God implementing a confusion of dialects and scattering the nations. This Biblical episode may be viewed as an attempt to explain the different languages of the world.

*Psalms*
miniature from a Hebrew bible
1396
Biblioteca Medicea Laurenziana,
Florence

אשרי

# The Vulgate of Saint Jerome

There is evidence that many (albeit fragmentary) Latin translations of the Bible existed in the very first Christian era. The appellation of *Vetus Latina* ("Ancient Latin") denotes a collection of these disparate translations gathered between the second and fifth centuries AD, starting with the Alexandrian Greek text. The quality of these translations varies greatly. Following these, another Latin translation began to circulate, the "Vulgate," from the phrase *latina vulgata editio*, literally, "Latin edition for the people." The Vulgate is traditionally attributed to Saint Jerome (*c.* 345–420), one of the most influential exegetes and linguists of Western Christendom. As Jerome based his translation on the *hebraica veritas*, the original Hebrew scriptures, he brought to light the many discrepancies between the Septuagint and the Hebrew Bible.

Antonello da Messina
*Saint Jerome in His Study*
*c.* 1460
National Gallery, London

24

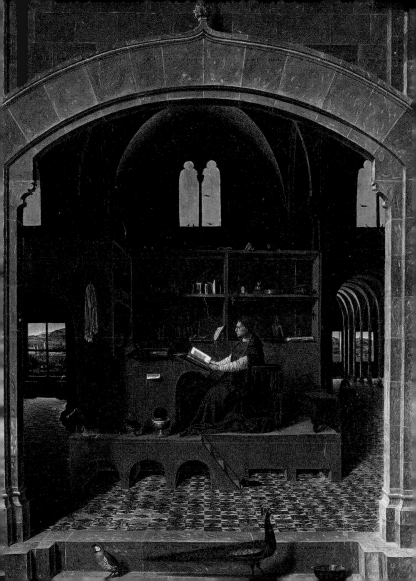

# The Biblical Canon

The criterion used by Christian theologians to select among the many biblical texts that circulated in antiquity is called "canon." The term "canon" is of Sumerian origin; in ancient Hebrew it was spelled *qaneh* and meant "rod," a small bamboo rod used as a unit of measurement. The Greek term *kanōn* came to mean "rule" or "principle." The standard was based upon a predilection for writings believed to be the true word of God, written under the direct inspiration of the Holy Spirit. The selections were made with the consensus of the entire Church, as the texts were recognized by the large Christian communities of Alexandria, Antioch, Edessa, Jerusalem, Rome, and, later, Constantinople. It was only in the late sixteenth century, after the Council of Trent (1545–63), that an official canon was established for the Bible. Meanwhile, the books had been subdivided into chapters by the English theologian Stephen Langton (1150–1228) and into verses by the Dominican friar and expert in ancient Hebrew Sante Pagnini (1470–1536).

Italian School
*The Council of Trent*
16th century
Louvre, Paris

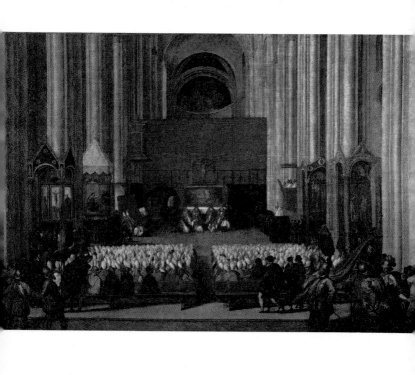

# *The Dead Sea Scrolls*

The different choices made by early Christian communities
in adopting the sacred texts were brought to light by a great
discovery in 1942, when the scrolls of the library of the
ancient community of Qumran were unearthed. Here, in the
first century BC, a sect of about 4,000 followers who had left
Jerusalem founded an isolated, monastic community on the
shores of the Dead Sea. There they followed the Law and the
Prophets, believing that only they could understand them.
Their leader, the Master of Justice, had received a revelation
according to which the Scriptures were to be analyzed with a
unique exegesis (the Hebrew word is *pesher*, to decipher) that
would reveal and decode the information hidden in the sacred
text. The exceptional nature of these noncanonical writings
discovered in Qumran lies in the fact that some of them,
although written at an earlier date, contain ethical principles
that we also find in the Letters of Paul and in the Gospels.
Carbon-14 dating has placed the scrolls in a period between
the third and the first centuries BC; hence some scholars sug-
gest that the New Testament and the Dead Sea Scrolls were
two different tracks of the same train of theological thought,
since both relied on ideas that were already circulating in
Hebrew culture.

*The Isaiah Scroll*
from the Dead Sea Scrolls
2nd century BC
Shrine of the Book Museum, Jerusalem

# Nonbiblical Texts

In addition to the Old and New Testaments, other writings
circulated in early Christian communities that eventually came
to be called "apocryphal," a disparaging term derived from the
Greek verb *apokryptein*, "to hide completely," denoting a text
whose author or authenticity is doubtful. Gradually, as the first
body of canonical texts took shape, another unique type of
literature developed: hagiographies, or narratives of the lives
of the saints. This genre was inspired by a lack of biographical
data about these figures instrumental to the development
of Christianity and the desire to know more about them.
In addition to the hagiographies, another type of literature
emerged that influenced many Christian dogmas: the writings
of the Fathers of the Church—philosophers and men of
letters who interpreted and meditated on the Scriptures,
bequeathing to us a body of teachings handed down from
generation to generation. Among them are the Doctors of
the Church: Saint Jerome and Saint Augustine of the Eastern
Church, and Saint Ambrose and Saint Gregory the Great
of the Western Church.

Giovanni Battista Moroni
*Doctors of the Church* (detail)
16th century
Santa Maria Maggiore, Bergamo

# The Bible of the Poor

Biblical illustrations are essential in Christian worship, particularly because, for the illiterate faithful, figured narrative replaces the text and becomes an educational tool. The Latin expression *Biblia pauperum*, literally "the Bible of the poor," refers to a collection of images of the life of Jesus complemented by images of events and characters from the Old Testament. The Fathers of the Church believed these images were prefigurations and foreshadowings of the history of Christ. These books consist of pages arranged chronologically, with the image of an episode in the life of Jesus at the center and explanatory text in each corner. In the center top and bottom are the figures of the Prophets, and on each side of Jesus are corresponding scenes from the Old Testament. Saint Oscar, bishop of Bremen (805–65), is credited with inventing these illustrated books for the city's cathedral houses. The books were perhaps used for religious instruction, or as models for artists.

French School
*David is welcomed after his victory over Goliath; Jesus enters Jerusalem; Elijah is welcomed at the gates of Jericho*
illustrations from a *Biblia Pauperum*
15th century
Musée Condé, Chantilly

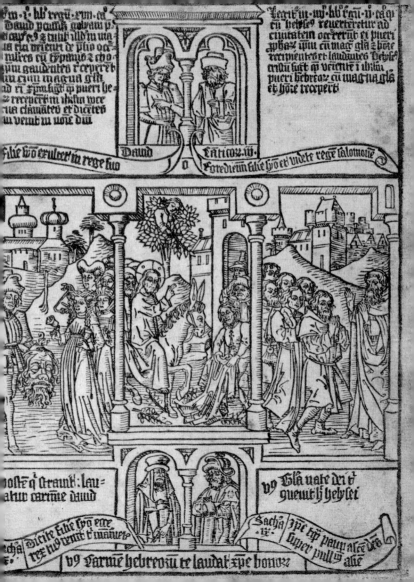

Jn i. lib' regu. cu[m] ed' Dauid p[er]uicit golia[m] p[h]ilisteu[m] et cap' e[ius] z tulit ill[um] in urb[e]m iria eia[us] veuicut de p[re]lio occu[r]rentes cu[m] t[y]mpanis z choris gaudiu[m] recept[er]a[n]t eu[m] cu[m] magna g[lor]ia ad ei t[r]iu[m]phu[m] q[ue] pueri heb[reorum] receptu[m] in ih[e]r[usa]l[e]m vce[r]u[n]t clama[n]tes et dice[n]tes in venib[us] in no[m]ie d[omi]ni

Legit in iiij. lib' xxij. i. ca[pitulo] q[uod] cu[m] helys[eu]s reuereret[ur] ad ciuitate[m] occe[r]ru[n]t et pueri p[ro]phaz ip[su]m cu[m] mag[na] gl[ori]a z b[e]te recipie[n]tes z laudates helyseu[m] c[er]tiu[m] s[u]t q[uod] oriente i[n] ih[e]r[usa]l[e]m pueri hebreo[rum] cu[m] mag[na] gl[ori]a et h[on]ore t[r]oc[e]p[er]ti

[F]ilie syo[n] exultet in rege suo ❦ [E]gredei[n]i filie syo[n] et videte rege[m] salomone[m]

**Dauid** · **Caticox iij**

...ci q[ui] st[r]aunt: laudatur carmine dauid · v[ersus] Gl[ori]a va[le]te d[omi]ni t[ibi] gueut li helylei

Dicite filie syo[n] ecce rex t[uus] venit t[ibi] ma[n]suete · Sacha[rias] ix · Ip[s]e t[ibi] paup[er] as[cendens] de[us] sup[er] pulli[us] asie

v[ersus] Carme hebreoiu te laudat x[pist]e bonor

# The Most Famous Illuminated Bibles

The Bible is by far the most illustrated and most published book of all time. The twelfth century was the golden age of Bible decoration: a perfect example is the Winchester Bible (1160–75), commissioned by Henry de Blois, a nephew of the king of England. It is the most ambitiously illustrated Bible of the Romanesque period; a profusion of initials crowded with inspired scenes, illustrated episodes framed by racemes, and separate spaces filled with images. In the thirteenth century, the "moralized" Bible first made its appearance in Paris. It combined exegesis of the text with small illustrations framed by medallions and brief legends. Illuminated Bibles became popular during the Renaissance. They were created for the new Humanist *studioli* of several lords. One such work is the *Bible of Borso d'Este* (1455–61), with illuminations by several well-known artists, and the *Bible of Federico da Montefeltro* (1476–78), which uses Saint Jerome's Vulgate.

Taddeo Crivelli and Franco de' Russo
*Maccabees I*
miniature from the *Bible of Borso d'Este*
1455–61
Biblioteca Estense, Modena

# The Gutenberg Bible

The Bible was the first book in Europe printed with moveable type. Germany was not only first in printing the Book, but also first in printing the largest number of them. The first edition, attributed to Johann Gutenberg (1394/1399–1468), the inventor of the printing press, is known as the "42-line Bible" and also as the "Mazarin Bible," because the first copy, printed in 1454–55, was found in the library of the French cardinal and statesman Jules Mazarin. The text is that of the Latin Vulgate, printed in two columns and two volumes. Gutenberg printed about 150 copies; only 45 have been found so far. At first, printed copies of the Bible did not include illustrations; it was only later that a trend to find a better decoration for the printed books emerged. As a result, the Bibles printed with moveable type were miniated by hand, at least until the printing process became easier and less costly. This development brought with it the need to find quicker and less expensive decoration processes, which in turn stimulated the development of woodcut prints, lithographs, and, later, copper etchings, sometimes created by celebrated artists.

Jean-Antoine Laurent
*Johannes Gutenberg*
1830
Musée des Beaux-Arts, Grenoble

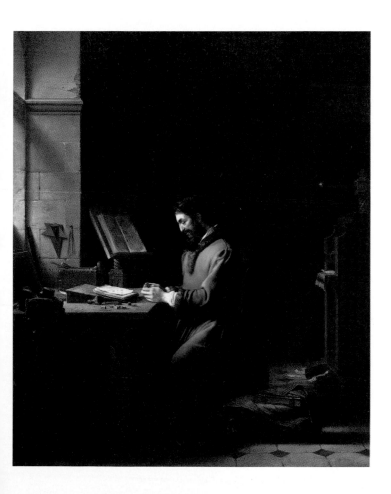

# *Art and Liturgy*

As the first Christian basilicas were being built, the need arose to create functional spaces for the assembly of the faithful. To this end, a new architectural element, the ambo (a raised desk or pulpit) appeared. As early as the fourth century basilicas included raised platforms from which the priests would read and proclaim the Word. They were probably made of wood, which would explain why the earliest examples have not survived. The term is derived from the Latin *ambonem*, in turn drawn from the Greek *ambon*, which means "curved surface," denoting the structure's original shape. Sometimes the Greek word *pergamus* is used, which means "rock" or "rise," or, improperly, the word "pulpit," from the Latin *pulpitum*, "platform"; in fact, the pulpit is higher than the ambo and used for preaching the homily, while the ambo is used strictly for reading passages from the Bible. In early Christian and Romanesque churches we often find two ambos, one on each side of the altar: the one on the right is usually smaller and is used for reading the Epistles, while the larger one on the left is only for reading from the Gospels. Ambos and pulpits are decorated with scenes of Jesus, with the intention of allowing the faithful attending the Eucharistic liturgy to identify with the life, death, and Resurrection of Christ.

Giovanni Pisano
*Pulpit*
1302–10
Duomo, Pisa

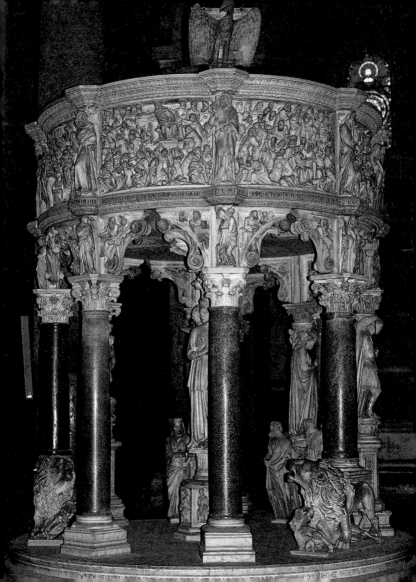

# *The* Exultet *Scrolls*

The rituals associated with specific liturgies also contributed to the dissemination of Christianity through images. An example of this word–image link is the *Exultet* parchment scrolls, on which miniature images were painted upside down with respect to the text, so that as the deacon recited from the ambo, the unrolled scroll revealed the decorated illustrations, making it easier for the faithful to understand the passage. The *Exultet* is a solemn hymn sung at the Easter night liturgy when the baptismal font is blessed. It recalls the Exodus of the Chosen People from Egypt and links the Easter celebration with the very beginning of human history by proclaiming that with the Cross, Christ paid Adam's debt for us, forever.

*Initial "V"*
miniature from *Exultet* 1:4
mid-11th century
Diocesan Museum, Bari

eoenutcem sei huius Luminis Cloe^iacte osem.

uine mecum que^so di o^mnp^a eanas^ misehief p^dief in uoleude
    quime nonme^s nichos^. Inleuicae^pum nune^num.

Dignacus est aeggf^gefe. Luminif sui g^ta e^gem In
    sundens^. Ce^se huius Loaudem Implese p^scipiaea
    ^ei dominum nr^m dnm de^f^n psum siu uiue naen
    secum ea^q fe^gna enae^m. In unicacae^s sp^i^anus^ se^
    deus. Pe^ om^niae seicula^ seiculo^um ^ A^men ^

# DOMIN'S UOBISEVM 6 custodio

# SVRSVM CORDA ◆ te^mus ceddominu ^

u nos adnosace^m uicam non ace^ne^bae^cum. Sed
Luminis moe^as^em^ p^du^cee^p di g^nace^us est. Inque
ehae^uae est aebis fehs^. Inp^ec^ noe^ dice^ fesuse e^go
mecuncuum ^

# Miracle Plays

Over time, the importance of visualizing the Word grew and gave birth to a theater genre: the mystery or miracle play, which consisted of the recital of a biblical episode by readers or actors. Saint Francis of Assisi (1182–1226) organized the first miracle play that called for "posing" actors, the living crèche (so to speak) in 1223 in Greccio. Plays were especially popular in the four-teenth and fifteenth centuries, when the "dramatized" lauds became veritable drama scenes: the number of characters grew; they were played outdoors, no longer in churches; and they took on a life of their own, different from the liturgical ceremonies, drawing inspiration especially from apocryphal literature.

One important development of the mystery plays are the Sacred Mounts, devotional complexes located along mountain ridges, essentially strings of chapels or small shrines that depict scenes from the lives of Christ, Mary, and the saints. Although there are no live actors, they are indeed miracle plays, with statues dressed in striking garb arranged before painted back-ground scenes, all to encourage the faithful to visualize the life of Christ and identify with it.

Antonio d'Enrico,
known as Tanzio Varallo, and
Pier Francesco Mazzucchelli,
known as il Morazzone
*Condemnation of Christ*
1614–15
Sacro Monte, Varallo Sesia

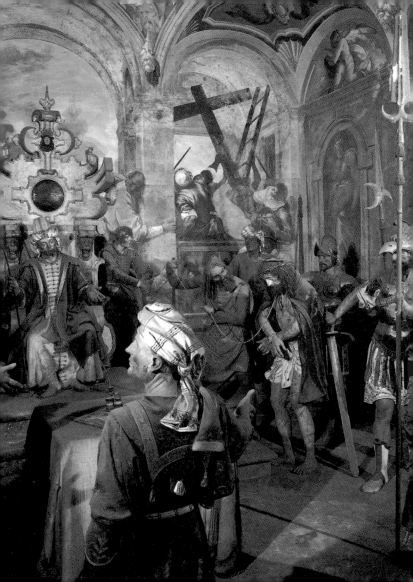

# The Bible and Hollywood

Throughout the centuries, the Bible has captivated the world—and so has cinema from its own beginning. It is no surprise that Erwin Panofsky (1892–1968), the German art historian, compared cinema to the great Gothic cathedrals. In fact, just as the sculptures and frescoes of Medieval churches were meant to present the Bible to the world independent of language or of literacy, cinema, the "cathedral of modern times," has become a post-Babel universal language. Directors such as Franco Zeffirelli, Mel Gibson, John Huston, Pier Paolo Pasolini, and Martin Scorsese have made films based on the Scriptures that have given us many memorable scenes, such as the legendary parting of the waters in Cecil B. DeMille's *Ten Commandments*, and mesmerizing characters, such as the Egyptian pharaoh played by Yul Brynner in the same film. This bond between the Bible and film is very much alive, as shown in the 2009 exhibition held at the New York Museum of Biblical Art (MOBIA) exploring how directors have approached biblical subjects, emphasizing the dramatic aspects of passion, violence, and machination.

Cecil B. DeMille
*The Parting of the Red Sea*
still from *The Ten Commandments*
1956

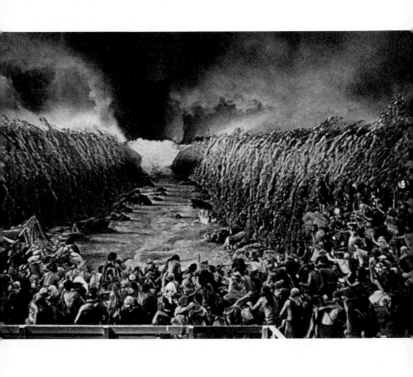

# The Old Testament

The Pentateuch - The Historical Books
The Wisdom Books - The Prophetic Books

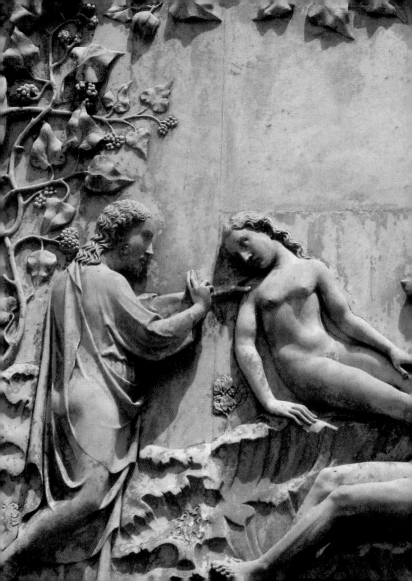

# The Seven Angels with Trumpets

In this section Saint John seems to have freely drawn from the plagues that God had unleashed against Egypt when he freed the Israelites. The Evangelist saw seven angels come forward, who were given seven trumpets. The first four brought devastation to one-third of plants and waters, animals and the skies. The rivers and the springs were hit by a star called "Wormwood" and turned into wormwood, poisoning scores of people. The fifth and the sixth trumpet unleashed plagues on the human race only: The former released the scourge of locusts that attacked the unjust for five months; the latter released four angels who had been chained at the Euphrates River. They became an immense army that slew one-third of the human race. Before the last trumpet sounded, the Evangelist saw an angel come down from Heaven; he held a small, open scroll in his hands and offered it to John: "Take it, and eat it up; and it shall make thy belly bitter, but it shall be in thy mouth sweet as honey." (Rev 10:9) The act of swallowing represents the prophet absorbing the Word. The seventh and final trumpet announced the imminent coming of the Kingdom of God. (Rev 8–10; 11:15–19)

*The Seven Angels with Trumpets*
13th century
Bodleian Library, Oxford

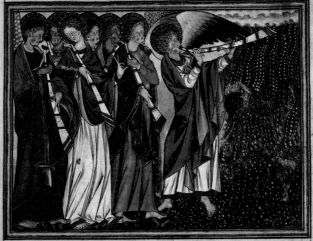

r septem angeli. qui hēbāt
septem tubas ꝓparauerunt
se ut tuba canerent. Et primus
angelus tuba cecinit et facta est
grando et ignis commixtus in
sanguine et missus est in terrā ⁊
tertia pars terre combusta est. et
tertia pars arborum concremata
est. et omne fenum uiride comb
ium est.    Et primus angls. ⁊c.

℣ Per primum angelum sicut diximus ꝓdicato
res qui ante legem fuerunt designantur primus
angelus tuba cecinit quia sancti uiri qui ante legē
fuerunt. quamuis nullam legem iurie nisi nam
ralem hoc quibus ante ꝓcreari euasisse creden
di sunt. ut uerum creatorem suum timerent amꝑ
diligerent ⁊ quod quis pati non uellet alii n̄ facrr̄.

Et facta est grando et ignis. et cet.

Ea que septem angelis tubis canēnub; facta fu
isse uisa sunt in bonam partem sicut mihi uicet
accipienda sunt. sic econtrario effusio sialanum
septem angelorum que sequitur in malam. ꝑ
grandinem ⁊ que premit uerba secundum uiuyꝯ
hur cordis prauorum hominum argumēto ꝑcu
tiebant designantur. que ignem ⁊ sanguinem ꝑ
mixtum habuisse uidebimus per ignem sic sanc
in designan̄. qui in sanctis suis inhiāns contin̄
uetuorum minister exorit. per sanguinem uero
ipse intelligitur. qui ex parib; sepe ꝑducens est.
⁊ eorum amb; ꝑsigurantur . Terra autem se
culi hoīes peccati subditos demonstrat ⁊ cetera

Et tertia pars terre combusta est.
et tertia pars arborum concrema
ta est. ⁊c.    Per tertiam partem terre eos
qui per doctrinam ⁊ exempla bo
norum hominum salui facti sunt. debemus intel
ligere. Qui igne innoxio dei ama ⁊ amoris quali
prauum in se sunt combusserunt amꝑ delenerunt.
Arbores uero qui per doctrinam uit eos uenuerunt ⁊
significatur ex quib; multi per doctrinam ⁊ exem
pla bonorum iuxantium salui facti sunt que ab
imtelleḋ ꝑ ab alueolo ⁊ per iob nr̄o amici ē. Per
fenum autem illud quod omne combustum ē
dicitur. hii designantur qui ⁊ superius p̄ma. ⁊c.

# The Woman Robed with the Sun

The author of Revelation mentions two signs that appeared in the sky; the first was a woman clothed with the Sun, wearing a crown of twelve stars on her head and holding the Moon under her feet. She was in labor. The second sign was a great red dragon with seven heads and ten horns and a crown on each head. The monster stood before the woman, waiting to devour the child as soon as it was born. And she brought forth a boy who was to rule all nations, and the child was kidnapped up to God's throne, safe from the dragon. The woman fled into the desert. A battle was fought in Heaven between the dragon with his angels and the Archangel Michael with his angelic army. The forces of Good prevailed and the dragon was cast out on the earth, where he pursued the woman, who was given two eagle wings to escape the monster. To stop her, the dragon spilled out of his mouth a flood of water, but the earth opened and swallowed up the flood and the monster fled. Christian iconography has merged the image of the woman in this vision with the woman who crushes the serpent's head in Genesis, thus creating a female figure that has been identified with the Virgin Mary and the mystery of her Immaculate Conception.

(Rev 12)

Lucas Cranach the Elder
*The Dragon and the Sun Woman*
1534
Private collection

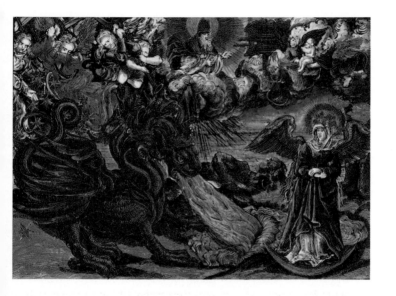

# The Beast from the Sea

The presence of Evil on Earth is recounted in Revelation with the appearance of two beasts. The first rose up from the sea and had the features of the four monsters that had appeared to the prophet Daniel (Dn 7): the body of a panther, the paws of a bear, the mouth of a lion, ten horns with ten crowns above them, and seven heads with the names of a blasphemy on each. A sort of diabolical opposition to the Lamb, this dragon had one head with a slit throat, but the wound had healed. The entire earth knelt before the beast, which was given great powers for 42 months, including mouthing blasphemies. In that period, the beast would make war with the saints and overcome them and would be worshipped by all those whose name was not written in the Book of Life of the Lamb. With reference to the difficult times when this book was written, as the infant Church labored under Roman persecution, some have identified the beast with the Roman Empire: the seven heads could represent the seven hills of Rome, and the blasphemies written on each of its seven heads could represent the sacrilegious speeches of the rulers.

(Rev 13:1–10)

Giusto de' Menabuoi
*The Seven-Headed Beast
Coming from the Sea*
*c.* 1393
Baptistry, Padua

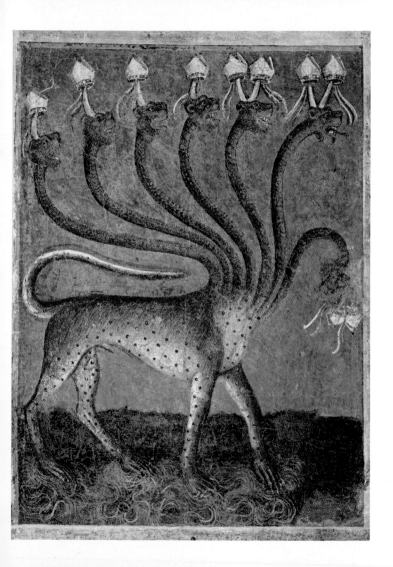

# *The Beast from the Earth*

After the beast from the sea, John beheld another monster, this one coming up out of the earth with two horns like a lamb. He was given the power of the first beast and his role was to enforce its authority. This monster, therefore, was a sort of false prophet who buttressed the blasphemous speeches of the first beast and made people worship it. The beast from the earth forced the people of the world to worship the beast from the sea, probably an allusion to the idolatry of the Roman Empire at the time that John was writing. The beast compelled everyone to be branded on the right hand or on the forehead with the number 666, which has become the symbol of the Antichrist, the first beast whose worship was proclaimed. (Rev 13:11–18)

*People Worship the Horned Beast*
13th century
Lambeth Palace Library, London

erunt ki habitent  rurt la prine. e al ki suff
erre: signefie ke el  les princes eles fiuenz en la
iurt obeissant a lui: qui  seruion. auerticrhaure eo
pur la ferme fei e pur la pacience

# The Antichrist

During his ministry, Christ had foretold the coming of an antagonist, "For there shall arise false Christs, and false prophets." (Mt 24:24) The Antichrist is the false Messiah who will try to impersonate the Son of God and will lead people astray by preaching falsehoods. While Jesus himself warned of his coming, Revelation described the monstrous features of this being, identified with the beast from the sea. But the Fathers of the Church adapted those features to make them closer to those of a man. In some works of art the Antichrist has the features and body of Christ, but he is embraced by the Devil, who whispers falsehoods in his ear. The number 666 that is branded on the forehead or the right hand of its worshippers and heralds the appearance of the beast is enigmatic, to say the least. Even assuming that the meaning was clearly understood by John's readers, that meaning has been lost in history. One widely accepted theory attributes decoding the number to *gematria*, a kabbalistic practice that calculates the numerical values of words. Following this system, some scholars believe that the number 666 hides the letters "NERWN QSR," or "Neron Qesar," meaning Nero Caesar, one of the Roman emperors who persecuted Christians.

Luca Signorelli
*Sermon and Deeds of the Antichrist* (detail)
1499–1502
Chapel of San Brizio, Duomo, Orvieto

# The Lamb and the Male Virgins

Another vision rich with evocative symbolism is the Lamb standing on Mount Zion surrounded by 144,000 people, all with his name and that of the Father written on their foreheads. The number of the elect symbolizes a full, realized totality; the brand on the forehead contrasts with the diabolical brand of the worshippers of the beast. This multitude was composed of "virgins," meaning all those who had not worshipped false gods. They began to sing a new hymn like the sound of harps. Then an angel was sent to announce that the time of judgment was at hand; a second angel followed, who proclaimed the fall of Babylon the Great, the city that corrupted all the other nations. Finally, a third angel sentenced the followers of the beast, on whom God would unleash his fury. (Rev 14:1–13)

Albrecht Dürer
*The Adoration of the Lamb and the Hymn of the Chosen*
Woodcut from *The Revelation of Saint John*
1497–98
Private collection

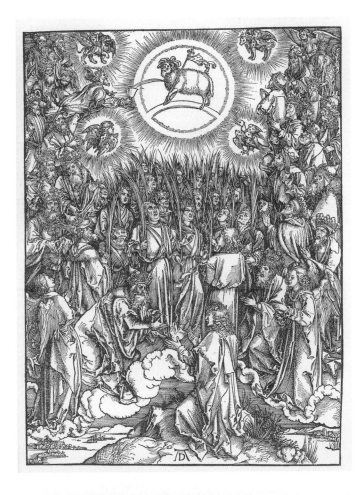

# The Angels of the Seven Plagues

The last seven plagues sent by God to fight the corruption of the world were kept in seven bowls, carried by angels who emptied them on the earth one by one. The first plague caused virulent sores on all those who were marked with the number of the beast. The second killed all the living creatures of the sea, while the third turned all the waters into blood, God's punishment for the murder of saints and prophets. The fourth bowl was emptied over the Sun, causing it to scorch people with its fierce heat. The fifth was poured on the throne of the beast, plunging its kingdom into darkness. The sixth angel poured the bowl into the Euphrates River, causing it to dry up so that a path was made for the kings of the East to cross. Along with the other rulers of the earth, they had been summoned to participate in the final battle by three foul spirits that issued from the jaws of the dragon and the other two beasts. The kings gathered in a place called, in Hebrew, *Armageddon*, the site of an ancient victory fought at the time of the judges. The last bowl produced a great voice that simply boomed, "It is done." (Rev 16:17) Thunder, lightning, and an earthquake followed; the hail of God's wrath rained down from the sky as men continued to curse God. (Rev 16)

*Seven Angels Pouring Out Vials of Plagues*
miniature from the *Book of Revelation of Amand Abbey*
9th century
Bibliothèque Municipale, Valenciennes

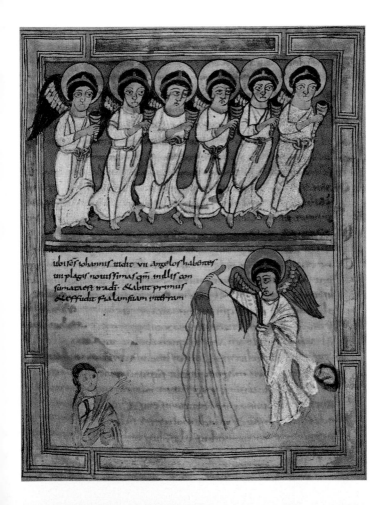

ubi ses iohannis uidit vii angelos habentes
vii plagas nouissimas qm mdlis con
sumata est iradi. & abiit primus
& effudit fiolam suam interram

# The Fall of Babylon

The city of Babylon, the paramount symbol of all sorts of idolatry and lust, is visualized in Revelation as a harlot arrayed in scarlet and purple, riding a beast of the same color with seven heads and ten horns that recall the monster from the sea. The harlot glittered with gold and precious stones and held in her hand a golden wine cup full of abominations, and she drank the blood of Jesus' martyrs and saints. John was mystified by the apparition, but the angel who escorted him explained: "The seven heads are seven mountains, on which the woman sitteth. And there are seven kings: five are fallen, and one is, and the other is not yet come; and when he cometh, he must continue a short space." (Rev 17:9–10) Some scholars have seen in the seven mountains the hills of Rome and in the seven kings the Roman emperors. The angel continued his explanation by announcing that the ten horns of the beast—representing the rulers of the vassal kingdoms of Babylon—were plotting to turn against the whore, who would be overpowered in a process of self-destruction. (Rev 17–18)

Jacobello Alberegno
*The Whore of Babylon*
from the *Polyptych of the Apocalypse*
1360–90
Gallerie dell'Accademia, Venice

XXVII

# Christ the Rider Defeats the Dragon

The battle between Good and Evil is resolved in the sky, with Jesus Christ taking part. He is described as a rider with fiery eyes and a sword coming out of his mouth. His name is not made explicit by the author, who calls him "The Word of God"; his is the task of ruling over nations and of pressing the wine of God's wrath, a clear reference to the Last Judgment. The rider defeated the two infernal beasts and hurled them into a lake of fire burning with brimstone. His sword slew all the followers of Satan and his forces, and their flesh became a banquet for the creatures of the sky. This episode expresses the everlasting victory of Good over the forces of Evil.
(Rev 19:17–21)

Nicolas Bataille
*The Beast Is Thrown into the Lake of Sulphur*
from *The Apocalypse of Angers*
1373–87
Musée de la Tapisserie, Angers

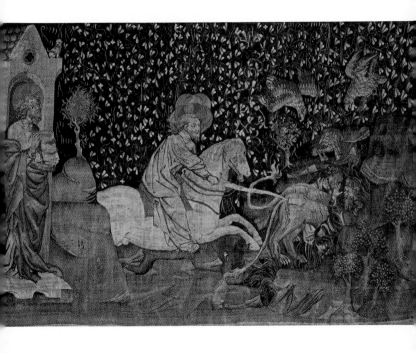

# The Angel with the Key to the Abyss

After Christ defeated the Satanic powers, the dragon, which was the image of Satan, was chained up by an angel come down from Heaven. The celestial figure held the key of the Abyss in his hand; he chained the beast and hurled it down the bottomless pit for a thousand years, after which time the beast must be released, though only for a short while. The dragon will try again to seduce nations and lead them astray but will again be defeated, and this time will be cast into the lake of fire and brimstone where the two Satanic beasts were thrown. This apocalyptic passage has probably helped to spread the so-called "millenarian" theory, which purports that before the end of times there will be a Kingdom of Christ on Earth that will last 1,000 years.

(Rev 20:1–3)

Odilon Redon
*And I Saw an Angel Coming Down
from Heaven . . .*
Plate VIII from the *Apocalypse of Saint John*
1899
Museum of Modern Art, New York

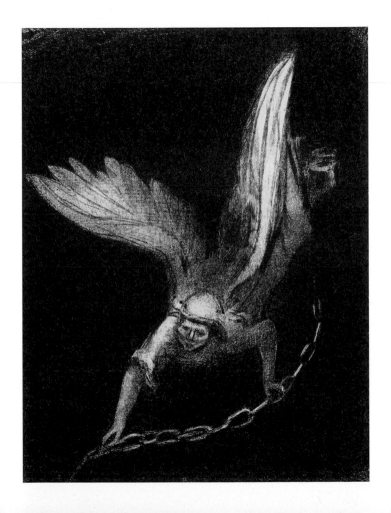

# The Last Judgment

One of the last two visions in Revelation is about the Second Coming of Christ on Earth to judge the living and the dead. The prophet saw a figure seated on a white throne, before whom the earth and the sky vanished. And all the dead were resurrected, and the Book of Life, according to which everyone was to be judged, was opened. Those whose names were written in the Book could enter the everlasting Kingdom, while those who were not were cast into the lake of fire and brimstone, where the infernal powers had already been thrown. This passage has inspired an enormous number of works of art, which usually set Christ the Judge at the center of the composition with the contrasting scenes of the elect entering the Heavenly Kingdom and the evil ones being sentenced to Hell on either side.

(Rev 20:11–15)

Stefan Lochner
*The Last Judgment*
*c.* 1435
Wallraf-Richartz-Museum, Cologne

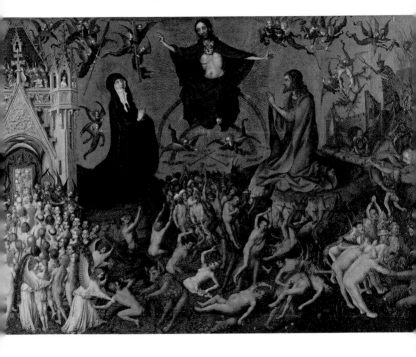

# The Heavenly Jerusalem

The Bible announces several times the coming of a messianic renewal of the city of Jerusalem. Saint John has the new city come down out of Heaven, decked out like a bride coming to her bridegroom for the mystical marriage to the Lamb-Jesus. Twelve are the foundation stones of the city, and on each one of them is carved the name of one of the twelve apostles. Twelve angels oversee the entrance to the twelve gates, three for each cardinal point, and each gate bears the name of one of the twelve tribes of Israel. Only those whose names are written in the Book of Life are allowed to enter. Inside the city the Temple is no more; in its place is the Lamb, the living symbol of the presence of God among His people. This, the last book of the Bible, ends with a strange warning to the reader not to change the text, or he will incur in God's wrath: "For I testify unto every man that heareth the words of the prophecy of this book, If any man shall add unto these things, God shall add unto him the plagues that are written in this book. And if any man shall take away from the words of the book of this prophecy, God shall take away his part out of the Book of Life, and out of the holy city, and from the things which are written in this book." (Rev 22:18–19)

(Rev 21–22)

*The Heavenly Jerusalem*
miniature from the *Book of Revelation of the Bishop of Auxerre*
12th century
Bodleian Library, Oxford

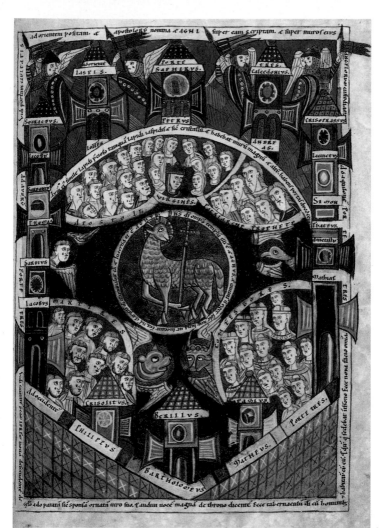

# The Pentateuch

Genesis
Exodus
Leviticus
Numbers
Deuteronomy

The term "Pentateuch" is derived from the Greek term *pentateuchos*, where *penta* means "five" and *teuchos* means "tool, vessel." It refers to the case where the rolls of the first five books of the Old Testament were kept. These writings tell the story of the origins of Israel and of the ancestral Covenant between God and the Chosen People.

# Genesis

"In the beginning God created the heaven and the earth."
(Gn 1:1)

The first book of the Bible is aptly named; its Hebrew name,
*bereshit*, translated into Greek as *génesis*, means "beginning."
The book is divided into two separate, complementary parts
that recount the beginning of God's revelation in the Scrip-
tures. The first eleven chapters recount primordial history,
from the Creation of the world and of man to Original Sin,
through Noah and the Flood, and up to the confusion of
tongues after the destruction of the Tower of Babel. The second
part narrates stories of the patriarchs, starting with God's call
to Abraham, continuing with the lives of Isaac and Jacob, and
ending with the story of Joseph, a self-contained tale that
bridges the separate events of Exodus. Thus, while the pro-
tagonist at the beginning is *adham*—that is, "man," understood
as the emblem of the human race at its origins—as the
narrative unfolds the focus shifts to the history of Israel and
the Chosen People. Rather than a compact whole, Genesis
is an amalgam of several oral traditions that were later unified
in a single book.

*Cupola of Creation*
early 13th century
Basilica di San Marco, Venice

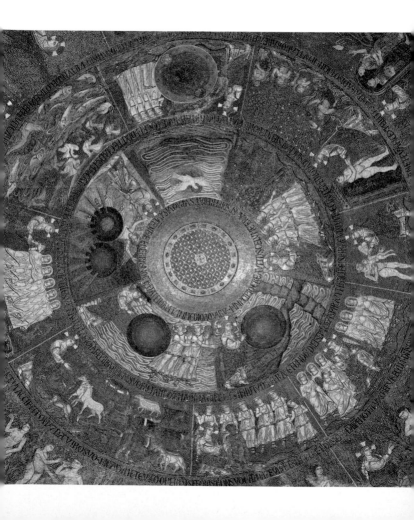

# The Creation of the World

God created the world in six days. On the first day God separated light from darkness; on the second, He divided the waters that are below the vault of heaven from those above. On the third He said: "Let the waters under the heaven be gathered together unto one place, and let the dry land appear," and the earth brought forth vegetation. (Gn 1:9) On the fourth day, to distinguish day from night and to separate the seasons, God made the Sun, the Moon, and the stars and set them in the firmament. Then He filled waters and sky with all kinds of animals. On the sixth day God created all kinds of earthly animals and placed man, whom He fashioned after his own image and likeness, to rule over creation. "And on the seventh day God ended His work. . . . And God blessed the seventh day, and sanctified it." (Gn 2:2–3) While artists have been greatly inspired by the fifth and sixth days of Creation because they could depict animals and, of course, the powerful scene of man's very first appearance, some have also attempted to depict the creation of the globe, the appearance of dry land, and the first signs of vegetation.

(Gn 1:3–31; 2:1–4)

Hieronymous Bosch
*The Creation of the World*
from *The Garden of Earthly Delights* triptych
*c.* 1500
Museo del Prado, Madrid

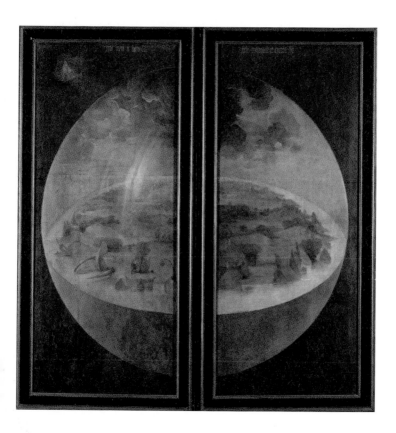

# The Creation of Adam

At the summit of His work of Creation, God fashioned man after His own image and likeness. In Hebrew *adham*, "man," comes from *adhamah*, which means "earth, soil," an allusion to the inextricable bond between the first living human being and the matter from which he was created. "And the Lord God formed man of the dust of the ground, and breathed into his nostrils the breath of life; and man became a living soul." (Gn 2:7) These short verses have inspired an extremely rich iconography: Sometimes God merely touches Adam; at other times, He breathes the vital principle directly into his nostrils. The space, as imperceptible as it is infinite, separating God's extended index finger from Adam's still inert finger in Michelangelo's masterpiece contains oceans of meaning: It is an infinitesimal interval in which all the mystery of the act of creation is contained.

Michelangelo Buonarroti
*The Creation of Adam* (detail)
1510
Sistine Chapel, Vatican

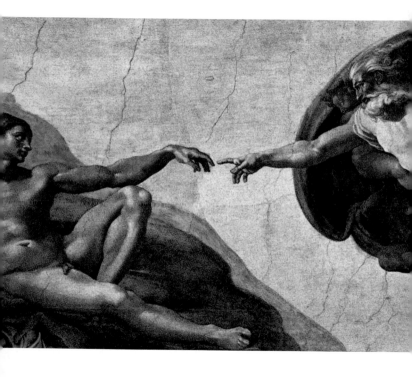

# *The Creation of Eve*

The biblical text contains a few inconsistencies; although in the very first narrative of Creation God generated "male and female" (Gn 1:27), leading the reader to understand that Adam and Eve were created simultaneously, later in the same book there is a second version in which the first woman was fashioned out of Adam. Having put the man to sleep, God took a rib and fashioned woman from it; Adam himself recognized her as "bone of my bones, and flesh of my flesh." (Gn 2:23) In earthly Paradise, the woman was called *isshah*, the female form of *ish*, which means "male." Adam's wife was given the name of "Eve," or "the giver of life," after they were banished from the Garden of Eden. (Gn 3:20)

(Gn 1:27; 2:21–25; 3:20)

Lorenzo Maitani (attr.)
*Creation of Eve*
1310
Duomo, Orvieto

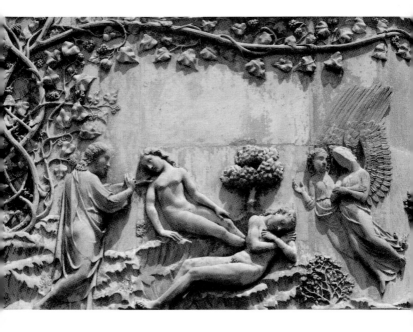

# The Earthly Paradise

"And the Lord God planted a garden eastward in Eden; and there he put the man whom he had formed." (Gn 2:8)

The earthly Paradise represents the place that God created for man to till and keep. The word *eden*, from the Sumerian, has been translated in the Greek version of the Bible with the Persian term *paràdeisos*, or "pleasure-grounds." The Garden of Eden was crossed by a river that in turn divided into four tributaries: Pison, Gihon, Hidekel, and Euphrates. This sketchy, somewhat confused description does not allow us to identify the place, but it has been variously thought to be either near the Persian Gulf, in India at the source of the Ganges, or in Armenia at the source of the Euphrates. Tradition holds that after the Flood, God hid the Edenic river. Because the location of Eden cannot be identified geographically, artists have often conjured up habitats familiar to them. Thus in southern climates Eden has become an oasis in the desert, while northern European art has imagined it as a wild woodland.
(Gn 2:8–17)

Hans Thoma
*The Garden of Eden*
1896
Staatliche Kunsthalle, Hamburg

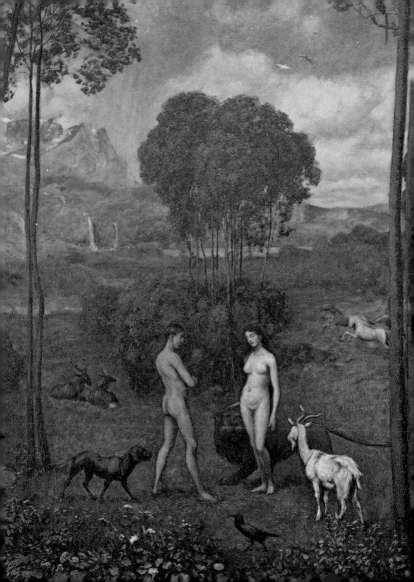

# The Original Sin

Deceived by the serpent, Eve ate the fruit of the Tree of the Knowledge of Good and Evil, disobeying God's admonition: "She took of the fruit thereof, and did eat, and gave also unto her husband with her; and he did eat." (Gn 3:6) After the act, the man and the woman acquired self-awareness, and realizing that they were naked, covered themselves with fig leaves, hiding from God's eyes. This episode, extremely popular with artists, has been variously depicted: Sometimes the tree is a fig or an orange tree, more often an apple tree, and our progenitors approach it or are caught eating the fruit. In some cases, such as this work by Tintoretto, the artist has captured the instant just before the sin, when Eve offers Adam the fruit that she has just picked.

(Gn 3:1–7)

Jacopo Robusti,
known as Tintoretto
*The Temptation of Adam*
1551–52
Gallerie dell'Academia, Venice

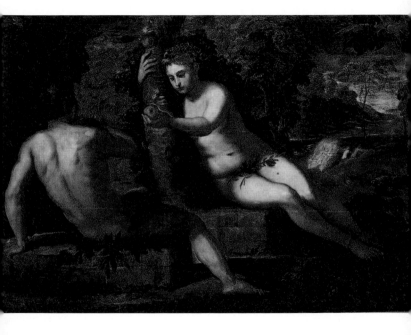

# The Expulsion from Earthly Paradise

Having learned of the Sin, God demanded an explanation from the progenitors of the human race. Adam blamed Eve, who justified herself by claiming that the serpent had deceived her. Then God sentenced the reptile to crawl in the dirt, the woman to suffer the pains of childbirth and be mastered by man, and the latter to make his living by the sweat of his brow. To prevent them from eating from the Tree of Life, which would have made them immortal, God dressed the couple with tunics made from animal skins and banished them from Paradise. He posted cherubs armed with fiery, flashing swords to guard Eden. The expulsion has been frequently represented as walking through a gate: Adam and Eve dejectedly leave the Garden, covering their private parts with their hands, thus signifying their newly acquired consciousness of the human condition.

(Gn 3:8–24)

Tommaso Cassai,
known as Masaccio
*The Expulsion from the Garden of Eden*
1426–27
Cappella Brancacci,
Santa Maria del Carmine, Florence

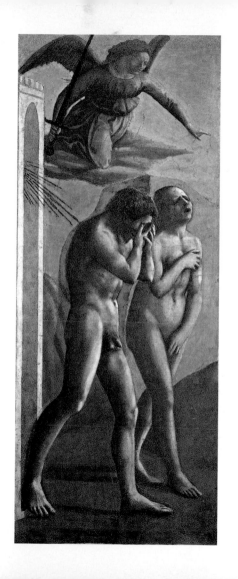

# Cain and Abel

Cain and Abel were the sons of Adam and Eve: Cain, the elder, tilled the soil and Abel, the younger, was a shepherd. One day they both made offerings to God of the fruits of their labor; Cain offered "the fruit of the ground" and Abel "the firstlings of his flock and of the fat thereof." (Gn 4:3–4) The Lord accepted Abel's offer, the hearts of his fattest lambs, but not Cain's, the produce from his fields. Cain flew into a rage and did not heed the Lord's warning, but took his brother into a field and killed him. As punishment, the Lord sentenced Cain to wander endlessly and to lose his ability to farm, for the earth would no longer yield its fruits to him. In the crucial scene of this episode, Abel is either kneeling or lying on the ground with Cain towering above him, about to strike. The murder weapons are as varied as a club, a rock, a tool, or, as in this representation, an ass's jawbone.

(Gn 4:1–15)

Giovanni Benedetto Castiglione,
known as il Grechetto
*Cain and Abel*
*c.* 1650
Galleria di Palazzo Bianco, Genoa

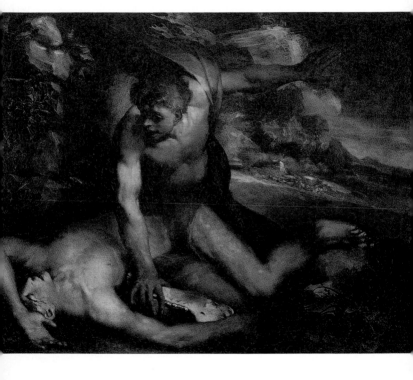

# Noah's Ark

Seeing that the generations descended from Cain were wicked and corrupt, God resolved to destroy all living beings, with the exception of Noah, a just and upright man. Thus He commanded Noah to build an ark of gopher wood, 300 cubits (about 400 feet) long. It was to have three stories, a door, and a roof. Noah, his wife, and their children, Shem, Ham, and Japheth, along with their wives, were to board it together with one pair of animals of each species. God would cause it to rain for 40 days and 40 nights, destroying all living things created by Him on the face of the earth. Noah, 600 years old at the time, obeyed the Lord and boarded the ark with his family and the animals. This episode has been very popular in art, and artists have endeavored to depict the various species of animals as they are about to board the boat, shown as a sort of large, floating house.

(Gn 6; 7:1–10)

Aurelio Luini
*The Animals Boarding Noah's Ark*
1555
San Maurizio al Monastero
Maggiore, Milan

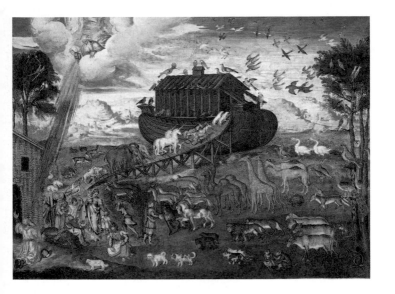

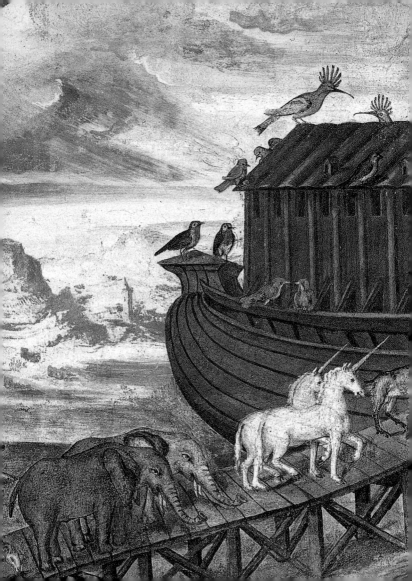

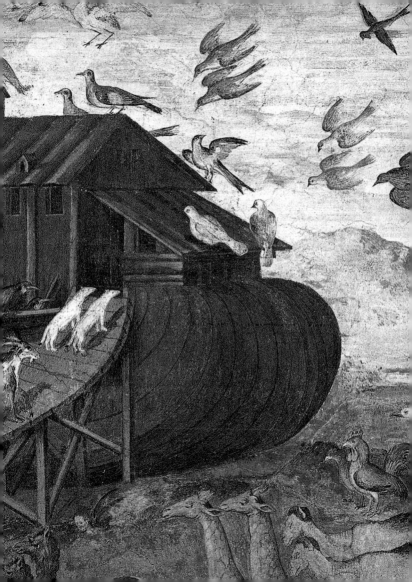

# The Flood

Forty days and forty nights of rain erased all trace of life on Earth. The waters covered all the earth; only the ark floated on this endless sea. After 150 days, the waters began to recede, and in the seventh month the ark came to rest on top of Mount Ararat. After waiting another three months, Noah resolved to send a raven to find out if other lands had emerged, but the raven returned because there was no land on which to rest its feet. Then the patriarch sent a dove, which also came back. After seven more days, he sent forth another dove, which returned carrying an olive branch in its beak, proof that the waters had abated. The third time he sent forth a dove, it did not come back. Now confident that the waters had dried up to again reveal the earth, Noah and his family left the ark with the animals. Wind, rain, and a swelling sea submerging Creation are all part of the dramatic representations of this event. Sometimes a dove is depicted carrying an olive branch, a symbol of good tidings and, more broadly, peace.

(Gn 7:11–24; 8:1–14)

J. M. W. Turner
*The Deluge*
1805
Tate Gallery, London

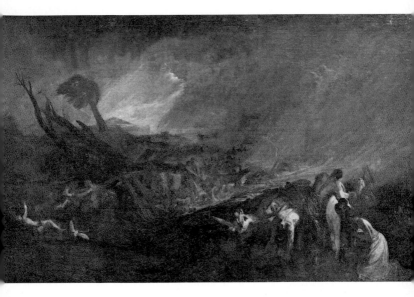

# Noah's Offering

As soon as he came out of the ark, Noah built an altar in thanksgiving to the Lord and on it sacrificed all kinds of clean animals and birds. God blessed the patriarch and his sons, encouraging them to multiply and have dominion over the earth. Then He made a pact with them: "And I will establish my covenant with you, neither shall all flesh be cut off any more by the waters of a flood; neither shall there any more be a flood to destroy the earth." (Gn 9:11) As a sign of His renewed faith in the human race, the Lord caused a rainbow to appear in the sky, so that He might be reminded of the Covenant He made with man. This important episode, when God first made a pact with humankind, has not been depicted often in art.

(Gn 9:1–17)

Jacopo Bassano
*Noah's Sacrifice*
c. 1574
Staatliche Schlösser und Gärten,
Potsdam-Sanssouci

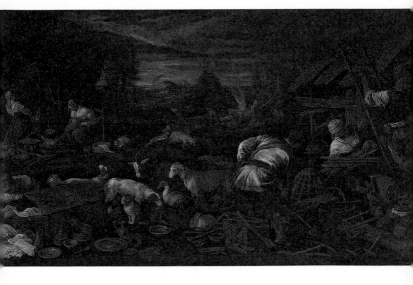

# Noah's Drunkenness

Noah's sons were Shem, Japheth, and Ham. After the flood, they were to repopulate the earth. One day Noah, now a farmer, drank wine from his vineyard and became inebriated, falling asleep naked in his tent. Ham saw his father naked and called Shem and Japheth, who took a cloak and, walking backward so as not to see him, covered their father's nakedness. When Noah awoke and learned what had transpired, he cursed Ham's son, Canaan, dooming him to be a slave to his uncles. "Canaan" was the name of a Palestinian people that worshiped idols; here they are symbolically cursed. "To see one's nakedness" means to be totally disrespectful. Comparisons have been made between Noah without clothes and Christ mocked on the Cross.

(Gn 9:18–27)

# The Tower of Babel

There was a time when everyone spoke the same language, but one day a group of men decided to found a city in the land of Shinar and began to build a tower to reach Heaven. The Lord resolved to punish their arrogance: "Go to, let us go down, and there confound their language, that they may not understand one another's speech." (Gn 11:7) And He multiplied their tongues and scattered them all over the earth. "Babel" comes from the Hebrew *balal*, which means, appropriately, "to confuse." Some scholars believe that the Tower could refer to Babylon's ziggurats, pyramidlike structures with wide outside stairs that one climbed to reach the shrine on the top.

(Gn 11:1–9)

Pieter Bruegel the Elder
*The Tower of Babel*
*c.* 1563
Kunsthistorisches Museum,
Vienna

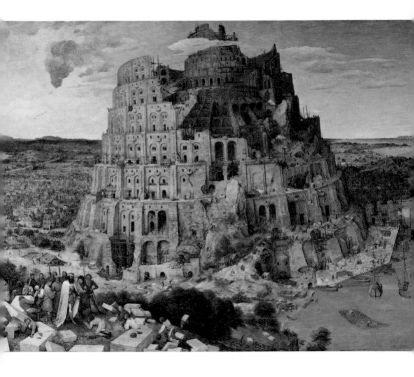

# *Abraham*

Abraham is the first of the great patriarchs of the Old Testament and the founder of the people of Israel. The son of Terah, he married his stepsister Sarai. When the Lord called him, he left his fatherland—the city of Ur in Chaldaea—to reach the land of Canaan, which God had promised to him, saying: "Unto thy seed will I give this land." (Gn 12:7) His wife and his nephew Lot went with him, and their servants and flocks. When a famine hit the land, Abraham went down to Egypt. Afraid he might be killed by the Egyptians, who were attracted by Sarai's beauty, he introduced her as his sister. The pharaoh took a liking to her and made her his concubine, treating Abraham to "sheep, and oxen, and he-asses, and menservants, and maidservants, and she-asses, and camels." (Gn 12:16) But the Lord, indignant at these doings, inflicted severe plagues on Egypt. When the pharaoh discovered the truth, he banished Abraham and his wife, who returned to Canaan. After parting company with Lot, the patriarch settled near Hebron, a short distance from Jerusalem. Abraham symbolizes faith unto the Lord; he was the first to receive the promise that God made to Israel.

(Gn 12:10–20)

*Abraham*
11th–12th centuries
San Giacomo, Santiago de
Compostela

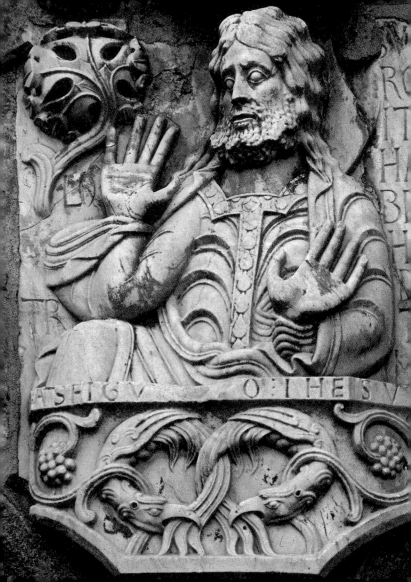

# Melchizedek

After a war between the kings of the land of Canaan,
Abraham's nephew Lot was taken captive. Upon learning
this, the patriarch mustered 318 men and gave chase to the
enemy, defeated them, and freed Lot. As he was making his
way home, Melchizedek, the king of Salem and a priest, came
to meet Abraham: he blessed him and offered him bread and
wine. The grateful patriarch in turn gave him a tenth of the
spoils. The biblical expression "priest of the Most High God"
(Gn 14:18), used for Melchizedek, emphasizes his faith in
only one god; the city of Salem has been identified by
historians as Jerusalem. The king, here depicted wearing
the bishop's miter, blesses Abraham while a servant holds
the gifts of bread and wine, in which the Christians see a
foreshadowing of the Eucharist.

(Gn 14:1–24)

Leonello Spada
*Abraham and Melchizedek*
*c.* 1605
Pinacoteca Nazionale, Bologna

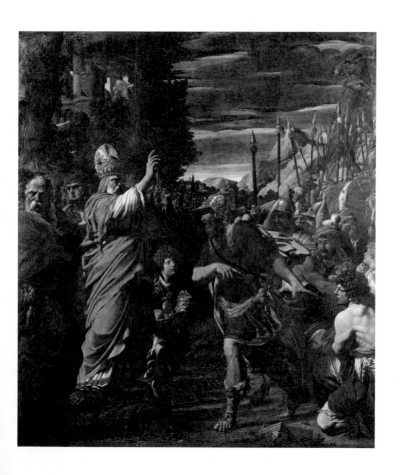

# *Abraham and the Three Angels*

On a hot, sultry day, while he was living near Hebron,
Abraham was visited by three men. Recognizing the divine
nature of one of them, and the angelic nature of the other
two, the patriarch ran to meet them: He bowed to the ground
and entreated them to stay and rest and refresh themselves.
The three men agreed, and he offered them veal and milk.
When they asked about his wife, he replied that Sarai (whose
name God changed to Sarah) was in the tent. Then God told
him: "I will certainly return unto thee according to the time
of life; and, lo, Sarah thy wife shall have a son." (Gn 18:10)
While this passage leaves no doubt that the Lord was one of
Abraham's three guests, artists have often represented them
simply as three angels. Christian tradition sees in the three
angelic figures a prefiguration of the Trinity.

(Gn 18:1–10)

Marc Chagall
*Abraham and the Three Angels*
1960–66
Musée Message Biblique
Marc Chagall, Nice

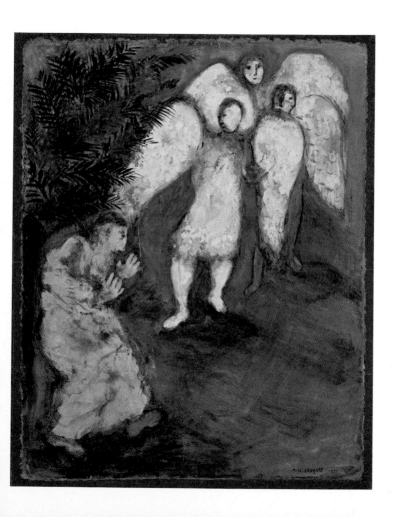

# Sarah and the Angel

During Abraham's meeting with the angels, one of them predicted to the patriarch that within a year his wife, Sarah, would bear him a child. Hidden at the entrance of the tent, she listened quietly to the conversation and upon hearing that she would be with child, she laughed in disbelief, because she was 89 years old: "After I am waxed old shall I have pleasure, my lord being old also?" (Gn 18:12) Because they had reached their old age without conceiving children, the announcement was miraculous. The angel heard Sarah laugh skeptically at the happy possibility, and the Lord transferred the laughter into the name of the child, Isaac, which means "God has laughed." (Gn 18:11–15)

*Sarah and the Angel* (detail)
1275
Basilica Superiore di
San Francesco, Assisi

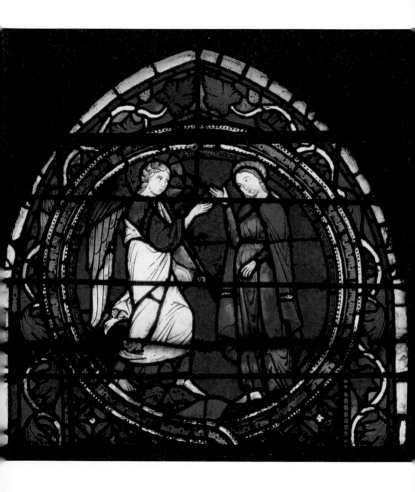

# *Sodom and Gomorrah*

According to tradition, the cities of Sodom and Gomorrah were located on the southwestern shores of the Dead Sea; at the time, they were havens of iniquity, lust, and violence. God resolved to destroy them with all their residents. Abraham begged the Lord to spare his nephew Lot, a good, upright man, and his family. God consented and sent two angels to Sodom, where Lot lived. As soon as he saw the two figures, Lot ran to them, inviting them to spend the night at his house. The townsmen surrounded the house, demanding that he send the guests out so they could abuse them, and they tried to break down the door but were blinded. Now the angels warned Lot: "Hast thou here any besides? son in law, and thy sons, and thy daughters, and whatsoever thou hast in the city, bring them out: for we will destroy this place." (Gn 19:12–13) They urged him to flee without ever turning to look back. Unable to persuade his sons-in-law to join them, Lot escaped with his wife and daughters. Then the Lord unleashed a storm of brimstone and fire that burned the two cities to the ground. As they were fleeing, Lot's wife, who was curious, looked back and was turned into a pillar of salt.

(Gn 19:1–29)

Jan Brueghel the Elder
*Sodom and Gomorrah*
1610
Alte Pinakothek, Munich

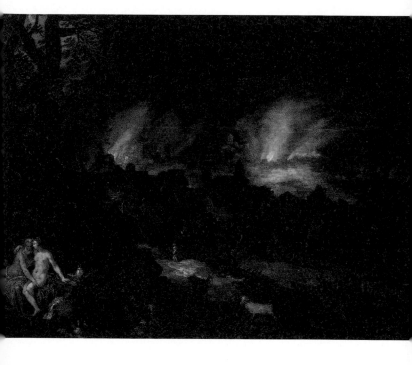

# Lot and His Daughters

Having been rescued from the destruction of Sodom and
Gomorrah, Lot and his daughters found shelter in a cave in a
mountain. Here the two young women, who had no more
hope of finding a husband, thought up a stratagy: They would
get their father drunk and sleep with him one night each,
hoping to be impregnated. And so it happened and both were
with child. The elder gave birth to Moab, the founder of the
Moabites, and the younger to Ben-Ammi, the ancestor of the
Ammonites. The two populations were enemies of Israel, and
their origin is tied to this illicit, incestuous episode. Usually
artists represent the part of the story when the girls entice
their father.

(Gn 19:30–38)

Giovanni Battista Caracciolo
*Lot and His Daughters*
1625
Galleria Nazionale delle Marche,
Urbino

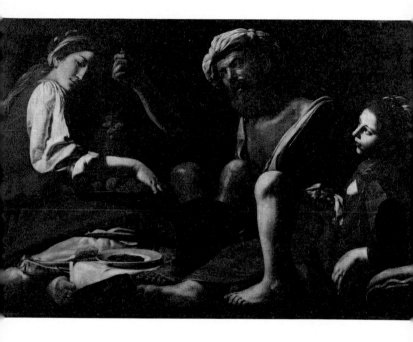

# *Hagar and Ishmael*

Before the angel's prediction, being elderly and barren, Sarah, Abraham's wife, had given to her husband as a concubine their Egyptian servant Hagar, who in due time begat a son, Ishmael, which means "God will hear." But after Sarah gave birth to Isaac she became intolerant of the slave and little Ishmael. She asked Abraham to cast them out. But Abraham was distressed by this, and so God asked him to fulfill his wife's request. Then Abraham gave bread and a skin full of water to Hagar and sent her and Ishmael away. The two wandered for a long time in the desert of Beersheba. When the bread and water were finished, Hagar, not wanting to watch her son die of thirst, left him under a bush and walked away. But the Lord heard the child's cry and sent an angel to reassure the woman: "Arise, lift up the lad, and hold him in thine hand; for I will make him a great nation." (Gn 21:18) Then Hagar opened her eyes and saw a well, where they quenched their thirst. While the heir of God's promise to the people of Israel is Isaac alone, God also gave a glorious future to Ishmael, for Muslims consider him the ancestor of the Arab tribes.

(Gn 21:9–21)

Giovanni Battista Tiepolo
*Hagar and Ishmael in the Wilderness*
1732
Scuola di San Rocco, Venice

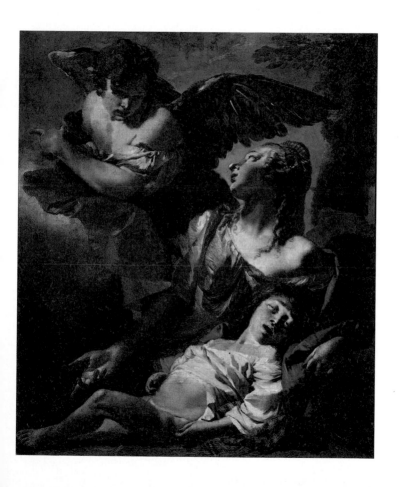

# The Sacrifice of Isaac

More than any other Old Testament story, Abraham's trial has
come to be the archetypal act of faith. When God called forth
the patriarch and asked him to sacrifice his son, Abraham
replied without hesitation: "Behold, here I am." (Gn 22:1) The
following morning, he saddled a donkey, chopped firewood for
the burnt offering, and set out with the boy and two servants
toward Mount Moriah, which has been identified with the hill
on which the Temple of Jerusalem would later be built. After
three days, they reached the foot of the hill, where Abraham
instructed his servants to stay. He loaded the wood on Isaac's
shoulders, and they climbed to the top. There he built an altar
and arranged the wood. Then he bound his son and took the
knife, ready to strike. But an angel called to him: "Lay not thine
hand upon the lad, neither do thou any thing unto him: for
now I know that thou fearest God, seeing thou hast not with-
held thy son, thine only son from me." (Gn 22:12) Hearing these
words, Abraham looked up and saw a ram caught in a bush; he
took the ram and offered it in place of his son. This scene, filled
with such deep ethical import, tells of the shift from human
sacrifice to animal sacrifice. It has been also interpreted as a pre-
figuration of the sacrifice that Jesus would make on the Cross.
(Gn 22:1–19)

Michelangelo Merisi da Caravaggio
*The Sacrifice of Isaac*
1601–02
Galleria degli Uffizi, Florence

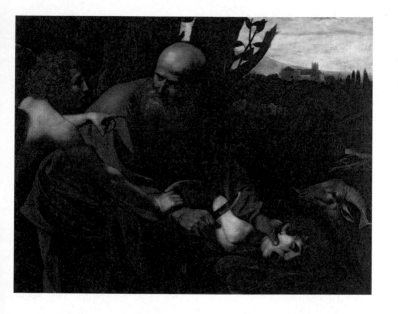

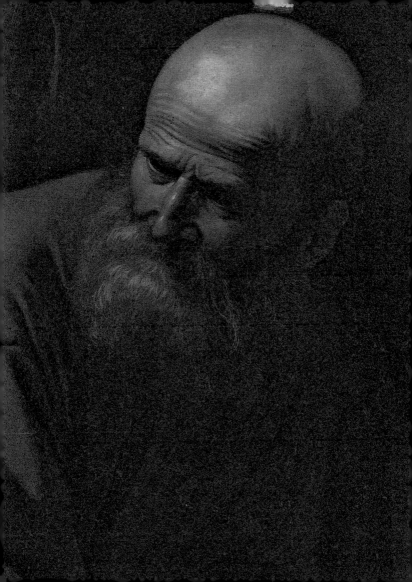

# Rebekah at the Well

In his old age, Abraham wanted to find a wife for his son Isaac. He asked a trusted servant, Eliezer, to travel to his native land to choose a woman from his kinfolk as Isaac's bride. He did not want his son to marry a woman from Canaan, the land that God had promised to him, because it was settled by idol-worshiping people. Eliezer left with a ten-camel caravan and reached the gates of the city of Haran, where Abraham's brother Nahor lived, and prayed to the Lord thus: "Behold, I stand here by the well of water: And let it come to pass, that the damsel to whom I shall say, Let down thy pitcher, I pray thee, that I may drink; and she shall say, Drink, and I will give thy camels drink also: let the same be she that thou hast appointed for thy servant Isaac." (Gn 24:13–14) Immediately Rebekah came toward him and offered water to him and the camels. Eliezer inquired about her, and was told that she was Nahor's granddaughter, and thus Abraham's kin. Then the servant revealed to her family the reason for his journey, and received the young woman's hand. In this painting, Abraham's wealth is suggested by the many caravan animals and the servant's splendid garments. Rebekah is portrayed as a comely young woman, caught filling her pitcher at the well.

(Gn 24:1–28)

Giovanni Battista Piazzetta
*Rebecca at the Well*
*c.* 1740
Pinacoteca di Brera, Milan

# Esau Sells His Birthright

Isaac and Rebekah begat two sons: Esau and Jacob. While they were still in the womb, the Lord predicted to the mother that the twins would found two hostile nations: "Two nations are in thy womb, and two manner of people shall be separated from thy bowels; and the one people shall be stronger than the other people; and the elder shall serve the younger." (Gn 25:23) When the time came, Esau was born first, followed by Jacob, who was grasping Esau's heel. For this reason, he was called Jacob, which means "he who grasps the heel," from the Hebrew *aqeb*, or "heel." And Esau's second name was Edom, from *adom*, which means "red," because he was covered with thick reddish hair; red was also the color of the soup he would one day receive in exchange for his birthright. For it happened that one day Esau came home from hunting, hungry and exhausted, and asked Jacob for the food that he was cooking. The younger brother asked for Esau's birthright, and so Esau gave up his right as firstborn for a bowl of lentil soup. The twins would be rivals for a long time and would found two nations: the Israelites and the Edomites.
(Gn 25:29–34)

Mattia Bortoloni
*Jacob and Esau*
1716
Villa Cornaro, Piombino Dese

# The Blessing of Isaac

When Isaac grew old, he decided to bless Esau, his firstborn.
He summoned him and ordered him to hunt for game, make
him a dish of it, and bring it to him. Then he would give him
his special blessing. Hearing these words, Rebekah ran to tell
Jacob, her favorite son, and hatched a plot for him to obtain
the blessing by fraud. She dressed Jacob with his brother's
clothes, cooked two kids, and used their skin to cover Jacob's
arms and neck so that he felt hairy like his brother. Then
Jacob brought the meat to his father. Isaac, who was almost
totally blind, wanted to make sure that he was indeed his son
Esau, so he touched him and asked him to come closer for a
kiss, so he could smell his scent. Convinced that he was indeed
Esau, Isaac blessed him. When Easu returned with the dish
that his father had requested, the trick was revealed, but the
blessing could not be withdrawn. Esau vowed to kill his
brother. Then Rebekah begged Jacob to seek shelter at his
uncle Laban's in the land of Haran. In this painting, Isaac is
portrayed blessing Jacob, while Rebekah helps her favorite son
and offers the meat dish.

(Gn 27:1–46)

Jacopo Carucci, known as Pontormo
*Isaac Gives Jacob His Blessing*
1520
Galleria degli Uffizi, Florence

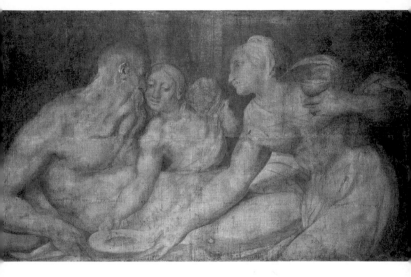

# *Jacob's Dream*

Jacob fled home to escape Esau's fury and journeyed toward Haran, where his uncle Laban, Rebekah's brother, lived. One evening, he stopped for the night at an unidentified place. Using a stone for a pillow, he lay down and went to sleep. In a dream, he saw a ladder joining Heaven and Earth, on which angels were climbing and descending. Above it stood the Lord, who renewed to Jacob the promise made to his ancestors: "The land whereon thou liest, to thee will I give it, and to thy seed." (Gn 28:13) When Jacob awoke he acknowledged the presence of God in that place: He took the stone he had used as a pillow, set it up as a pillar in homage, and called the place Bethel, which means "house of God." Scholars have identified the place as Beitin, near Jerusalem. This episode has inspired fantastic, visionary images. The angels have been interpreted as Christian preachers or as symbols of two models for life: the active life represented by the ascending angels, and the contemplative life represented by the descending ones, to mark man's path toward God.

(Gn 28:10–22)

William Blake
*Jacob's Ladder*
*c.* 1799–1807
British Museum, London

# Leah and Rachel

Having reached the plains of Haran, Jacob stopped by a well;
there he met his lovely cousin Rachel, Laban's daughter, and fell
hopelessly in love with her. To marry her, he made a contract
with Laban that he could have her hand only after working
seven years for his future father-in-law. When the term expired,
Laban tricked Jacob by bringing him his older daughter, Leah,
instead of Rachel, for it was the custom to marry off the elder
before the younger. After seven more years of work Jacob won
the hand of his beloved Rachel, who was barren, unlike her
fertile sister. It was only in her old age, and by God's inter-
vention, that Rachel would beget two sons for Jacob: Joseph
and Benjamin. In all, the patriarch begat twelve sons, who went
on to found the Tribes of Israel, and one daughter. In time,
Jacob resolved to return home with his family, but as they were
leaving Rachel stole the household idols, or *teraphim*, from her
father, and Laban chased in vain after the group to recover
them. Artists have often emphasized the contrast between
Rachel's beauty and Leah's homeliness; because of this, God
compensated Leah with the gift of fertility.

(Gn 29:1–35)

Jan van Neck
*Meeting of Jacob and Laban with*
*Rachel, Leah, and Servants*
late 17th century
Private collection

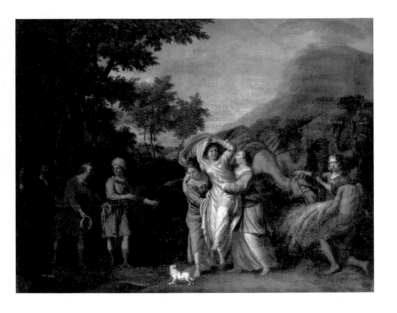

# Jacob Wrestles with the Angel

While traveling back to the Promised Land, Jacob's caravan
reached the Jabbok, an eastern affluent of the river Jordan.
His caravan and family crossed the ford while he stayed behind.
Then a man appeared and began to wrestle with him. They
wrestled the whole night until dawn broke. Unable to prevail,
the stranger struck him on the hip socket, dislocating the sciatic
nerve and laming him. Then he asked Jacob to let him go, but
Jacob, having intuited the stranger's angelic nature, asked to be
blessed first. Thus the angel renamed him Israel, "for as a prince
hast thou power with God and with men, and hast prevailed."
(Gn 32:28) Then Jacob named the place Peniel, from *peni'el* or
"face of God," because he had seen God face-to-face and had
survived. This story highlights the value of man's personal
encounter with God through prayer. After this encounter,
"the children of Israel eat not of the sinew which shrank, which
is upon the hollow of the thigh, unto this day: because he
touched the hollow of Jacob's thigh in the sinew that shrank."
(Gn 32:32)

(Gn 32:23–32)

Paul Gauguin
*Vision of the Sermon*
*(Jacob Wrestling with the Angel)*
1888
National Gallery of Scotland, Edinburgh

# Jacob and Esau

Returning to the land of Canaan, the God-promised land, Jacob feared the wrath of his brother Esau, whose birthright he had stolen and from whom he had fled in fear for his life. Thus he sent messengers ahead to divine his brother's state of mind. The messengers came back with the news that Esau was marching toward him with 400 men. Frightened, Jacob sent his best cattle ahead as gifts to placate his brother and win his favor before the meeting, then divided his train in two groups, hoping to thus save at least one of them. Finally, he arranged his family with the two slave women, Zilpah and Bilhah, and their children in front, then Leah and her children, and in the back, his favorite wife, Rachel, with their son Joseph. As Esau approached, Jacob bowed seven times to the ground, until his brother lifted him in an embrace and wept as he kissed him, his hate having dissipated. Reconciled, the two brothers then returned to the Promised Land. Several works of art show the brothers' affectionate embrace.

(Gn 33:1–20)

Francesco Hayez
*Jacob and Esau*
1844
Pinacoteca Tosio Martinengo, Brescia

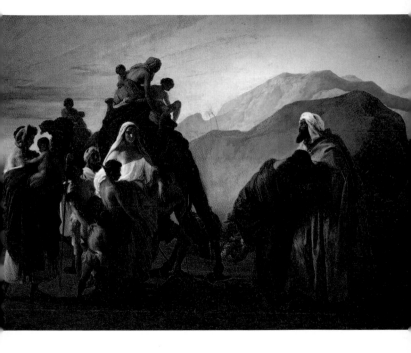

# Joseph Is Sold by His Brothers

Joseph was the elder of the two sons that Jacob begat with Rachel, and his father's favorite by far. His privileged position aroused the hatred of his brothers, heightened by his premonitory dreams. In the first dream, he was binding wheat sheaves with his brothers when he saw his sheaf rise suddenly and stand upright and the other sheaves bow to it. In another dream the Sun, the Moon, and eleven stars bowed to him. When he turned seventeen, his father had a finely decorated tunic made for him. One day, Joseph went to a remote pasture where his brothers were watching the flocks. Seeing him approach, the brothers plotted to kill him and tell their father that he had been torn to pieces by a wild beast. But one brother, Reuben, who wanted no bloodshed, saved him. Thus they took Joseph, pulled off the tunic, and threw him down a well. A caravan of slave merchants en route to Egypt was passing by, and Jacob's sons sold their brother for a few coins. Then they dipped the tunic in animal blood and took it to their father, who wept and mourned his son, believing he had been devoured by a wild beast. The well scene has been interpreted as a prefiguration of the deposition of Jesus in the tomb and of his Resurrection.
(Gn 37:1–36)

Luchino Belbello da Pavia
*Joseph Is Sold by His Brothers*
miniature from the *Visconti Book of Hours*
1475–1500
Biblioteca Nazionale, Florence

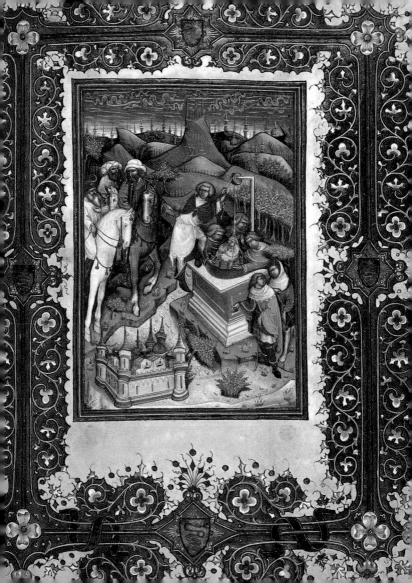

# Joseph and Potiphar's Wife

Having been taken to Egypt by slave merchants, Joseph was bought by Potiphar, the commander of the pharaoh's guards. With God's help, the youth stood out and the high Egyptian official was so pleased with him that he put him in charge of his household. But Potiphar's wife threatened Joseph's prestigious position when she fell in love with him and tried vainly to seduce him. After many futile attempts, one day the woman found Joseph alone in the house, caught him by the tunic, and tried to pull him on the bed. Joseph escaped, leaving the tunic in her hands. When her husband came home, the scorned woman showed him Joseph's tunic and told him that the servant had tried to take her but had run away when she screamed. Potiphar believed her and, thinking that Joseph had betrayed his trust, threw him in jail. In this story, the woman symbolizes the pagan temptress who tries to sway the upright Jew from the right path. The scene in Potiphar's wife's bedroom has inspired numerous artists.

(Gn 39:1–18)

Jean-Baptiste Nattier
*Joseph and Potiphar's Wife*
1711
Hermitage Museum,
Saint Petersburg

# Joseph Interprets Dreams

During his time in the dungeon, Joseph became popular with the commander, who put him in charge of the other prisoners. The youth also became known for his gift in interpreting dreams. The pharaoh's chief cup-bearer and baker were also being detained. They each had a dream that Joseph interpreted correctly. The cup-bearer dreamed of three vine branches from whose grapes he squeezed juice into a cup, which he offered to the pharaoh; this meant that he would be restored to his position. The baker dreamed that three wicker trays filled with food were being picked by birds; it meant that in three days he would be hanged. Two years later, the pharaoh summoned Joseph and asked him to interpret two of his own dreams. In the first, the king saw seven fat cows come out of the Nile, followed by seven starved cows that devoured the seven fat ones. Then he dreamed that seven fat ears of grain growing on one stalk were being swallowed by seven shriveled, heat-scorched ones. Joseph explained that Egypt would enjoy seven years of plenty, followed by seven years of famine. He suggested that the pharaoh appoint an honest administrator who would tax one-fifth of the kingdom's harvest each year and store it as a reserve for the coming famine. Recognizing Joseph's wisdom, the pharaoh made him a viceroy of Egypt.

(Gn 40–41)

Anton Raphael Mengs
*Joseph Interprets the Dreams*
1755
Graphische Sammlung Albertina, Vienna

# Joseph and His Brothers

The predicted famine did come to Egypt, but the kingdom fared well because it had plenty of reserve supplies set aside. Canaan also was plagued by famine, and so Jacob sent his sons to Egypt to purchase some grain. He kept only Benjamin with him, the youngest son of his beloved Rachel. Joseph disguised himself and jailed one of his brothers, asking for his younger brother in exchange for the grain. Jacob despaired at the idea of losing his beloved Benjamin, but hunger forced him to accept the deal. The brothers then retuned to Egypt and received the grain promised them. Joseph had his men hide a silver cup in Benjamin's sack. After the brothers left, the soldiers pursued them and accused them of stealing the cup. Joseph decided to detain only the alleged thief, but the other brothers told him that their father would die of grief at the news, since Rachel's other son had been dead for many years already. Hearing these words, Joseph could no longer hide his feelings and revealed his identity to his shocked brothers. He pressed them to bring their father to Egypt. The most touching scene of Jacob's story is the warm embrace between Joseph and his elderly father, Jacob.

(Gn 42–46)

Nicola Karcher (from a design
by Agnolo Bronzino)
*Joseph Reunited with His Father*
1549–53
Palazzo Vecchio, Florence

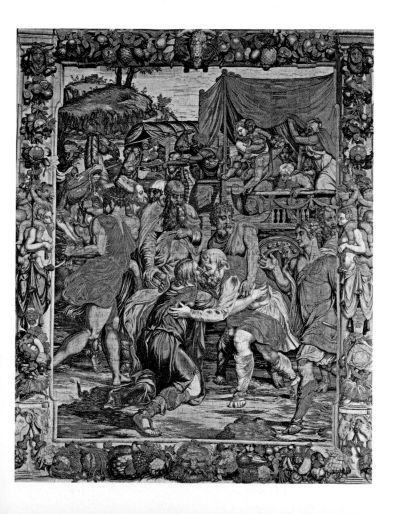

# Exodus

Many scenes from Exodus have been immortalized in art, including those of the life of Moses and of the victory over the pharaoh. The word "exodus" means "going out" and refers to the flight of the Israelites from Egypt toward the Promised Land. The book opens with an introduction that links to the earlier book of Genesis and serves as background to the narrative of the life of Moses. After the death of Joseph and his brothers, their sons multiplied, as did the succeeding generations. A new pharaoh, identified by historians as Ramses II (1297–13 BC), forgetful of the services that Joseph had rendered to the kingdom and fearing the might of such a populous nation, decided to enslave the Israelites and ordered that all the Hebrew male infants be thrown into the Nile immediately after birth.

*Exodus*
miniature from the *Bibbia di San Paolo Fuori le Mura*
(also known as the *Bible of Charles the Bald*)
870
San Paolo Fuori le Mura, Rome

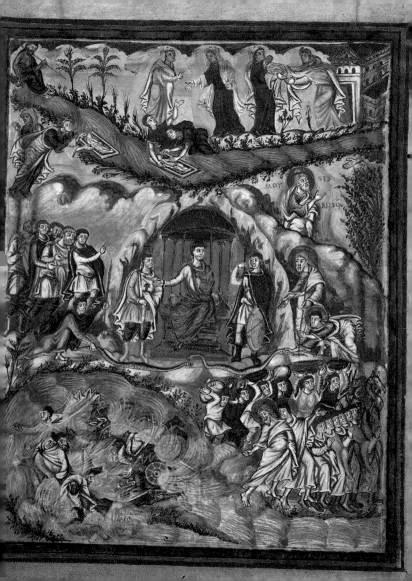

# Moses Is Found on the Banks of the Nile

During the reign of Ramses II in Egypt, an Israelite woman named Jochebed gave birth to a son by her husband, Amram, and broke the pharaoh's law by keeping the baby hidden for three months. Finally, she was forced to put him in a papyrus basket and entrust him to the Nile. The pharaoh's daughter, who was bathing in the river, saw the basket and sent one of her maids to fetch it. When she heard the baby cry, she was taken with pity. Miriam, Jochebed's daughter, was watching nearby and offered to find him a Jewish wet nurse—in reality, his true mother. The pharaoh's daughter called the child Moses, a name probably derived from the Egyptian verb *mshj*, "to give birth." But in the Bible, the meaning of the name Moses is "pulled from the waters," because of its assonance with the Hebrew *mashah*, "to draw out, pull out," referring to how the child was found. Artists often depict the scene when the natural mother places the basket in the river, and also when the basket is found.

(Ex 2:1–10)

Bonifacio Veronese
*The Finding of Moses*
1540s
Pinacoteca di Brera, Milan

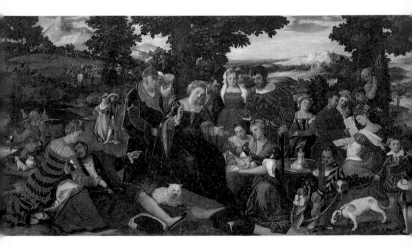

# Moses and the Daughters of Jethro

Moses grew up believing that he was Egyptian. One day he visited a construction site where the enslaved Hebrews were working. He saw an Egyptian beat up a slave, and killed the Egyptian and hid his body in the sand. But word spread of his deed, and fearing for his life he fled to Midian (near the Gulf of Aqaba-Eilat), where he came to rest near a well. The seven daughters of Reuel (in the Bible also called Jethro, which means "forefather"), a priest of Midian, were walking toward the well to fetch water when some men drove them away. Moses sprang to their aid. To thank him, Jethro invited him to dinner. Moses then settled near Jethro, who gave him one of his daughters, Zipporah, in marriage. She begat Moses a son, Ghersom. While artists have usually represented these events by emphasizing the narrative aspects and the surroundings, Rosso Fiorentino has portrayed the scene where Moses fights with the shepherds. The composition is very intense, as if to underscore the painter's ability to draw vigorous features and bodies deformed by the physical struggle.

(Ex 2:11–25)

Giovanni Battista di Jacopo,
known as Rosso Fiorentino
*Moses Defending the Daughters of Jethro*
1523–24
Galleria degli Uffizi, Florence

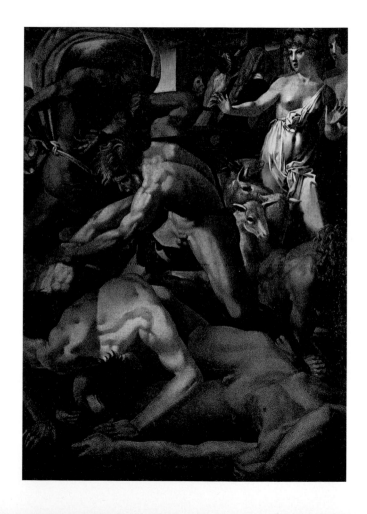

# The Burning Bush

One day, while tending his father–in–law Jethro's flock, Moses
came to Mount Horeb, also known as Mount Sinai, at the tip
of the Sinai Peninsula. There he saw a blazing bush that kept
burning without consuming itself. He heard God's voice call
his name and order him to take off his sandals, for he was
standing on "holy ground." (Ex 3:5) The Lord appeared as the
God of his Fathers. Moses covered his face with his hands, for
he was afraid to look at God. God commanded him to return
to Egypt and free His people, the "children of Israel." (Ex 3:9)
In answer to Moses, who asked Him His name, the Lord
replied, "I am that I am." (Ex 3:14) From this expression the
Hebrew name "Yahweh" was derived, meaning "He is."
Some artists have drawn the Madonna inside the bush, for the
burning bush is considered a prefiguration of the Mother of
God, specifically of her virginity. In this fresco, Raphael has
followed to the letter the biblical passage and drawn God as a
man, mindful of the verse in Genesis, "Let us make man in
our image, after our likeness." (Gn 1:26)

(Ex 3:1–15)

Raffaello Sanzio,
known as Raphael
*The Burning Bush*
*c.* 1515
Palazzi Pontifici, Vatican City

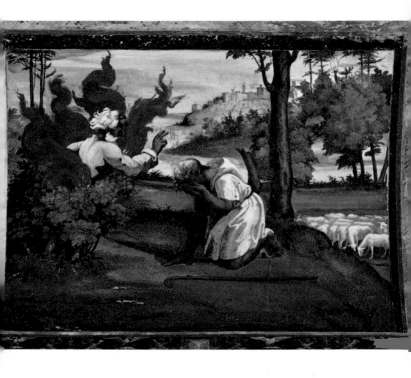

# The Plagues of Egypt

Obeying God's instructions, Moses left the land of Midian and began his journey back to Egypt with his wife and son. Along the way he met Aaron, his brother, who would become his spokesman in the mission that God had thrust upon him. Thus they both appeared before the pharaoh and asked him leave to lead the Israelites into the desert, where they could worship their God. The pharaoh refused and even intensified the already harsh conditions of the Israelites. Then God rained ten plagues upon the kingdom of Egypt: The waters turned into blood; frogs invaded the country; then mosquitoes; then horseflies; all the livestock died; men developed boils that broke into sores all over their body; a hailstorm struck the country; locusts swarmed all over; darkness came over the land; and finally, all the Egyptian firstborn children died, including the pharaoh's son. This painting by Alma-Tadema has caught the human side of the pharaoh and his despair: after this final tragedy, he would relent and let the Israelites go. (Ex 7:14–25; 8–11)

Lawrence Alma-Tadema
*The Slaying of the Pharaoh's Firstborn Son*
1872
Rijksmuseum, Amsterdam

# The Crossing of the Red Sea

Following God's directions, the Israelites asked the Egyptians to lend them "jewels of silver, and jewels of gold, and raiment" (Ex 12:35) and set out for Succoth (which has been identified as Tell-el-Maskhuta, about halfway down the modern Suez Canal). God directed them toward the desert, wanting to avoid the risk of a war with the Philistines. Having learned that instead of taking the usual road to Palestine, the Israelites had changed route, the pharaoh became suspicious and decided to pursue them and force them to come back to Egypt. When the Egyptian army was about to overtake the Israelites, Moses, commanded by God, raised the staff that God had given him on Mount Sinai and the waters of the Red Sea parted to allow the Israelites to cross. But as the Egyptians were advancing down the dry path left by the parting waters their chariot wheels became stuck. When Moses again raised his staff, the waters began to flow back and drowned the army of the pharaoh. The might of God exemplified by this portent is what has most fascinated artists: among whirlpools, towering waves, and huge billows, one can glimpse the heads of the Egyptian soldiers and the pharaoh's crown as the men try in vain to escape the submerging waters. (Ex 12:31–42; 13:17–22; 14)

Lucas Cranach the Elder
*The Passage through the Red Sea*
1540
Bayerische Staatsgemäldesammlungen, Munich

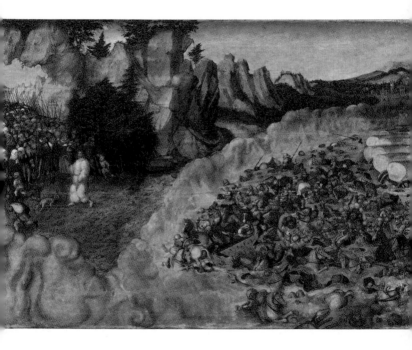

# The Manna Harvest

After many days in the desert, where finding water was difficult, the Israelites reached a place between Elim and Mount Sinai; there they began to complain to Moses because they were thirsty and hungry. Hearing these complaints, the Lord promised quail for the evening meal and bread for the following days. At twilight many quail flew in over the camp and the following morning the ground was covered with a layer of dew that left on the ground "small round things, as small as the hoar frost on the ground." (Ex 16:14) Moses then reassured his people: it was the "bread" that the Lord offered as nourishment. The narrative continues with a number of guidelines and rules for harvesting "manna," the name that the Israelites gave to this food, like white coriander seeds. Numbers explains that this food was baked in pans to make cakes that tasted like oil. In general, artists have portrayed the moving episode of the offer of manna as a shower of crumbs falling from the sky.

(Ex 15:22–27; 16:1–36; Nb 11:7–9; 31–35)

Jacopo Robusti,
known as Tintoretto
*The Miracle of Manna*
1576–81
Scuola Grande di San Rocco, Venice

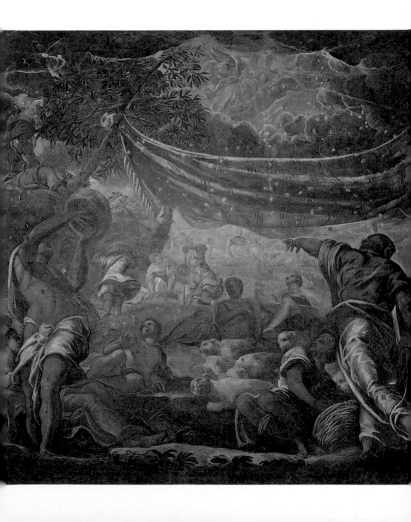

# A Spring Flows from a Rock

The Israelites pitched camp near Rephidim, probably in a valley of the Sinai Massif, but there was no water and again they complained to Moses, who appealed to the Lord. Following God's instructions, the prophet took the staff he had used to part the waters of the Red Sea and struck a rock, causing water to flow from it. For this reason, he gave the place the names of Massah ("trial") and Meribah ("contention") because there his people had put God to the test. This episode is also recounted in Numbers, where it is written that Miriam, Moses's sister, died and was buried in Meribah. This miracle has been reprised frequently in Christian art, including on this medal, which Benvenuto Cellini made for Pope Clement VII.

(Ex 17:1–7; Nb 20:1–13)

Benvenuto Cellini
*Moses Striking the Rock*
1534
Museo Nazionale del Bargello, Florence

# The Tables of Law

The story of Moses is typically narrated by the "E" tradition, but neither it nor the "J" tradition mentions the delivery to him of the Tables of Law and the Ten Commandments. In fact, there were many Middle Eastern tales about heavenly tables miraculously brought to Earth to impart secret divine knowledge. From these tales, together with the "J" and "E" narratives about Moses's vision of God on Mount Sinai, was fashioned the biblical story of Yahweh directly handing to Moses the stone tables with the divine laws carved on them. At first, when he had been called to the top of Mount Sinai with his brother Aaron, Moses had heard Yahweh bellow out the Ten Commandments. Then he "wrote down all the words of the Lord" (Ex 24:4); finally, he climbed the mount again, where God handed him "tables of stone, and a law, and commandments which I have written" (Ex 24:12) so that Moses might teach them to his people.

(Ex 20–24; Dt 5:1–22; 10:1–5)

Achille Funi
*Moses with the Tables of Law*
1939
Court House, Milan

# The Golden Calf

Yahweh enunciated the first commandment, "Thou shalt have no other gods before me" (Ex 20:3), and continued, "Thou shalt not make unto thee any graven image, or any likeness of any thing. . . . Thou shalt not bow down thyself to them, nor serve them: for I the Lord thy God am a jealous God." (Ex 20:4–5) Thus, the Jewish law banning all images of the godhead was set down at this time. After receiving the Tables of Law, Moses descended Mount Sinai and was devastated at the sight of what the people of Israel had wrought while he was away: Breaking God's law, Aaron, goaded by the people, had built a golden calf as an image of God, to whom they offered worship and burnt offerings. Furious, Moses shattered the tables he had just received from Yahweh, took the idol, threw it into the fire, and crushed it until he had "ground it to powder, and strewed it upon the water," forcing the Israelites to drink it. (Ex 32:20) Artists have frequently depicted the worship of the golden calf next to the scene of Moses climbing down from the mountain with the tablets, as we can see on the left of this painting by Nicolas Poussin, but the two episodes have also been the subjects of separate works. (Ex 32:1–24)

Nicolas Poussin
*The Adoration of the Golden Calf*
1633–34
National Gallery, London

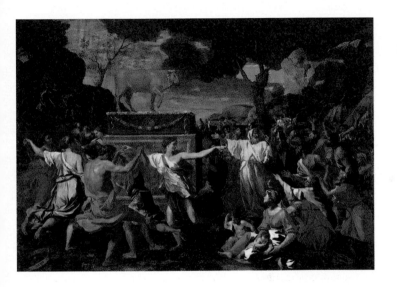

# *Leviticus*

Like Numbers and Deuteronomy, Leviticus has not usually been the subject of separate works of art, but has instead been illustrated in larger cycles. It was added to the Pentateuch by the "P" or "Priestly" tradition (the ancestral texts were revised around 550 BC during the Babylonian exile, while the Israelites awaited the restoration of the Davidic monarchy) and draws on different sources, including the "Holiness Code," a collection of seventh-century laws (Lv 17–26), and the Tabernacle Document, a description of the "portable" temple of Yahweh where the Ark of the Covenant was kept when the Israelites were roaming the Sinai desert. It is called Leviticus, or "book of the Levites," or priests, not just because it was written by priests but because it contains the liturgy and the rules of holiness of the Hebrew nation. It sets forth the proper rules for worship: the types of offerings, the consecration to the priesthood, the purification rituals, as well as social customs.

*Leviticus*
miniature from a Bible
13th century
Biblioteca Medicea Laurenziana, Florence

34

# Sacrifice and Burnt Offering

The first section of Leviticus is a collection of the rules to be followed to atone for sins committed, both intentional and involuntary. The burnt offering, or holocaust, was the most solemn of sacrifices. The word comes from the Greek *holókauston*, which means "totally burnt," and is equivalent to the Hebrew *olah*, which means "rising upward," indicating the smoke from the victim burning on the pyre, a gift that rose directly to God. Before burning, the animal was slaughtered and its blood sprinkled around the altar. Killing the victim by slitting its throat has been a frequent subject in art, probably because of the rawness of the scene. Other types of sacrifice included vegetable offerings, especially of unleavened cakes. The cakes could not contain yeast, which was considered a symbol of corruption; they could contain salt, a symbol of alliance, because it preserves food from spoiling. In some cases, in addition to sacrifices in atonement for a sin, God also demanded reparation offerings. All sacrificial rituals always required the presence of a priest.

(Lv 1–10; Dt 12:13–28; 14:3–28)

Girolamo da Cremona
*Biblical Sacrifice*
miniature from a Psalter
15th century
Libreria Piccolomini, Siena

# The Rules of Purification

After reviewing sacrifice and the priesthood, Leviticus sets forth a number of dietary laws. In the Eastern world, for health reasons, there has traditionally been a clear distinction between clean and unclean animals. For the Hebrews, this distinction also took on a spiritual connotation. The latter part of the book deals with rules concerning childbirth, for conception was treated as a loss of vitality that could negatively impact the relationship between God and man. Thus rules were to be followed to become whole again. After giving birth to a male, the mother was considered impure for seven days. On the eighth, the boy was to be circumcised and the mother lived in isolation for 33 more days in order to be cleansed. If the child was a girl, the woman was considered impure for two weeks and had to purify herself for 66 days. At the end of her confinement, the woman was to offer a year-old lamb as a burnt offering, plus a dove or a turtledove for the atonement sacrifice. If she was poor, she could substitute another dove or turtledove for the lamb. For this reason, in works of art depicting the presentation of Jesus in the Temple, the Madonna carries two doves.

(Lv 11–12)

Gerolamo Romanino
*Presentation of Jesus at the Temple*
1529
Pinacoteca di Brera, Milan

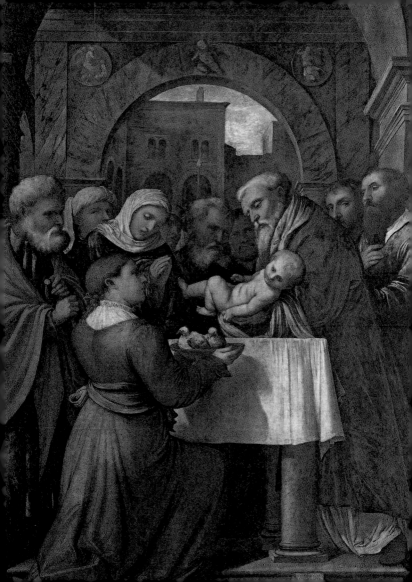

# The Hebrew Passover

Leviticus also sets forth the rituals to be followed for the Holy Days. After the Sabbath was sanctified, there were rules for Passover referring back to the lamb sacrificed just before Israel was freed from Egyptian slavery. In fact, in Exodus God had instructed His people to get one lamb or one kid "without blemish, a male of the first year" (Ex 12:5) for each family, slaughter it at sundown, and mark with its blood the posts of each house before the last plague—the killing of all the first-born of Egypt. God promised His people that He would save their sons: "The blood shall be to you for a token upon the houses where ye are: and when I see the blood, I will pass over you, and the plague shall not be upon you." (Ex 12:13) The passing over of God marked the beginning of the Jewish holiday. The Hebrew word for Passover comes from *pesach*, which literally means "passing over." According to Leviticus, on this holy day the first fruits of the new harvest were to be offered to God in solemn thanksgiving. In representations of Passover, the lamb is usually included together with unleavened bread. In Christian iconography, the bread becomes a prefiguration of the bread at Christ's Last Supper, and the lamb is Christ himself.

(Ex 12:1–51; Lv 23:4–14; Nb 9:1–14; 28:16–25; Dt 16:1–8)

*Celebration of the Hebrew Passover*
miniature from a Bible
1450
Private collection

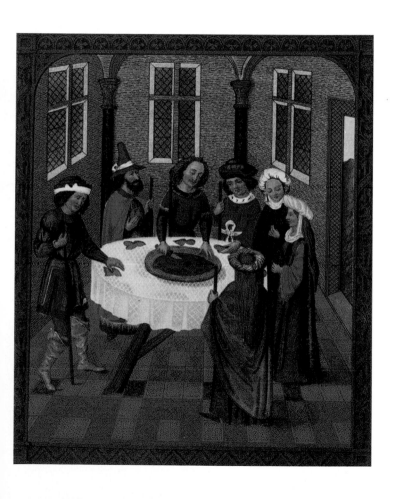

# The Hebrew Pentecost

This holy day has its origins in Leviticus. According to ancient lore, it was a day of thanksgiving celebrated at the end of the wheat harvest, about 50 days after Passover. Later, it also celebrated God's revelation to Moses on Mount Sinai, when He gave the Torah to His people. In Exodus, God told Moses that the Israelites were to celebrate the Feast of Seven Weeks, the period between Passover and the Pentecost. *Shavuoth* is the original name of this Hebrew holiday; in ancient Greek it was translated as *pentekostè*, meaning the fiftieth day after Passover. In the New Testament, the Pentecost takes on a different meaning, as it celebrates the event narrated in the Acts of the Apostles (Ac 2:1–11) when the Holy Spirit descended. The Hebrew Pentecost has not usually been represented in art, because it is understood to be included in representations of God delivering the Tables of Law to Moses.

(Ex 34:22; Lv 23:15–22; Nb 9:1–14; 28:26–31; Dt 16:8–12)

*God Delivers the Tables of Law*
12th century
San Zeno, Verona

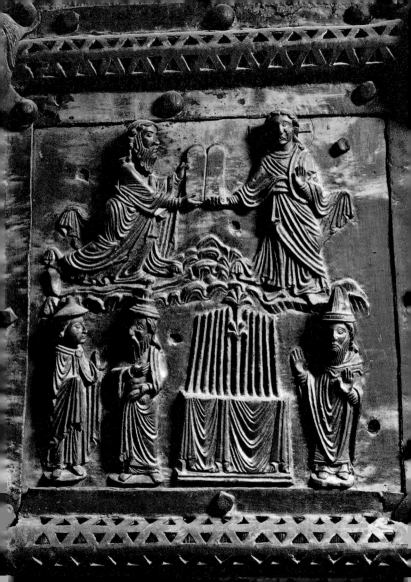

# Numbers

Numbers comes from the "P" tradition during the Babylonian captivity; it is a collection of ancestral documents including genealogies, laws, and ritual texts, some of which had been handed down orally, collected by looking at the past in the hope of future freedom. The book's setting is the Sinai desert, during a census of the Tribes of Israel. The protagonists are God, Moses, and the Hebrew people, who are journeying toward the Promised Land. The events recounted in Numbers unfold over a span of 38 years. The first section harks back to Exodus and Leviticus, with the instructions for the departure from Egypt, then continues with a narrative of the years spent wandering in the desert and, later, in the Plains of Moab, until the Israelites reached the land of Canaan that God had promised to them.

*Numbers*
miniature from a Bible
11th century
Bibliothèque Mazarine, Paris

# INCIPIT LIBER VAIE DABER

## QVE NO DEM NVMER R̄

# O CVTUS EST DNS

admor̄ sen in deser̄ to sr̄nai in tabnacu
lo f̄ederis· prima die msīs scd̄i· anno
altero egr̄essionis eoru̅ ex aegȳpto·
dicens· Tollite summā uniuerse con
gr̄egationis filioru̅ irl̄ pcognationes
ꝛdomos suas· ꝛ nomina singuloru̅·
quicquid sexus ÷ masculini a uicesi
mo anno ꝛsupr̄a omium uiroru̅ for
tiu̅ exirl̄· ꝛ inumerabitis eos ptmas
suas tu ꝛaaron· Eruntq̄ uobis cū
principes tribuu̅ ac domoru̅ in cog
nationib̄·
suis· quoru̅
ista sunt
nomina·

De ruben· helisur· filius sedeur· De sr̄meon· salam
hel· filius surisaddai· De iuda· naason filius amina
dab· De isachar· nathanahel filius suar· De zabu
lon· heliab filius helon· Filioru̅ aut ioseph· de e
phraim· elisama filius ammiud· De manasse· gam

# The Journey in the Desert

While the people of Israel wandered in the desert, God instructed Moses to take a census "after their families, by the house of their fathers, with the number of their names, every male by their polls; From twenty years old and upward, all that are able to go forth to war in Israel." (Nb 1:2–3) Eleven tribes were counted; the twelfth, that of the Levites, God left out of the census because its members were to look after the Tabernacle of Testimony (also known as the Ark of the Covenant), the portable sanctuary that Moses had built and in which the Tables of Law were stored. Among the episodes of the desert journey is the miracle of the quail also mentioned in Exodus (Ex 16:13). Artists have pictured the life of the Israelites camping in the desert with their women and children. (Nb 1–12)

Francesco Maffei
*The Hebrews in the Desert*
1657–60
Cappella di San Massimo,
Santa Giustina, Padova

# The Scouts Return from Canaan

The Lord asked Moses to send chiefs from the twelve tribes to reconnoiter the land of Canaan. From the tribe of Ephraim He sent Oshea, which means "salvation," but changed his name to "Joshua," which means "Yahweh is salvation," for he would be entrusted with the task of leading the Hebrews into the Promised Land after Moses died. The expedition returned to the camp after 40 days carrying fruits and bunches of grapes so large that they had to be carried "between two upon a staff." (Nb 13:23) The land of Canaan was so lovely that it "floweth with milk and honey," the scouts reported. But other people already lived on it: the Amalekites, the Hittites, the Jebusites, the Amorites, and the Canaanites. The people of Israel were facing a long, drawn-out period of war. Undoubtedly, the yearning of the Israelites exaggerated the richness of the land of Canaan; still, artists have pictured a fertile, bountiful landscape, sometimes interpreting the text literally, such as in this intaglio.

(Nb 13:1–33)

*The Scouts Return from Canaan*
(detail)
19th century
Monastery of Saint John Bigorski, Rostuse

# The Bronze Serpent

Upon learning that the Promised Land was inhabited by other nations, the people of Israel became angry with God. The Lord punished the rebels by striking them dead in the desert before they could see the dreamed-of land. He saved only Caleb and Joshua, who trusted in His power. As they kept walking toward Canaan, the Israelites continued to mutter against God, who responded by sending fiery serpents among them. Frightened, they implored Moses to intercede with the Lord, who, in turn, ordered him to build a bronze serpent and "set it upon a pole"; those who were bitten by the fiery serpents only had to look at the bronze statue and they would be healed miraculously. This episode is well known for its anecdotal qualities and many artists have endeavored to depict it. Here we see it in a thirteenth-century stained-glass window where the pole has taken the form of a T-shaped Latin cross, an allusion to the Crucifixion of Christ in expiation for the Original Sin caused by the serpent in Genesis.

(Nb 14:1–38; 21:4–9)

*Moses and the Bronze Serpent*
*c.* 1270
Musée de l'Oeuvre Notre-Dame,
Strasbourg

# The She-Ass of Balaam

After fighting a number of battles and wars against the nations who refused to allow them passage through their lands, the Israelites set up camp in the Plains of Moab, east of the river Jordan, in front of the city of Jericho. Balak, king of Jericho, terrorized by what the Israelites had done to the other nations, sent envoys to the sorcerer Balaam asking him to curse the invaders. But Balaam had been warned by God that he should refuse, and so he sent the Moabite princes back, although they insisted. Finally, the wizard relented and set out with the envoys on his she-ass. Incensed at what was happening, the Lord sent an angel with a drawn sword who placed himself before the animal. At the sight of the angel, the animal veered off the road, hit a wall, and finally lay down with Balaam still astride, who kept striking her, for he could not understand what was happening. Then God gave the ass the power to talk and the animal complained to her master for striking her. Balaam understood that the ass had veered off to save his life, and that God was against this journey. He therefore obeyed God's command and, after reaching Moab, blessed Israel and predicted to Balak that this people would have a glorious history.

(Nb 22:1–25)

*Balaam's Ass*
1130
Saint-Andoche, Sanlieu

# Deuteronomy

The earliest texts contain no reference to the written teachings of Yahweh. According to the stories of the "J" and "E" traditions, Moses handed down God's will orally. It was only in the seventh century BC that historians began to revise the tradition, adding verses in which they explained that Moses had written down all of the Lord's words and had read the *Sepher Torah* (the Book of Law) before "the people" (Ex 24:3). In 622 BC, as the Temple of Solomon was being rebuilt, the High Priest Chelkias claimed to have found Moses's original scroll, which had been lost. The find was probably an ancient version of Deuteronomy that mentioned a "second law" (in Greek, *deuteronomion*) that Moses allegedly handed down shortly before his death. Deuteronomy consists of new writings that the reformers, appropriately called Deuteronomists, attributed to the great men of the past. While the high point of the book of Exodus is God's apparition to Moses on Sinai, in Deuteronomy the high point of the Israelites' wandering in the desert is the gift of the *Sepher Torah*.

*Deutoronomy*
miniature from the Gutenberg Bible
1454–55
Gutenberg Museum, Mainz

et cognatione sua: et cuncte femine de
eadem tribu maritos accipient: ut here-
ditas permaneat in familijs nec sibi
misceantur tribus: sed ita maneant ut
a domino separate sunt. Fecerunt; filie
salphaad ut sibi fuerat imperatum: z nu-
pserunt maala z thersa z egla z melcha
et noa filijs patrui sui de familia ma-
nasse q̃ fuit filius ioseph: et possessio
q̃ illis fuerat attributa mãsit in tribu
et familia pris earz. Hec sunt mãdata
atqz iudicia q̃ mãdauit dñs p manũ
moysi ad filios isr̃ in campestribus
moab supra iordanem ꝗtra iericho.
Explicit liber numeri: Incipit liber helleadaberim qui deuteronomiũ inscribitur.

Ec sunt verba q̃ locu-
tus ẽ moyses ad o-
mnem israhel trans
iordanem in solitudi-
ne campestri: cõtra
mare rubrum: inter
pharan et thophel et laban et aseroth.
Vbi auri est plurimũ: undecim dieb;
de oreb: p via montis seir usqz cadesbarne. Quadragesimo anno undeci-
mo mense prima die mensis locutus
est moyses ad filios israhel omnia que
preceperat illi dñs: ut diceret eis: postꝗ
percussit seon regem amorreorũ qui
habitauit i esebon: et og regem basan
qui mansit in aseroth et in edrai trãs
iordanem in terra moab. Cepitqz moy-
ses explanare lege z dicere. Dominus
deus noster locutus est ad nos i oreb
dicens. Sufficit vobis q̃ in hoc mon-
te mansistis. Reuertimini et uenite ad
montem amorreoꝝ z ad cetera que ei
proxima sunt campestria atqz mõta-
na z humiliora loca contra meridiẽ
et iuxta litus maris: terram chananei
orũ et libani usqz ad flumen magnũ

eufraten. En inquit tradidi vobis. In-
gredimini et possidete eã: sup qua iu-
rauit dñs patrib; uris abraham ysa-
ac z iacob: ut darem illam eis z semini
eorum post eos. Dixiqz vobis illo in
tempore. Non possum solus sustine-
re vos quia dñs deus ur̃ multiplica-
uit vos: et estis hodie sicut stelle celi
plurimi. Dominus deus patrũ uro-
addat ad hunc numerũ multa milia:
et benedicat vobis sicut locutus ẽ. Nõ
valeo solus negocia uestra sustinere z
pondus et iurgia . Date eꝝ vobis vi-
ros sapientes et gnaros quoꝝ cõuer-
satio sit probata in tribub; uris: ut po-
nam eos vobis principes. Tunc respõ-
distis michi. Bona res est quã vis fa-
cere. Tuliqz de tribubus uris viros sa-
pientes et nobiles et cõstitui eos prin-
cipes tribunos z centuriones z quin-
quagenarios ac decanos qui docerẽt
vos singula: precepiqz eis dicens. Au-
dite illos: z quod iustũ ẽ iudicate. Si-
ue ciuis sit ille siue peregrinus: nulla
erit distantia psonarũ. Ita paruũ au-
dietis ut magnũ: nec accipietis cuius-
ꝗ psonam: quia dei iudiciũ ẽ. Quod
si difficile vobis visum aliquid fuerit
referte ad me: et ego audiã. Precepiqz
omnia que facere deberetis. Profectiqz
de oreb transiuimus p heremũ terri-
bilem z maximam solitudinem quã uidi-
stis per viam montis amorrei: sicut
preceperat dñs deus noster nobis. Cũqz
uenissemus in cadesbarne dixi vobis.
Venistis ad montem amorrei: quẽ dñs
deus noster daturus ẽ vobis. Vide ter-
ram quã dominus deus tuus dabit
tibi. Ascende et posside eã: sicut locut' ẽ
dñs deus noster pribus tuis. Noli ti-
mere: nec quicqz paueas. Et accessistis
ad me omnes atqz dixistis. Mittamus

# The Ten Commandments

After giving an account of Moses's speech about divine
providence and the ban on idols, Deuteronomy sets forth his
prescriptions to the people of Israel after they left Egypt,
including the Ten Commandments. There are only minor
differences between this version and the Decalogue in Exodus,
but Moses's later instructions are new: "And thou shalt love
the Lord thy God with all thine heart, and with all thy soul,
and with all thy might." (Dt 6:5) In telling the parable of the
good Samaritan, Jesus repeated the same words, adding, "and
with all thy mind; and thy neighbour as thyself." (Lk 10:27)
Deuteronomy also narrates how, after shattering the Tables
of Law, Moses was instructed by God to make new ones,
carving the commandments with his own hand. He was also
commanded to build the Ark of the Covenant in which
to store them.

(Ex 36; Dt 5–6; 10:1–4)

*Moses and the Ten Commandments*
1600
Museum Catharijneconvent, Utrecht

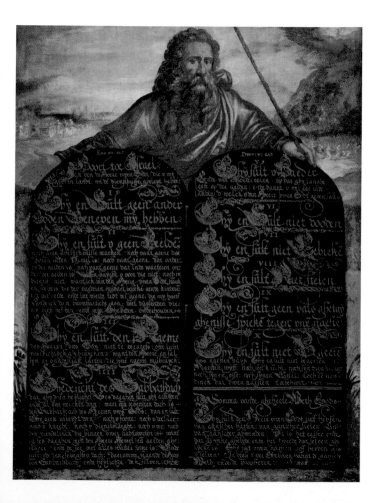

# The Law of Retaliation

One of the laws proclaimed by Moses (it is also mentioned in Exodus and Leviticus) is the famous law of retaliation—"Life shall go for life, eye for eye, tooth for tooth, hand for hand, foot for foot" (Dt 19:21)—in which the punishment was often identical to the crime committed or the damage inflicted. This "law of retaliation," which still survives in some Muslim states (such as Iran), has remote origins. We find it, for example, in the Code of Hammurabi, one of the earliest collections of law in human history. The code was written during the reign of the Babylonian king Hammurabi (1792–50 BC); most likely, the Judaic tradition drew from it in the period of the Hebrew captivity in Mesopotamia. The Christian law would be very different indeed: "Whosoever shall smite thee on thy right cheek, turn to him the other also." (Mt 5:39; Lk 6:29)

(Ex 21:24; Lv 24:20; Dt 19:21)

*The Code of Hammurabi* (detail)
18th century BC
Musée du Louvre, Paris

# The Death of Moses

Deuteronomy closes with a historical appendix that recounts the end of the long journey as the Israelites reach the Promised Land. At the venerable age of 120, Moses would not be allowed, as God had foretold him, to set foot in the longed-for land of Canaan. Thus Moses summoned before the entire assembly Joshua, whom the Lord had chosen to succeed him, and blessed him. Then he climbed Mount Nebo, where his eye could roam over the Valley of Jericho, and there he died. God buried him in the Valley of Moab, though no one knew the exact site. The iconographic tradition has added to this episode some anecdotal details that are not in the Scriptures. For example, this well-known fresco in the Sistine Chapel illustrates different scenes from Deuteronomy: at bottom left Joshua receives the succession from Moses; in the foreground on the right, Moses explains the Law to the people; in the background are glimpses of the land of Canaan; at the center on top, Moses is on Mount Nebo; at the left on top, the dead Moses is mourned by his people. This last scene illustrates the following verse from Deutoronomy: "And the children of Israel wept for Moses in the Plains of Moab thirty days." (Dt 34:8)

(Dt 31–34)

Luca Signorelli
*Moses's Testament and Death*
1481–82
Sistine Chapel, Vatican

# The Historical Books

These writings record the events in the history of the Hebrew people between the thirteenth and second centuries BC.

# Joshua

The first book in the historical writings is named after Joshua, which in Hebrew means "God is salvation." He was the valiant commander of the army of Israel, chosen by Moses to succeed him in the enterprise of leading the Israelites into the Promised Land. Joshua succeeded in this feat. The narrative is divided in two parts: The first is an account of the subjugation of the land of Canaan by the Israelite army; the second, the partitioning of the land among the Twelve Tribes, their settlement, and the renewal of the Covenant with God, which took place on the eve of Joshua's death. With this book begins the history of the people of Israel in the Promised Land.

*Joshua Receives Orders from God*
miniature from the *Bible of Guiart Desmoulins*
1305
Bodleian Library, Oxford

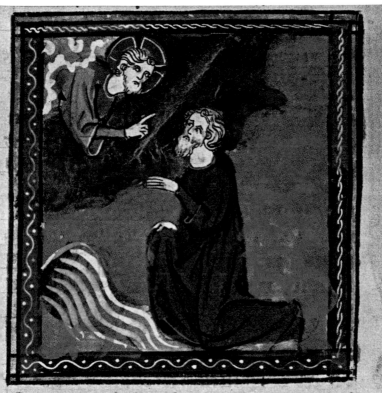

Comment Josue fu fais dus et meneur

# The Fall of Jericho

Led by Joshua, the Israelites were about to set foot in the
Promised Land. They reached a ford in the river Jordan in
early spring when the river, swollen by the melting winter
snows, usually overflowed. However, as soon as the priests
carrying the Ark of the Covenant set foot in the river, the
waters flowing down from the mountain immediately stopped
and took the shape of a wall, while the waters downstream
continued to flow. Thus a dry path appeared for the Chosen
People. During the crossing, 12 men—one from each
Tribe—each picked up a stone with which to raise an altar
to the Lord. After the momentous crossing, the Israelites went
on to capture Jericho, until then believed to be impregnable.
After they seized the city, all the major towns of the land of
Canaan also fell, and the Israelites completed their takeover
of the Promised Land. The episodes in this book are often
styled as military chronicles, though the help of God is always
emphasized as proof of the legitimacy of the Israelites' wars
and of their uprightness.

(Jos 3:1–17; 6:1–27)

Benjamin West
*Joshua Crosses the River Jordan
with the Ark of the Covenant*
1800
Art Gallery of New South Wales,
Sydney

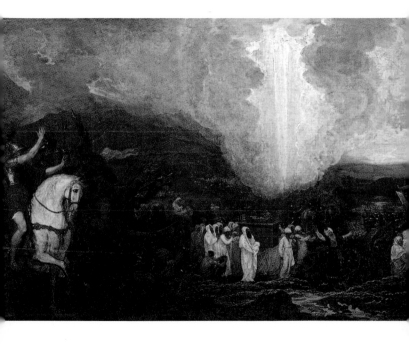

# Judges

The title of this book refers to the chieftains of some of the Israelite tribes, whose role was to consolidate the presence of the Hebrews in the Promised Land by battling the many threats from neighboring nations, including the Canaanites and the Philistines. The events cover the period after the Hebrew takeover of the land of Canaan, from the late thirteenth to the eleventh century BC. It was a trying time, as they suffered attacks from the subjugated pagan tribes yearning to take revenge. The actions of the judges, whom God had chosen to defend His people, must be seen in this context. There were "major" and "minor" judges: The former were not so much rulers as charismatic figures whom God called into action in particular times of danger; after conquering the threat, they usually went back to their private lives. The minor judges were the chiefs who ruled each Tribe in ordinary times. The biblical narrative pays special attention and offers copious details about the "major" judges, those chosen by God, because they played such an important role in the history of Israel.

*Judges*
miniature from a Hebrew Bible
1396
Biblioteca Medicea Laurenziana, Florence

# Barak and Deborah

The settlement of the Hebrews in the Promised Land was not without challenges. At the beginning of the twelfth century BC, they were again oppressed by the Canaanites, ruled at the time by the pagan King Jabin and his army commander, Sisera. In those years, Deborah was a prophetess and a judge of Israel; the people turned to her to resolve their issues. Inspired by God, one day the woman summoned Barak, a simple, upright Jew, and ordered him to gather an army of 10,000 warriors and march with them to the river Kison, where she would lead Sisera's troops and deliver them into his hands. She warned Barak, however, that a woman, not he, would claim victory; that woman, it would be revealed later, was Jael. Barak followed her instructions and at Deborah's signal furiously led his men against the enemy army. God caused panic and confusion among the Canaanites, for as soon as Sisera's troops saw the Israelites, they became disoriented and scattered about and were defeated. Only Sisera escaped. In a male-dominated society such as that of the ancient Hebrews, God chose Deborah, a woman, to express His will. Led by the Lord, she is the one who imperiously chose Barak for this challenging mission.

(Jg 4:1–16)

Francesco Solimena
*Deborah*
c. 1710
Private collection

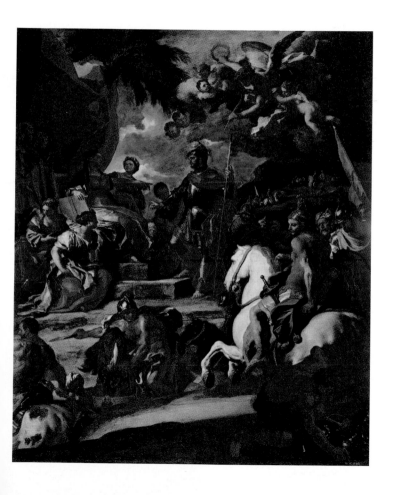

# Jael and Sisera

After escaping the fury of Barak's army, which had routed his troops, Sisera hid in the tent of Jael, a nomad woman who took him in, gave him water, and allowed him to rest, reassuring him that she would stand watch at the entrance to make sure that no intruder came in. Jael was a Kenite, a people generally hostile to the Israelites. Still, as soon as Sisera fell asleep, she took a tent peg and drove it through his temple with a hammer, killing him. When Barak reached the tent, Jael greeted him with these words: "Come, and I will show thee the man whom thou seekest." (Jg 4:22) Thus the Hebrew commander saw Deborah's prophecy come true: Sisera had fallen at the hands of a woman. Here Jael is depicted as she is about to hammer the tent peg into the head of the sleeping general.

(Jg 4:17–23)

Bartholomeus Spranger
*Jael and Sisera*
late 16th–early 17th century
Statens Museum for Kunst, Copenhagen

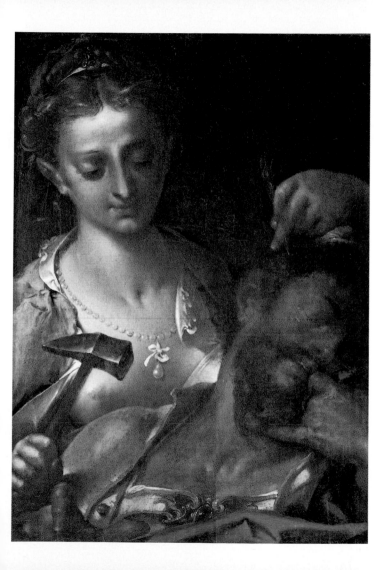

# Gideon

The Midianites, a nomadic tribe, threatened the political independence of the people of Israel. As often happens in the Bible, God chose a plain, humble man and entrusted him with the all-important task of shoring up and defending His people in the Promised Land. In this case, the challenge fell on Gideon, who belonged to the poorest family of the Manasseh tribe. The young man was frightened by the mission, and three times asked the Lord for a sign of His presence and His support. The first time, the angel of the Lord appeared and turned the food the youth had prepared for him into a burnt offering. Then Gideon left an open fleece in the yard for two consecutive nights: while the first night the dew fell only on the fleece leaving the earth around it dry, the following night it wet the soil without touching the fleece. Seeing that his prayers had been answered, Gideon gathered a large army and set out to do battle with the enemy. During the night he surrounded the enemy camp, and at his signal the soldiers unleashed a deafening noise by blowing their horns and smashing pitchers. The Midianites were thrown into confusion by the uproar: frightened, they killed each other. Here Gideon is depicted in armor, with his fleece. Sometimes lying at his side is a broken pitcher, to signify his victory, or a vessel filled with dew, to signify God's blessing. (Jg 6–7)

*Gideon*
c. 1490
Musée du Petit Palais, Avignon

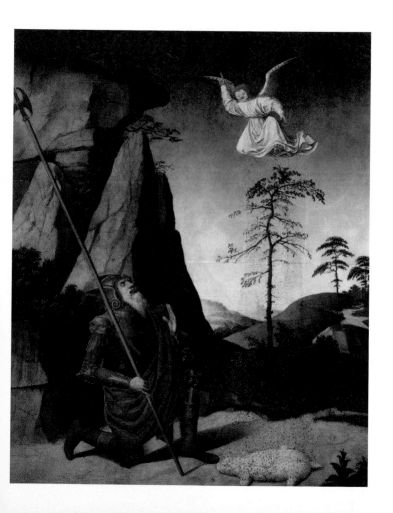

# *Samson*

Samson was the son of a sterile woman who in her old age
received from an angel the news that she was with child. But
God's messenger had warned her that the child was to be con-
secrated to God as a Nazarite, a monastic status that forbade the
eating of unclean foods and the cutting of one's hair. Born with
immense strength, Samson broke all of these rules in his life-
time, although more out of naïveté than lack of faith. He also
fell in love with pagan women. The first one was a Philistine,
whom he married. Returning from a trip, however, he dis-
covered that his father-in-law had given her to another man.
Enraged, Samson set fire to the Philistine village. He was caught,
but broke the ropes that held him, took the jawbone of an ass
that was lying on the ground, and massacred his enemies, killing
about 1,000 men. In his later years, Samson was undone by
another destructive female figure: Delilah. She discovered that
the hero's strength lay in his hair. While he slept, the woman
sold her lover to the Philistines, who cut his hair and threw
him in jail. In this painting by Guido Reni, Samson has just
slaughtered the Philistines with the jawbone, from which the
artist has caused water to spring forth.

(Jg 13–16)

Guido Reni
*The Triumph of Samson*
1611–12
Pinacoteca Nazionale, Bologna

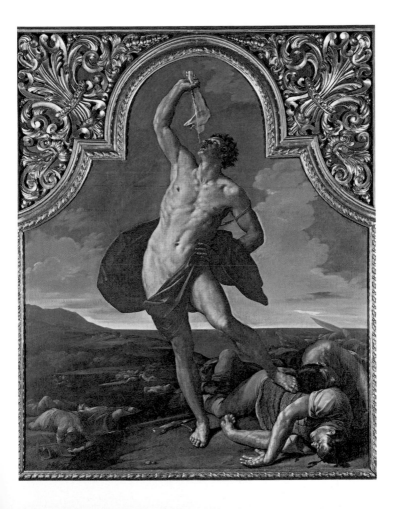

# *Ruth*

In the time of the judges, a famine struck the Promised Land. The book of Ruth, one of only two biblical books dedicated to a woman, opens with this plague. Although the authorship of the book is still in dispute, it may be considered an appendix to the book of Judges, as the events it narrates took place in the same historical period. Neither the exact time nor the judge in question have been identified. The protagonist of this story is Ruth, a young Moabite who had married Chilion, a son of Elimelech and Naomi. Having been left a widow, she was bought by Boaz, a rich Israelite. Although the woman was not an Israelite, she has a fundamental role in the history of salvation, since from her union with Boaz would be born Obed, the grandfather of King David, who was to be Jesus's ancestor.

Francesco Hayez
*Ruth*
1835
Pinacoteca Nazionale, Bologna

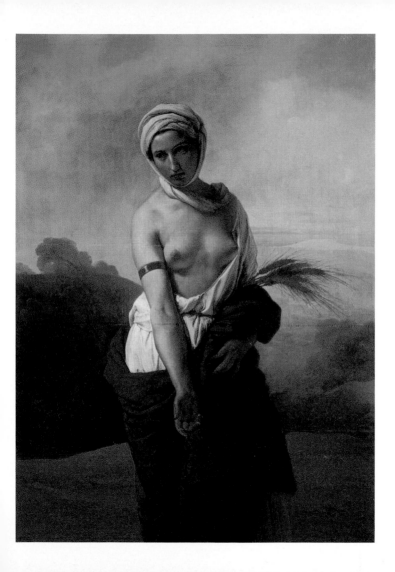

# Ruth and Boaz

The lovely Ruth, widow of Chilion, and her mother-in-law, Naomi, went back to Bethlehem, the land of Ruth's deceased husband; but being without men, the women could not claim their inheritance. According to the Hebrew laws governing the poor, Ruth could, however, glean after the harvesters; thus she began to glean in a field owned by Boaz, a distant relative of Elimelech. The man took notice of the beautiful widow and, having learned that they were related, decided to take her as his wife, availing himself of the levirate, a law that allowed the relative of a deceased husband to redeem the widow in order to provide descendants to the deceased. From this marriage was born Obed, Jesse's father, who in turn begat David. This artist has focused on the beauty of the young woman and the affection between her and her new husband.
(Rt 1–4)

Aert de Gelder
*Ruth and Boaz*
1672
Akademie der Bildenden Künste,
Vienna

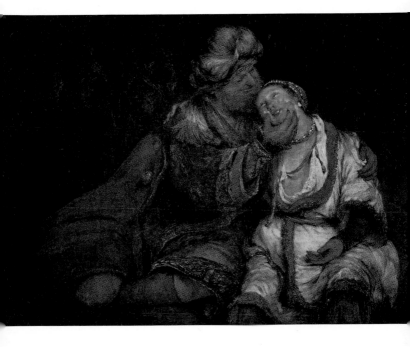

# Samuel I

This book covers the transition from the time of the judges to the monarchy. For the first time since they had first set foot in the Promised Land, the Tribes of Israel recognized one single ruler and placed themselves under his authority. The historical reason for this union must be sought in the grave threat coming from the Philistines. The leading characters are the prophet Samuel, the last judge of Israel, and Saul, the first king, who began his rule happily and with a victory but later lost God's support and spent his last years in bitterness. Around the middle of the book, the imposing figure of David appears: He will dominate the later books. This writing, together with the Second Book of Samuel and Kings I and II, covers a timespan that runs from the birth of the monarchy in Israel (second millennium BC) to the destruction of the Temple by the Babylonians (586 BC). Though named after the last Hebrew judge, Samuel is not the author, as several passages suggest a lapse of time between the narrative and the events described; scholars believe that the final version of the book dates to before the Assyrian exile of 722 BC, as that event is not mentioned at all.

*Samuel I*
miniature from the *Latin Bible of Gerardsbergen (Belgium)*
1195
Private collection

in regnum constituitur saul·
gduaritur samuele reducit saul a dūo
constituitur dux istra·
primum bellum saul cont naas·
Deuterōij obscuru et pdo rem innoua
uit regnū saul samuel in galgalis·
Excelsit saul offerens uictimas inuicas·
Fama edes iouachan de phylistijm·
Puerū drm fecisse saul regem·
testimonium ipse dicturus· nolle drm
sacficiu sz obedientiam·
Spcto saul rege elegit dūs filium isaj·
Soliat spiritu insurget cont istl et erigi
ouachas filij saul· dz interst sed fraud·
A crepere saul parere nolure dz lanoru·
post arreptione saul denuo ipsauerit cū
Dauid nituit reporte· Sceris·
& eligit dz ad achis regem geth·
Fugit rem in speluncam modolam·
A crepe a diabolo saul iussit doech· et inte
fecit sacerdotes lxx·
Consulait dauid drm sedo· si urbe ue
cruit cont phylistheu·
Gictus iouachas in siluas· ad seruandū dz·
Muratur dz locum latendi m engaddi·
quic secutus est saul·
Testimoniū cōt saul argueudis dz dz·
Obruit samuel pphete·
Cū saul post beneficiū ego ei coerstit
dauid psequitur eum·
iterum absconder se dauid in regiōe phy
lustinoz quotieus ingtles·
Gctum achis cont istl·
Saul rex exerstit queres phiponassam·
Est spamati loquit ao seuil· pandict ei
morten futura·
Spsuag ipsi lapidare nolurerum dauid
dolentes p saul quicaper erūt·
Superatur istl a phylistim· misficatus
filios saul expulsus saul·

iuter regum pmus· i·

Nte urū
uinus de
Ramatha
sophijm de
monte effra
ijm· et nome
ei helchana
filij iieroboal·
filij hiu· fi
lij thau· filij
suph effrateū
et habuit
duas uxores· nomen uni anna· et nomē
secle fenenna· fueruntqz fenenne filij·
Anne aū non erant liberi· Et ascendebat
uir ille de ciuitate sua statutis diebz·
ut adoraret et sacficaret dūo exercitu
um in silo· Erant autem ibi duo filij iiely
ophni et finees· sacerdotes dmini· Ue
nit ergo dies et immolauit helchana·
deditqz fenenne uxori sue et cunctis
filijs eius et filiabz partes· Anne autē dedit
partem unam tristis· qa annā dilige
bat· Drs aū concluserat uuluam eius·
Affligebatqz eam emula eius et uehementer
angebat· in tantū ut exprobraret qd con
clusisset drs uuluam ei· Siccp faciebat per
singulos annos· cū redeunte tempre ascende
ret templum drī· et sic puocabat eam· porro
illa flebat· et no capiebat cibum· Dū
xit ergo ei helchana uir suus· Anna cur
fles· quare no comedis· et quāobrem affli
gitur cor tuū· Nūquid non ego melior sū
tibi· qm decem filij· Surrexit aut anna post
qm comederat in silo et biberat· et hely sacerd
te sedente sup sellam ante postes templi dō
mini· cū ess anna amaro aīo oraret dō
minum flens largiter· et uouit uouū dicens·
Drē exercituum si respiciens uideris afflictio
nem famule tue· et recordatus mei fueris· nō
oblitus ancille tue· dederisqz serue tue ser
uum uirilem· dabo eum dūo omnibz diebz
uite et· et nouacula no ascendet sup caput

# Eli and Samuel

Hannah, the wife of Elkanah, was barren until old age. Every year she went with her husband to the shrine of Shiloh, where she prayed to the Lord to give her a child. One day Eli, the temple priest, understanding the woman's sorrow, blessed her: "Go in peace: and the God of Israel grant thee thy petition that thou hast asked of him." (1 Sam 1:17) Within a year Hannah gave birth to Samuel. After she weaned him she decided to consecrate him to the Lord as a Nazarite. Most of the artists who have portrayed Samuel as a child have chosen the scene when Hannah delivers the child to Eli the priest. Thus the child was educated inside the temple and grew into a just and upright man, unlike the children of Eli, bullies who led depraved lives, even stealing the offerings that the faithful brought to the shrine. God became highly displeased with them and decided to slay them. He sent an angel to warn the priest of his plan. Later, a divine messenger appeared to Samuel, who began a dialogue with God that was to inform his entire life and make him known to the people of Israel as the Lord's prophet.

(1 Sam 1:24–28; 2–3)

Gerbrand van den Eeckhout
*The Infant Samuel Brought by Hannah to Eli*
*c.* 1660
Ashmolean Museum, Oxford

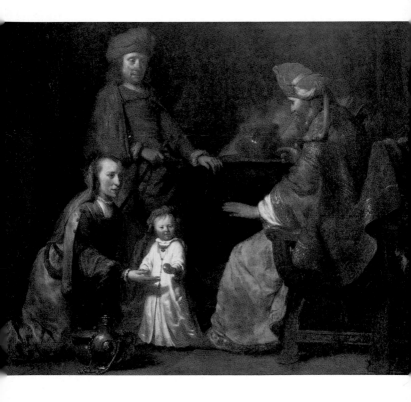

# The Capture of the Ark of the Covenant

Toward the end of the time of the judges, Israel lived under the oppressive threat of the Philistines, which continued through many years and many bloody battles. Having lost too many men in war, the Hebrews decided to move the Ark of the Covenant from the shrine of Shiloh to the middle of the camp so that it might bring the Lord's presence to the battle. Unfortunately, the Israelites were soundly defeated in the next battle; the enemy slew 30,000 of their men and seized the Ark, killing the two Ark bearers, sons of Eli the temple priest. Upon learning the grim news, the priest instantly died. The Ark—the most sacred object of the Israelites—had fallen into the hands of the Philistines, who placed it in the shrine of their god Dagon in the city of Ashdod. But the Lord struck the inhabitants of that city with a great plague such that, out of despair, the Ark was moved to a nearby city. After moving the Ark several times from one city to the other, each in turn struck by the Lord's curse, the Philistines finally resolved to return it to the Israelites. Thus, by God's will, the Ark was returned to the Chosen People. Artists have depicted the capture of the Ark in cruel battle scenes, where the Ark has lost all its power and become a mere spoil of war.

(1 Sam 4–6)

Gerrit Bleker, *The Battle of Ebenezer*
1640
Szépmûvészeti Múzeum, Budapest

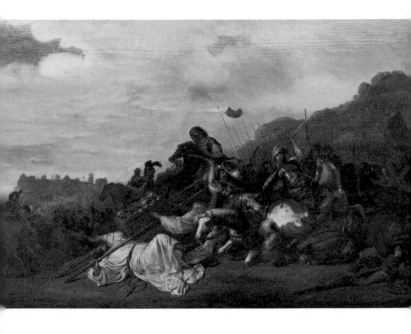

# Saul Becomes King

As the Philistines continued to threaten the Israelites, the latter loudly demanded that Samuel, their prophet, give them a king. The Lord chose Saul, from the poorest family of the Tribe of Benjamin. Samuel consecrated him by anointing his head with oil (in Hebrew, *mashiah*, from which "messiah" is derived, literally "anointed," later translated into Greek as *christos*) and introduced him to the people assembled. Saul was accepted coolly at first, but he strengthened his standing after a victory against the Ammonites. Still, his good luck was short-lived. On the eve of a battle with the Philistines, the king broke the priestly law by presiding over a burnt offering. When he saw this, Samuel prophesied that Saul's reign would be short and that none of his progeny would be king after him. After defeating the Amalekites, Saul decided to spare their king, Agag, and the choicest livestock, disobeying God's command that everyone be killed. The Lord censured Saul and expressed His displeasure through Samuel with these words: "The Lord hath rent the kingdom of Israel from thee this day, and hath given it to a neighbor of thine, that is better than thou." (1 Sam 15:28) Hearing these words, the king repented and fell into a state of melancholy and sadness for the remainder of his reign.

(1 Sam 5–15)

*The Coronation of Saul*
miniature from a German Bible
15th century
Private collection

bey dir. Und der koch hub auff den bug. vnnd
legtet den für saul. Vnd samuel sprach. Sih. Sz
da ist belybē das leg für dich vñ isse. wan es ist
dir behalten mit fleyß. Da ich rüffte das volck.

**¶ Das. X. Capitel. wy saul**
von samuel gesalbet ward vñ was warzeychen
er i gab. vñ wie er vñd die propheten kam.

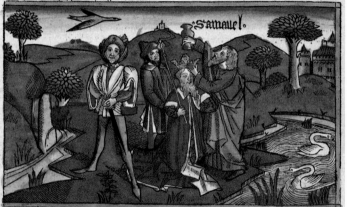

·Samuel·

**ND samuel nam eyn**
das des öls. vñ goß auff sein haubt.
vnd küst in. vnnd sprach. Sih. der herr
hatt dich gesalbet zu einē fürsten vber sei erb.
vñ du wirst erlöse sein volck võ dē hendē seiner
feind. Sie da sein in seinem vmbring. Vnd ditz
wirt dir ein zeychen. Dz dich der herr hat gesal-

thabor. so werden dich finde drey man. dy stey-
gē auff zu got in bethel. d ein tregt drey hytzlei
vñ der and drey küchlin brotz. vñ der dyt tregt
ein lagel weyns. Vñ so sy dich grüssen. so wer-
dē sy dir gebē zway brot. dy wirst du neme von
irer hāde. Nach disen dige kumbst du auff den
bühel des herrē. So ist städ d philistiner ist. Vñ

# David Is Elected King

After censuring Saul, the Lord asked Samuel to travel to Bethlehem, where he would point out the new king to him from among Jesse's sons. So as not to raise the king's suspicion, Samuel took a calf with him, pretending that he wanted to make a burnt offering. Inspired by God, the prophet invited Jesse and his sons to attend the sacrifice. One by one, the young men were introduced to him, but God chose none of them. Then the prophet learned that there was another son, the youngest, named David, who was away tending the flocks. David was called back to the city, and the Lord recognized him as His chosen, and Samuel secretly anointed him king. Once more, God had chosen the humblest man for a leading role. In the Bible, David is described as "ruddy, and withal of a beautiful countenance, and goodly to look to" (1 Sam 16:12), features that artists have endeavored to faithfully reproduce. Symbolizing everlasting royalty, the youth for Christians is a prefiguration of Jesus, David's direct ancestor.

(1 Sam 16:1–13)

Agostino Santagostino
*David Is Anointed King by the Prophet Samuel*
1670
San Marco, Milan

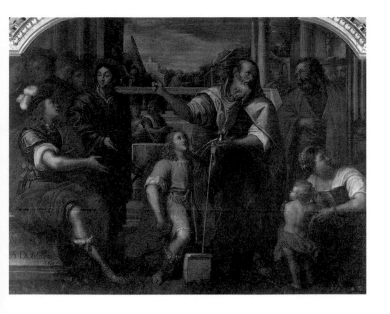

# David and Saul

Bereft of God's favor, Saul lived in a perpetual state of depression. To soothe his sorrows, the courtiers suggested a good musician: David, the son of Jesse, a skilled player of the kithara. Thus, David was summoned to court and Saul unknowingly met face-to-face with his successor. While at first the king found some comfort in the young man's music, he began to be distressed by the young man's growing fame, for David was also an excellent military leader. Saul's intolerance of David grew into a deep hatred, and he tried in every way to cause his death. He even promised him the hand of his daughter Michal, provided that David brought him the foreskins of 100 Philistines. He was thus hoping for David to fall into the hands of the enemy. But David brought back 200 and became Saul's son-in-law. One day, Saul lost his patience and threw a spear at the young man, who miraculously dodged it and fled to Samuel. The difficult relationship between the two men has been portrayed often; sometimes, the scenes show Saul being comforted by David's music. While the biblical text clearly speaks of a kithara, over time the instrument has been rendered as a harp or even a viola.

(1 Sam 16:14–23; 18:8–30; 19:9–24)

Jehuda Epstein
*David Playing the Harp for King Saul*
1896
Judaica Collection Max Berger, Vienna

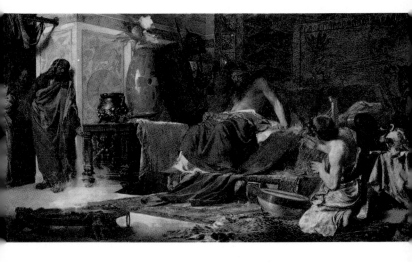

# David and Goliath

In the heat of a battle with the Israelites, the most valiant Philistine soldier came out of the ranks and demanded that an enemy duel with him. This warrior was Goliath, a giant protected by a helmet and armor and armed with a heavy spear. Only David was brave enough to come forward and ask King Saul for permission to fight. The king gave him his blessing and offered him armor, which David refused because it was too bulky. When he stood before the giant armed only with a sling and five river stones, the Philistine mocked him. But his slight build gave him more speed: first he shot a stone that hit Goliath in the center of the forehead; then, when the giant fell to the ground unconscious, he brandished his enemy's sword and beheaded him. At that point, the Israelites routed the Philistine army. David came back to the city carrying the head of the enemy in his hands and was welcomed joyously by the women of Israel, who sang a song to him: "Saul hath slain his thousands, and David his ten thousands." (1 Sam 18:7) Hearing these words, the king was displeased and began to harbor a deep envy for David. In art, the favorite scene of this episode is the victorious youth standing over the fallen body of the giant.

(1 Sam 17)

Donato di Niccolò di Betto Bardi,
known as Donatello
*David*
c. 1440
Museo Nazionale del Bargello, Florence

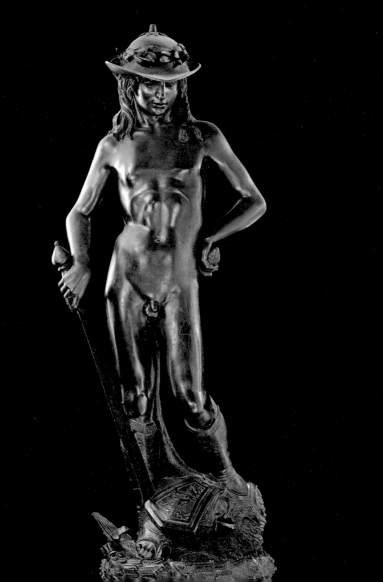

# *Jonathan*

After Goliath was slain, Saul's hatred for David became increasingly manifest and the king tried repeatedly to kill him. The text adds another layer of complexity to the difficult relationship between these characters on account of the true friendship that bloomed between David and Jonathan, a son of Saul. As a token of his deep affection, Jonathan gave the young shepherd his cloak, his military uniform, his sword, and his bow and arrows. The two youths shared a deep and sincere bond, even though destiny required them to compete for the throne of Israel. Jonathan was never envious of David's success; on the contrary, he often tried to help and pleaded with his father to spare his friend's life. But once he realized that his words were futile, he warned David that he must flee: "Go in peace. . . . The Lord be between me and thee, and between my seed and thy seed for ever." (1 Sam 20:42) The two embraced and wept in each other's arms, lamenting the unhappy fate that was forcing them to separate. In art, this is one of the most moving scenes of the Old Testament, precisely on account of the deep, sincere love the two friends felt for each other.

(1 S 18:1–7; 19:1–8; 20:1–42)

Rembrandt van Rijn
*David and Jonathan*
1642
Hermitage Museum, St. Petersburg

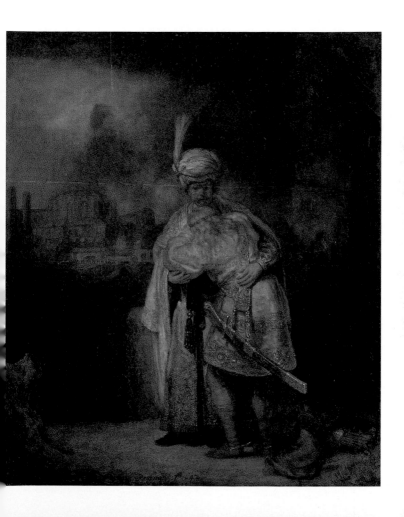

# David, Nabal, and Abigail

Having reached the desert of Judaea with his men, David made his home there for a while, watching over the flocks of the shepherds of Nabal, a wealthy local landowner. After some time, David demanded a tribute for having protected Nabal's livestock and kept peace in the region. He therefore sent ambassadors to him. But Nabal, whose name means "fool," replied haughtily: "Who is David?" (1 Sam 25:10) David was bent on avenging the offense, so he resolved to march against Nabal, intending to kill him and all his progeny. Abigail, Nabal's sensible wife, learned of the impending danger and, decrying her husband's folly, took great quantities of wine and food to soothe David's wrath and went to meet him. As soon as she saw him, she dismounted and, falling on her face, pleaded with him to forgive her husband's folly and desist from his plan, accepting the gifts instead. David, struck by the woman's intelligence and beauty, relented. After ten days the Lord punished Nabal by striking him dead, and David took Abigail as his third wife. In the Old Testament, polygamy was allowed because a long-lasting progeny was a token of God's favor.

(1 Sam 25:2–44)

Antonio Grano and
Gioacchino Vitaliano
*Abigail Soothes David's Wrath*
1706–8
Chiesa del Gesù, Palermo

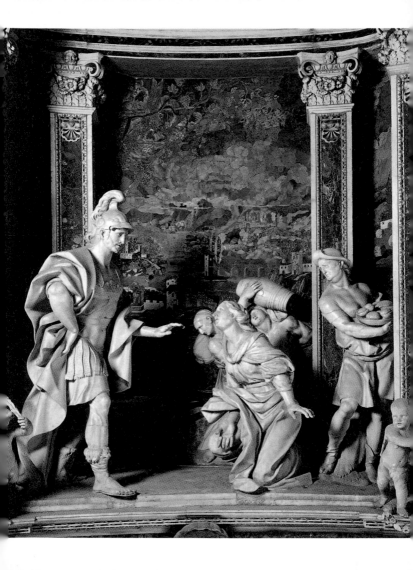

# Samuel II

The book opens with David's lament over the deaths of Jonathan and Saul, for the king and his son had died in combat against the Philistines; Saul had been slain by the enemy, and Jonathan had thrown himself onto his own sword to avoid surrendering. Because of the great friendship that had tied him to Jonathan, notwithstanding his tense relationship with Saul, David wept forlornly for the loss of the two men: "Saul and Jonathan were lovely and pleasant in their lives, and in their death they were not divided." (2 Sam 1:23) After fighting several battles to unify the kingdom under his hand, David was anointed king by all the Tribes of Israel. After wresting Jerusalem from the Jebusites, the new king proclaimed it the new capital and moved the Ark of the Covenant, the most sacred relic of the Israelites, there. But God contested David's intention to build a temple in which to house the precious relic. Still, He promised David an everlasting lineage that would build the temple in the future. Later, David would commit adultery and murder a man, and though he later repented, by the law of retaliation so prevalent in the Bible, a season of family discord would begin for him.

Pieter Bruegel the Elder
*The Suicide of Saul*
1562
Kunsthistorisches Museum, Vienna

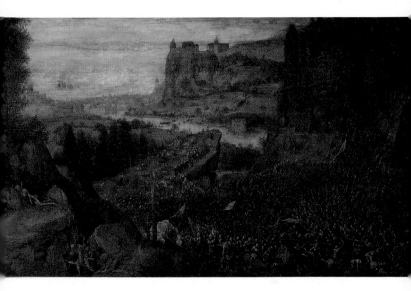

# Jerusalem, Capital City

Having been proclaimed king by the Twelve Tribes of Israel, David sought to give a capital to his people. To this end, he decided to march on Jerusalem, at the time inhabited by the Jebusites, and make it the center of the newly constituted government. A sentence announced its fall, and Jerusalem was immediately rechristened "the city of David." (2 Sam 5:9) The sovereign wanted to mark the hallowed nature of the city by moving the Ark of the Covenant there, the Ark being the most venerated relic of the Hebrews and a symbol of their religious unity as one people. David gave orders for a procession, and the Ark was placed on an ox-driven cart and led into Jerusalem followed by a long train of joyful, dancing faithful. Even David, dressed in just his loincloth, followed the relic, dancing with all his might. His wife, Michal, angered by such behavior, made a malevolent comment, which God immediately punished by making her barren. It is perhaps for this reason that some artists have depicted the king in full dress and carrying his beloved harp, an instrument that he played like a god.

(2 Sam 5–7)

*The Ark is Carried to Jerusalem*
miniature from a Bible
1490
Russian National Library,
Saint Petersburg

niam ite domine ſpmmi: Dicit in eraudies
me due dz mis. Quia dixi ne eŏ uando ſup
gaudeant michi inimici mei: r dum cōmouere
tur pedes mi: ſup me magna locuti ſ. Quo
nia ego ad flagella paratus ſum: r dolor mis
i conſpectu mo ſemp. Qm iniquitate meam
Anuntiabo: r cogitabo pro peccŏ mo. Inĩ aũt
mei ſiuunt r cōfirmati ſ ſup me: r multiplica
ti ſ: qŏ oderunt me iniq. Qui retribuũt
mala pro bonis detrahebant mi: r qm ſeĉtbar bo
nitatem. Ne derelinqs me domine dz mis ne
diſceſſeris a me. Intende i Adutoriũ meũ
domine dz ſalutis me. Glŏ ſia pr̄ et. Amen.

# David and Bathsheba

One day, while strolling on his terrace, David was captivated by the beauty of a woman bathing. It was Bathsheba, whose husband, Uriah, was away waging war against the Ammonites. David summoned her to his palace and lay with her. She became pregnant and told David. Faced with his obvious adultery, the king recalled Uriah and encouraged him to sleep with his wife. But the man, observant of the prescriptions about sexual abstinence in time of war, slept at the gates of the king's palace. Then the king sent him back to the battlefield with a letter for Joab, the army commander, asking him to send Uriah to the front line, where he would be exposed to the enemy's attack. After Uriah was slain, David married Bathsheba but aroused the wrath of the Lord for his double sins of adultery and murder. The Lord punished David: "Thou shalt not die. Howbeit, because by this deed thou hast given great occasion to the enemies of the Lord to blaspheme, the child also that is born unto thee shall surely die." (2 Sam 12:13–14) Finally, the king repented and in vain pleaded with God to save the child. After the child's death, David comforted Bathsheba and again lay with her: from this union was born Solomon, the future king of Israel. The scene most frequently represented in art is Bathsheba bathing.

(2 Sam 11–12)

Julius Schnorr von Carolsfeld
*Bathsheba Bathing*
1820
Nationalgalerie, Berlin

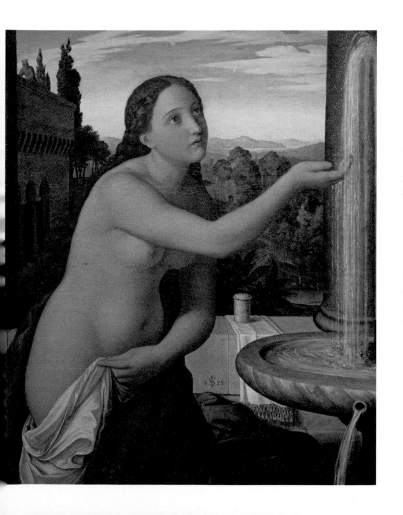

# *Kings I*

Kings I continues the uninterrupted narrative of the books of Samuel. King David was now old; the Bible tells of the lovely virgin Abishag, who had been summoned to the palace to minister to the old king and warm him with her body, for he suffered from rheumatism. A deep affection developed between them, though out of respect David never lay with her. Still, after his death, Abishag was often numbered among his concubines. Before dying, David anointed his son Solomon to succeed him. Under Solomon's rule, the unified kingdom was to reach a golden age, but at his death it would split into two: the kingdom of Judah with Jerusalem as capital, and the kingdom of Israel with Samaria as capital. The history of the two parallel monarchies begins in Kings II.

Frederick Goodall
*David's Promise to Bathsheba*
late 19th century
Private collection

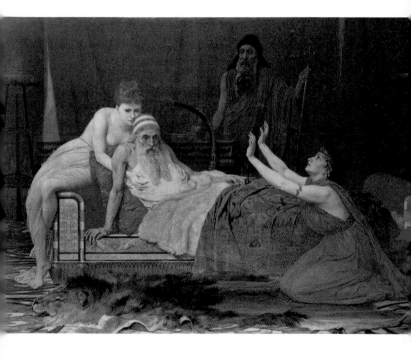

# The Building of the Temple

The name "Solomon" means "peace, wellbeing" in Hebrew, and these qualities did indeed mark his reign. The Bible speaks of this king as the perfect monarch. Educated by the prophet Nathan, Solomon was anointed king by his father, by intercession of his mother, Bathsheba. To keep the promise that God had made to David, that he would enjoy an everlasting dynasty, which would build a shrine to God, Solomon began the construction of a temple in which to house the Ark of the Covenant. It was a grandiose plan: Solomon made a contract with Hiram, king of Tyre, who was to supply the cedar and juniper timber. The temple took seven years to build and was overlaid entirely with pure gold. While the Bible gives a wealth of details about measurements and construction materials, it is vague about the style and shape of the building, giving free rein to artists' imaginations.

(1 Kgs 5–6)

Jean Fouquet
*Construction of the Temple of Jerusalem*
miniature from *Antiquitatum Iudaicarum*
of Flavio Giuseppe
1475
Bibliothèque Nationale, Paris

# The Judgment of Solomon

One night the Lord appeared to Solomon in a dream and told him that he would give him whatever he asked. The king, knowing how challenging his duties were, asked for "an understanding heart to judge thy people" (1 Kgs 3:9) so that he might discern between good and bad. God was pleased with Solomon's wish and granted it. His wisdom is exemplified in a celebrated biblical episode that has been the subject of many works of art. Two harlots appeared before the monarch, both claiming to be the mothers of an infant boy. One of the women said that they lived in the same house and that both had given birth to a boy in the same three-day period. The woman accused the other of involuntarily suffocating her baby by lying over him while sleeping and of switching it with the other baby. Solomon asked for a sword and said: "Divide the living child in two, and give half to the one, and half to the other." (1 Kgs 3:25) Hearing these words, the true mother of the living child, moved to pity, begged the king to spare the baby, even if he were to decide that the child belonged to the other woman. But the other woman agreed with Solomon's decision. Then the king understood that the real mother was the one who was willing to give up her child in order to save his life, and he gave the child to her.

(1 Kgs 3:16–28)

Giorgio Barbarelli da Castelfranco, known as Giorgione
*The Judgment of Solomon*
1495–6
Galleria degli Uffizi, Florence

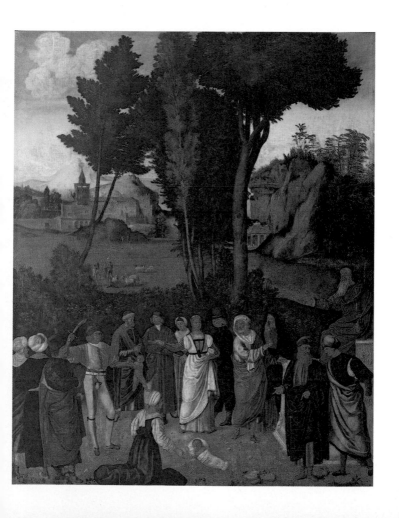

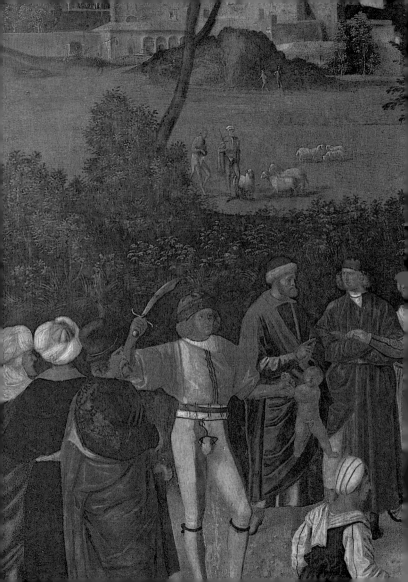

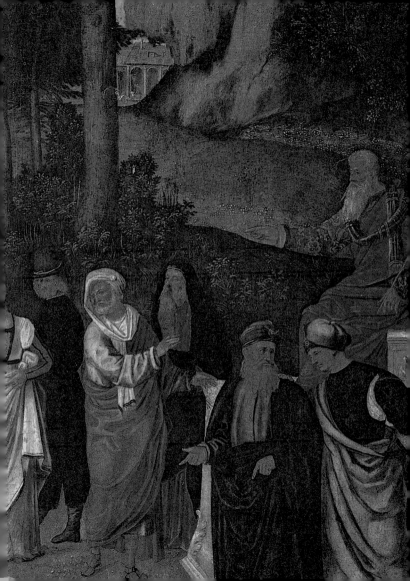

# The Queen of Sheba

The Bible narrates that the queen of Sheba decided to travel with a large train to visit Solomon, king of Israel, in order to ascertain his wisdom. When she stood before him, she tried him with a number of questions, all of which the king answered correctly and appropriately. Amazed by Solomon's judgment, the queen praised him and blessed Yahweh: "Thy wisdom and prosperity exceed the fame which I heard. . . . Blessed be the Lord thy God, which delighted in thee, to set thee on the throne of Israel!" (1 Kgs 10:7–9) After exchanging gifts, the queen of Sheba returned to her kingdom, which scholars still have not been able to identify. The reason for the journey must also have been to set up commercial relations with neighboring kingdoms, rather than just a queen's curiosity about a king. In all probability, the Priestly tradition gave the episode a religious flavor in order to bear witness to the greatness of God's chosen kingdom.

(1 Kgs 10)

Nicholas of Verdun
*King Solomon and the Queen of Sheba*
(detail)
1181
Sammlungen des Stiftes, Klosterneuburg

# The Idolatry and Death of Solomon

Although he was a just and wise monarch, Solomon did not disdain pagan women and even allowed them to continue worshiping their gods. The Bible mentions 700 wives and 300 concubines. In his old age, the wives persuaded him to worship their idols and even built two altars, one dedicated to Chemosh, the god of the Moabites, the other to Milcom, the divinity worshiped by the Ammonites. The Lord became deeply displeased with Solomon's behavior, and spoke thus to him: "I will surely rend the kingdom from thee, and will give it to thy servant. . . . I will rend it out of the hand of thy son. Howbeit I will not rend away all the kingdom; but will give one tribe to thy son for David my servant's sake, and for Jerusalem's sake which I have chosen." (1 Kgs 11:11–13) Thus the Lord punished Solomon, but still kept the promise He had made to David that he would have an unending royal lineage. After ruling for 40 years, Solomon died and his kingdom was divided in two: Judah to the south, and Israel to the north. Solomon's idolatry has been represented for the most part with scenes of burnt offerings or with the monarch bowing before the statue of a pagan deity.

(1 Kgs 11)

Marcantonio Franceschini
*Solomon Worshiping the Idols*
1709
Galleria Nazionale di Palazzo
Spinola, Genoa

# Elijah

In the ninth century BC Israel was ruled by the wicked Ahab, who began to worship Baal, the god of rain, deeply offending the Lord. The prophet Elijah, whose name means "Yahweh is God" in Hebrew, lived in Tishbe near the river Jordan. Elijah predicted that the kingdom would be struck by a drought sent by the Lord to prove Baal's inefficiency. When the drought came, God sent Elijah to hide by the torrent Cherith. Then the Lord sent Elijah to the king of Israel to triumph over the prophets of Baal and bring back the rain. But Ahab's wife, Jezebel, a Phoenician, resolved to have the prophet killed, and he had to flee. Having come to Beersheba in the kingdom of Judah, he fell asleep under a gorse tree. There an angel appeared to him, gave him food and drink, and sent him on to Mount Horeb (Sinai). From there, the Lord commanded him to go to Hazael, who would surely help him. The most frequently depicted scene in the story of Elijah is the dream with the angel of the Lord. Over time, the bread and the pitcher of water offered by the angelic creature have taken on a Christian meaning, an allusion to the Eucharistic mystery of the body and blood of Christ.

(1 Kgs 16:29–34; 17–19)

Pier Francesco Mazzucchelli,
known as il Morazzone
*Elijah's Dream*
1616–18
San Raffaele, Milan

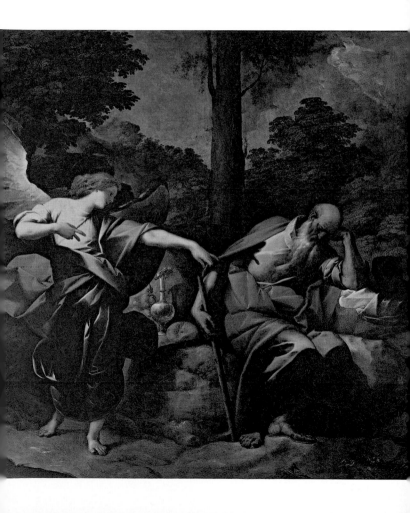

# Kings II

Kings II begins with Elijah's last mission against Ahaziah, the king of Israel who had begun to worship Baal-Zebub instead of Yahweh. Having fulfilled the missions that the Lord had assigned to him, Elijah knew that it was time to be raised up to Heaven. He therefore had to part from Elisha, his faithful friend and disciple, but although he tried more than once to persuade him to leave, Elisha stubbornly followed him to the banks of the river Jordan. Here Elijah took his cloak, rolled it up, and struck the water with it. The river parted, allowing the two men to cross on the dry bed. Then the prophet asked Elisha to express one last wish before taking leave; the disciple asked for "a double share" of his spirit. As they were walking, a fiery chariot with fiery horses separated them and a whirlwind carried Elijah up to Heaven as Elisha watched. The prophet vanished; the disciple picked up his master's cloak and turned to go back. When he struck the water with the cloak, the river parted, allowing him to cross, and so Elisha understood that the spirit of Elijah was upon him. Artists have often depicted the whirlwind and the horses together, with Elijah flying up to Heaven atop a fiery chariot. Christians consider this Old Testament story a foreshadowing of the Ascension of Jesus to Heaven. (2 Kgs 1; 2:1–18)

*Elijah Transported to Heaven*
early 19th century
Collezione Intesa Sanpaolo

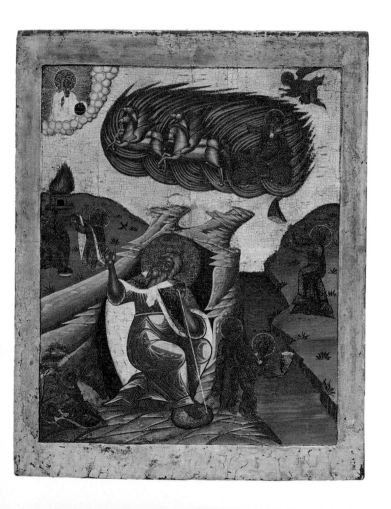

# *Elisha*

Unlike Elijah, the prophet Elisha built a following around him and exerted great political influence on the kingdom of Israel. An irascible man (he had 42 children torn to pieces by two bears because they had mocked his baldness [2 Kgs 2:23–24]), he performed several miracles in his lifetime. The one most popular in art is the miracle of the Shunammite woman. Learning of Elisha's goodness, the woman and her husband decided to minister to him and to his servant Hehazi, and they welcomed them in their home. Feeling honored, the prophet wanted to repay the kindness, but the humble, simple woman refused. Still, because she was barren, Elisha caused her to be with child, but the child died in infancy. And so the woman mounted a donkey and rode to Mount Carmel, where the prophet and his servant lived, and beseeched him to follow her. Elisha went with her, followed her into the house, and resurrected the child.

(2 Kgs 4:1–38)

Gerbrand van den Eeckhout
*The Prophet Eliseus and the Woman of Sunem*
1664
Szépmûvészeti Múzeum, Budapest

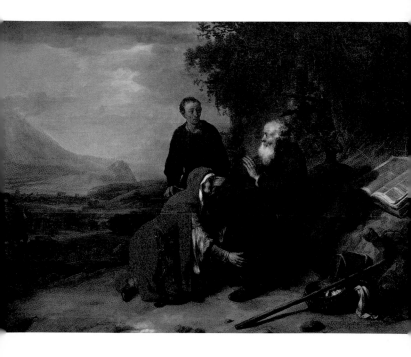

# Chronicles I and II

When the Deuteronomists expanded the Exodus story to include Joshua's conquest of the northern plateaus (they would be recaptured by Josiah in the seventh century BC), they also wrote a history of the kingdoms of Judah and Israel (Kings and Samuel) in which they claimed that the Davidic monarchs were Israel's only legitimate rulers. Still, after the Babylonian exile another group of miscellaneous writings was produced that in time became known simply as the Ketuvim ("the writings"), which are sometimes merely reinterpretations of the earlier books. The books of Chronicles, written by priests, are in fact a commentary on the Deuteronomic history contained in the books of the Kings and Samuel. Translated into Greek, the Ketuvim were dubbed *Paralipomena*, i.e., "the things left out." The authors wrote "between the lines" to soften what they considered discrepancies in the "P" tradition (the revisions added during the Babylonian captivity) with the intention of reaching out to the Israelites who had not been forced into exile and lived to the north.

*Chronicles I*
miniature from the Gutenberg Bible
*c.* 1455
Staatsbibliothek, Berlin

debreiamin id est verba dieru in ipre
tatus sum idcirco fer. ut inextricabile
moras et siluam nominu q scriptor
confusa sunt vitio. sensummq barba
riem aptius et pcutsuu cola digerere:
michi incipit z meis. iuxta ismenium
cantio. si aures surde sut ceterorum. Ex
plicit prolog. Incipit liber paralipomenon.

dam seth enos cayman
malaleel iared e
noch matusale la
mech noe sem cham
z iafeth. Filii iafeth:
gomer magog ma
dai et iauan thubal mosoch thiras.
Porro filii gomer: ascenez et riphat et
thogorma. Filii autem iauan: elisa
et tharsis cethim et dodanim. Filii
cham: chus et mesraim phut z chana
an. Filii autem chus: saba z et euila
sabatha et regma et sabathaca. Por
ro filii regma-saba z dadan. Chus au
tem genuit nemroth. Iste cepit esse po
tens in terra. Mesraim vero genuit lu
dim et ananim et laabim z nepthu
im: phethrusim quoq; et chasluim de
quib; egressi sunt philisthiim z capthu
rim. Chanaan vero genuit sydonem
primogenitum suum: etheum quoq;
et iebuseum et amorreu et gergeseum
eueumq; et aracheum z asineum ara
dium quoq; et samareum et emathe
um. Filii sem: elam et assur. Et arsa
zad-et lud z aram. Filii aram: hus z
hul-et gebther-et mes. Arsaxat autem
genuit sale. q; ipse genuit heber. Por
ro heber nati sut duo filii: nomen uni
phaleth quia in diebus eius diuisa e
terra: et nomen fratris eius iectan. Ie
ctan autem genuit elmodad z saleph
et asormoth et iare: aduram quoq; z
uzal et de ela ebal etiam et abimael et

saba-necno et ophir-et euila-z iobab.
Omnes isti filii iectan seu arfaxat sa
le heber phaleth ragau-seruch nachor
thare abram:iste est abraham. Filii
autem abraham:isaac et ismahel. Et
hee generationes eorum. Primogeni
tus ismahelis nabaioth:et cedar z ab
dehel et mabsan et masma et duma
massa abdeb et thema iachur naphis
cedma. Hii sunt filii ismahelis. Filii
autem cethure concubine abraham
quos genuit:zanram iecsan madan
madian iesboe et sue. Porro filii iec
san:saba z dadan. Filii aut dadan:asu
rim et lathusim z loommim. Filii aute
madian: epha et epher z enoch z abi
da z eldaa. Omnes hii filii cethure. Ge
nerauit autem abraham isaac : cui fue
runt filii esau z isrl. Filii esau:eliphaz
rahuel iehus iehlon chore. Filii eliphaz:
theman omar zepphi gothan ce
nez thamna amalech. Filii rahuel:
naach zara samma meza. Filii seir:
lothan sobal sebeon-ana-dilon-eser di
san. Filii lothan: horri-ahohman.
Boror autem lothan fuit thamna. Fi
lii sobal alian z manaath-et ebal et se
phi-onan. Filii sebeon: aphia et ana.
Filii ana: dison. Filii dison: hama
ran z efetan-z iethran z charan. Filii
eser:balaan-z zaban et iachan. Filii di
san:us z aran. Isti sunt reges qui im
perauerunt in terra edom: anteq; esset
rex super filios israhel. Bale filius be
or: z nome ciuitatis ei denaba. Mor
tuus est autem bale:z regnauit pro eo
iobab filius zare de bosra. Cumq; z io
bab fuisset mortuus:regnauit pro eo
husam de terra themanorum. Obiit
quoq; z husam:z regnauit pro eo adad
filius badad qui percussit madian in
terra moab: z nomen ciuitatis eius

# *Ezra and Nehemiah*

These two books were considered one by the Hebrews, but were later separated by the early Christians. In content and style they are connected to the Chronicles. In the early fourth century BC the Persians tried to standardize the laws of their subject populations, hoping to strengthen the empire. To this end, toward 400 BC, the Persian monarch sent Ezra, his minister of Jewish affairs, to Jerusalem with the task of legalizing the revised Torah of Moses. Ezra, an expert in the sacred Hebrew Book, drew up a set of precepts that could satisfy both Mosaic and Persian law. But once in Jerusalem, he realized that the population was not following the precepts of the Torah. Thus he called an assembly and read it out loud, explaining its meaning, while the Levites circulated among the crowd giving precise instructions. In the meantime Nehemiah, a Hebrew cup-bearer at the Persian court, prevailed upon the king to send him to Jerusalem in order to rebuild the walls and the temple of his people.

*Ezra Writing*
miniature from the *Codex Amiantinus*
690–716
Biblioteca Medicea Laurenziana,
Florence

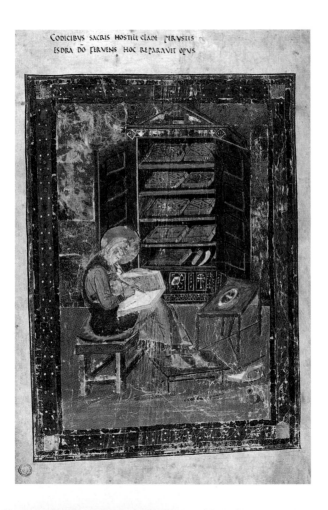

CODICIBVS SACRIS HOSTILI CLADE PERVSTIS
ESDRA DO FERVENS HOC REPARAVIT OPVS

# *Tobit*

This book is a narrative of the life of a pious man whose conduct is an example on how to lead one's life. It is not among the books recognized by the Jewish canon (it is deutero-canonical) and is filled with chronological and geographical inconsistencies; still, its narrative and edifying qualities have endeared the story of Tobit to artists. At its core, the book addresses the power of an upright person to trust in God, even when sorely tried. Tobit, of the Tribe of Naphtali in Upper Galilee, which had broken away from the faith of their fathers, still kept his piety and his faith in the God of Jerusalem. He had been a slave in Babylon, and after his release had made his way home to his wife, Anna, and their son, Tobias. One evening the man fell asleep under a nest of sparrows whose droppings fell on his eyes, blinding him. His wife then took up weaving for wages. One day, in addition to the regular payment, she also received a kid from a customer. When Tobit heard the animal bleating, he assumed that his wife had stolen it and he ordered her to take it back, for he felt ashamed for her. Anna resented the comment and retorted that all the alms he had freely given away in the past could not save him from his bad luck. Hearing that, Tobit sighed and wept and prayed to God to take him.

(Tb 1–3)

Rembrandt van Rijn
*Tobit Accusing Anna of Stealing the Kid*
1626
Rijksmuseum, Amsterdam

236

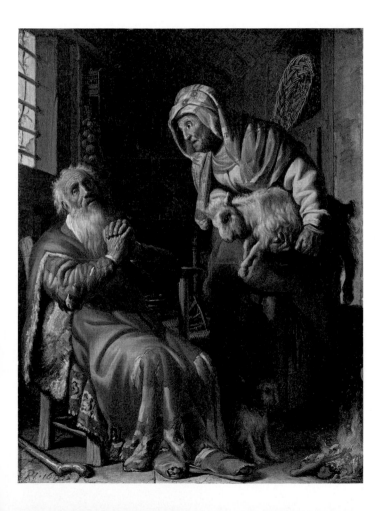

# Tobias and the Angel

Praying to God to take him soon, Tobit began to worry about his son, Tobias. He called him and explained that years before he had left some sacks of silver with Gabael, who lived at Ecbatana, over 100 miles from Nineveh, and asked him to travel there and reclaim the money, which he might need after his death. He counseled his son to find a trustworthy traveling companion whom they would pay for his services upon their return. The youth met Raphael, an angel sent by God; unaware of the stranger's angelic nature, Tobias asked him directions for reaching Ecbatana. The angel replied that he knew the way very well. Then Tobias introduced him to his father, and received his blessing for the journey. Tobias and the angel thus set out on their journey, followed by the family dog. At one point they stopped at the river Tigris to bathe. A big fish appeared and tried to devour Tobias, but the angel urged the boy to catch the fish, gut it, and "take out gall, heart and liver," which had "curative properties." (Tb 6:5)

(Tb 4–5; 6:1–9)

Giovan Gerolamo Savoldo
*Tobias and the Angel*
c. 1530
Galleria Borghese, Rome

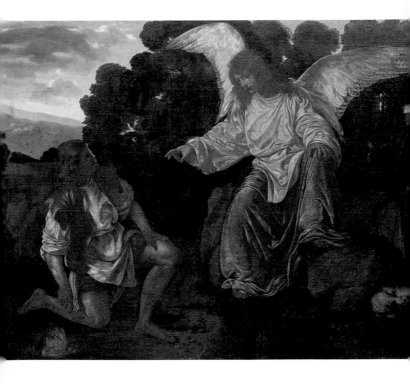

# *The Marriage of Sarah and Tobias*

Tobias and Raphael reached the home of Raguel, a kinsman of the boy in Ecbatana. The angel tried to persuade Tobias to take Sarah, Raguel's daughter, as his wife. But the youth was afraid because he knew that the girl was possessed by the demon Asmodeus and had already been given seven times in marriage, the bridegrooms having all died on the wedding night before lying with her. Raphael heartened him: once in the bridal chamber, he advised, Tobias should take some liver and heart from the fish they had caught in the Tigris and put them on the brazier. The demon would smell the foul odor and flee from the girl once and for all. But he also admonished him that before lying with his bride they should pray together to the Lord, asking for His protection. And so it happened, and as soon as he smelled the fish Asmodeus was so distressed that he fled to Egypt, where Raphael pursued him and shackled him.

(Tb 6:10–19; 7–8)

Eustache Le Sueur
*Tobias and Sarah's Wedding Night*
1642–55
Hotel de Fieubert, Paris

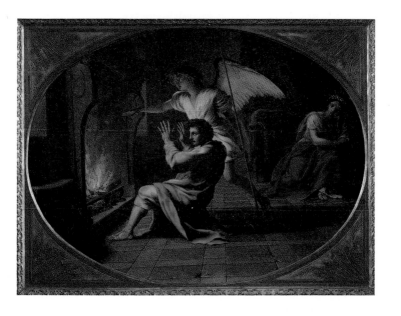

# Tobit's Sight Is Restored

Now happily married to Sarah, Tobias asked the angel to travel to Gabael's to collect the money that his father had left in his care. Meanwhile, his parents, unaware of the wedding, had begun to worry. While Tobit did not despair, Anna began to fear that her son might be dead. Fourteen days after the wedding, Tobias began his journey home with his bride, always in the company of Raphael and with a dog at their heels. As soon as Anna saw her son, she ran to give Tobit the happy news. Following the angel's advice, Tobit spread the preserved gall from the fish on his father's eyes, thus restoring his sight.

(Tb 9–11:1–15)

Bernardo Strozzi
*The Healing of Tobit*
*c.* 1635
Hermitage Museum,
St. Petersburg

# The Return of Tobias

After regaining his sight, Tobit learned that the son had been
able to collect the money from Gabael and had married a
good woman. Thus he went to the city gates to properly
welcome his daughter-in-law. The city of Nineveh celebrated
Tobit's restored sight, as well as the happy newlyweds. At the
end of the feasting, Tobit wanted to pay fair compensation to
Raphael. Tobias believed that his companion deserved at least
half of what he had reclaimed for all the favors he had done
to him. But Raphael revealed his true nature—an angel sent
by the Lord—blessed them, and vanished. The book ends
with Tobit's hymn of joy and a brief account of the death
of father and son.

(Tb 11:16–20; 12–14)

Benjamin West
*The Return of Tobias*
1803
Delaware Art Museum,
Washington

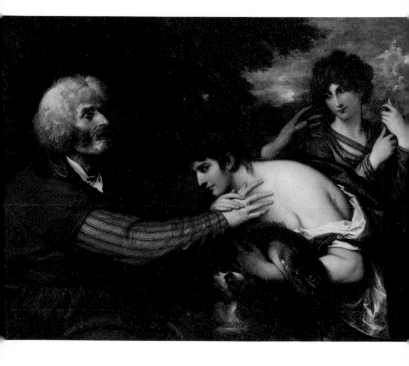

# Judith

The book of Judith should be treated as a historical novel, an edifying tale that aims to show how the Lord protects His people in challenging times. The book is replete with inaccuracies from the very first page, since it claims that the events took place during the reign of Nebuchadnezzar, who is described as an Assyrian king who ruled over a territory with Nineveh as capital, while in truth the city had been destroyed by his father. Also, Nebuchadnezzar was Babylonian, not Assyrian. The heroine, Judith, whose name signifies "the Jewish woman" par excellence, saved her people from conquest by Holofernes, the general of the Assyrian army. The woman was a widow from Bethulia, a fictitious city besieged by the enemy that would be freed only thanks to Judith's feat. The figure of this heroine has fired the imagination of many artists, even in the twentieth century.

Gustav Klimt
*Judith II (Salome)*
1909
Galleria d'Arte Moderna, Venice

# Judith Beheads Holofernes

Led by Holofernes, the Assyrian army had laid siege to the Israelite city of Bethulia. After 34 days the residents were exhausted and on the point of surrendering when Judith, a very beautiful widow, offered herself as a tool of salvation. She left the city with her maid and walked to the enemy camp, where she convinced Holofernes that she had fled Bethulia and was ready to help him seize the city. Charmed by her beauty and her words, the general allowed Judith into the camp and promised to spare her life; he also authorized her to leave the camp every night for her prayers. On the evening of the fourth day, the Assyrian general gave a banquet, to which he invited Judith. Alone with the sleeping general after the feast, Judith beheaded him with two strikes of his scimitar. She then hid the head in a sack, gave it to her maid, and both left the camp as they did every night, ostensibly to pray. The beheading of Holofernes is probably the most-reproduced scene of the Old Testament, perhaps simply due to its raw violence, which has always excited artists.

(Jdt 8–12; 13:1–10)

Artemisia Gentileschi
*Judith Beheading Holofernes*
1611–12
Museo Nazionale di Capodimonte,
Naples

248

# The Return of Judith

After beheading the Assyrian general Holofernes, Judith returned to the city of Bethulia, where she was greeted with joyful hymns. Exhibiting the commander's head, Judith suggested that it be hung from the city walls so that the next day the enemy would see it and fear for their lives. And so it was: As soon as the Assyrian soldiers saw their captain's disembodied head, they became terrified and fled helter-skelter, pursued by the Hebrews. Bethulia had been saved and Judith raised a song of praise to the Lord. In many paintings, the heroine is portrayed next to a juniper tree, a symbol of her virtue. The olive branch she carries in her hand symbolizes the newly won peace.

(Jdt 13:10–20; 14–15)

Alessandro di Mariano Filipepi,
known as Sandro Botticelli
*The Return of Judith to Bethulia*
*c.* 1472
Galleria degli Uffizi, Florence

# *Esther*

The story of Esther takes place after the Babylonian exile, at the time of the Persian slavery when Ahasuerus I (Xerxes I in Greek) was king. Although the book begins with a historical fact, the tale is a not reliable history due to its many anachronisms and factual inaccuracies. In all likelihood, the author was an exiled Judaean who wrote the book a long time after the events, inserting an edifying tale into a historical context that aimed to underscore God's constant presence in the history of the people of Israel. This is a historical novel, therefore, centered around the figure of Esther, a comely young Jewess who became the wife of Ahasuerus and pleaded with him on behalf of her people. Another leading figure is Mordecai, Esther's tutor, who counseled her about the conduct she should keep with the king. After repudiating his wife, Vashti, the king had begun to look for an attractive virgin to make his new bride. Messengers dispatched to all the corners of the kingdom had brought back to the royal palace the fairest virgins of the kingdom, each one of whom was presented to the king. But Ahasuerus fell hopelessly in love with Esther as soon as he saw her and made her his queen by crowning her himself with the royal diadem.

Jacopo del Sellaio
*The Coronation of Esther*
*c.* 1485
Musée du Louvre, Paris

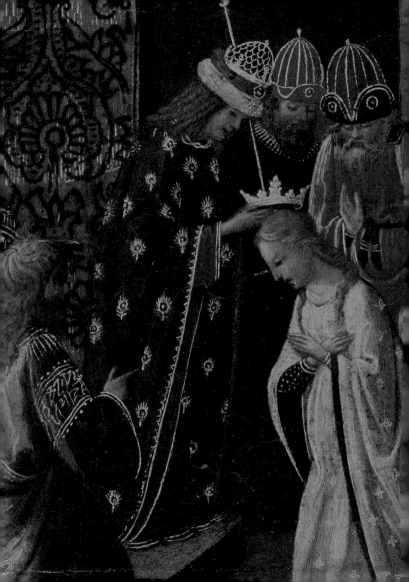

# *Esther Visits Ahasuerus*

Haman, the highest minister of the Persian kingdom, convinced King Ahasuerus to issue an edict ordering the extermination of all the Jews of the kingdom on a certain date. Mordecai beseeched Esther to go to the king and reveal to him that she was a member of the people sentenced to die, something she had always kept secret. Even though the law banned anyone from appearing before the monarch without his express invitation, Esther entered Ahasuerus's quarters. When he looked at her, eyes blazing with anger, she fainted and fell to the floor. Then the king turned his scepter toward the woman, indicating that he was sparing her life. He asked her the reason for her intrusion. Esther revealed to him that she was a Jew and begged him to repel the edict. Moved by his wife's courage, the king granted her wish, at the same time sentencing Haman to death. But because the law did not permit the revocation of an edict, he issued another one that authorized the Jews to defend themselves. Thus, on the day drawn by lot for the massacre, it was the Jews who crushed their enemies. In memory of the event, the feast of Purim was instituted, from *pur*, which means "lot" in Hebrew and refers to the manner in which the date of the massacre had been chosen. The feast has, over time, become a day of merrymaking.

(Esth 3–9)

Filippo Abbiati
*Esther Appeals to Ahasuerus*
1700–10
Civiche Raccolte d'Arte del Castello Sforzesco, Milan

# Maccabees I

Both Maccabee books are deuterocanonical and chronicle the Jewish struggle when the kingdom of Judah was ruled by the Diadochi, the successors of Alexander the Great. The first book is an account of the growing rebellion against the foreign rulers, in particular after 167 BC, when Antiochus Epiphanes, the monarch of the Seleucid empire in Palestine and Mesopotamia, desecrated the Temple of Jerusalem by introducing a Hellenistic cult. Judas Maccabeus and his family (also known as the Hasmoneans, from their ancestor Hasmon) led the resistance against the Seleucid regime (a dynasty descended from Seleucus, who ruled Mesopotamia); in 165 BC, the rebels drove the Greeks from the Temple. But the war dragged on, and among its victims were Judas and his brothers, who had succeeded him in leading the people of God toward freedom. In 143 BC the Maccabees finally expelled the foreigners and restored independence to the kingdom of Judah, which was ruled by the Hasmonean dynasty until 63 BC. Artists have generally highlighted the faith of the Jewish people and the exceptional qualities of their leaders. This painting depicts the sacrifice of the Maccabee brothers, who gave their lives to defend their religion.

Antonio Ciseri
*Saint Felicity and the Maccabean Martyrs*
1853–63
Santa Felicita, Florence

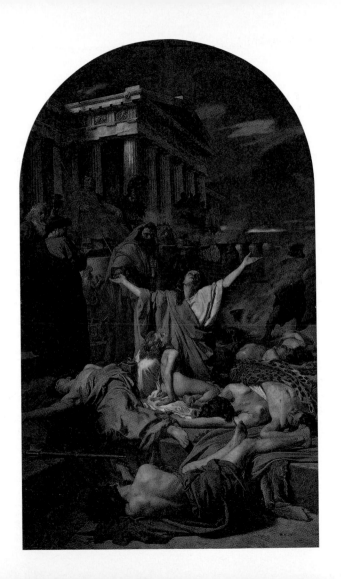

# *Maccabees II*

Maccabees II recounts some events that precede the narrative of the first book, between 176 and 160 BC. It opens with two letters written by the Jews of Jerusalem to the Jews of Egypt. The best-known episode of this book is the punishment of Heliodorus. When the High Priest Onias led the Temple of Jerusalem, it received splendid donations. Having learned of the Temple's treasure, the Seleucid king asked Heliodorus, his treasurer, to confiscate it. At the Temple, Heliodorus began to make an inventory of the riches it contained, whereupon Onias and the faithful, dismayed, began to pray to the Lord to defend His shrine. God listened and sent a fearsome rider dressed in a golden armor. Two exceedingly strong young assistants flanked the rider and began to strike the treasurer. At that point the Judaeans, moved to pity, asked Yahweh to save Heliodorus, that he might go back to his king and recount the prodigy he had witnessed.

(2 Macc 3)

Tuscan School
*Heliodorus Is Driven from
the Temple*
14th century
Private collection

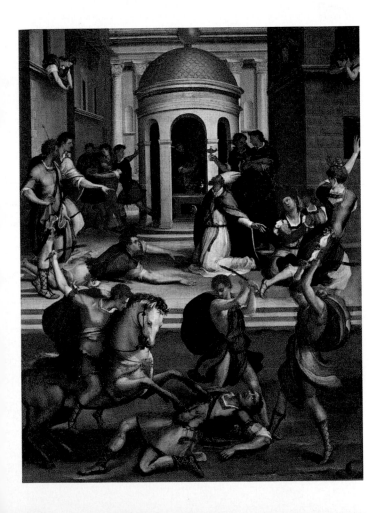

# The Wisdom Books

Job
Psalms
Proverbs
Ecclesiastes (Qoheleth)
The Song of Solomon
Wisdom
Sirach (Ben Sira)

These books treat of
the importance of both
divine and human wisdom.
They are also known as the
poetic books, because their
style is unlike that of the
other sacred texts.

# Job

The book of Job was inspired by an ancient folk tale and, like the other wisdom texts, grapples with the unfathomable mystery of the suffering of the innocent in the world. It is the second biblical book, after the Chronicles, in which the word "Satan" appears. (1 Ch 21:1; Jb 1:6) God granted to Satan permission to test the virtue of Job, an upright, honest man; the Devil decided to inflict upon him a number of terrible, undeserved misfortunes, including the death of his own children. Still, even when faced with dire injustice, Job never sinned, though he protested. He could not understand why such misfortunes had befallen him and was comforted by his friends.

(Jb 1–37)

Eugène Delacroix
*Job Tormented by the Demons*
c. 1820–25
Musée Bonnat, Bayonne

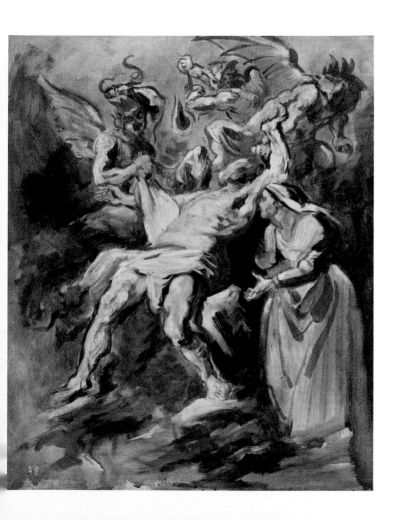

# God Proclaims Job's Innocence

Still, his friends' support could not comfort him and Job continued to voice his desire to speak with the Lord. Finally, Yahweh answered and accused him of pride for wanting to know the reasons for God's actions. He invited him to contemplate the grand design that rules Creation, to make him understand that he could never comprehend divine wisdom. Job then reprimanded himself: "Therefore I have uttered what I did not understand, Things too wonderful for me, which I did not know." (Jb 42:3) He understood that studying God's Law was not enough, one also had to meditate on the wonders of Creation so as to gain more wisdom. In the end, God granted Job His grace, blessed him, and put an end to his misfortunes.

(Jb 38–42)

*Job Consoled by His Friends*
1210
Notre-Dame, Paris

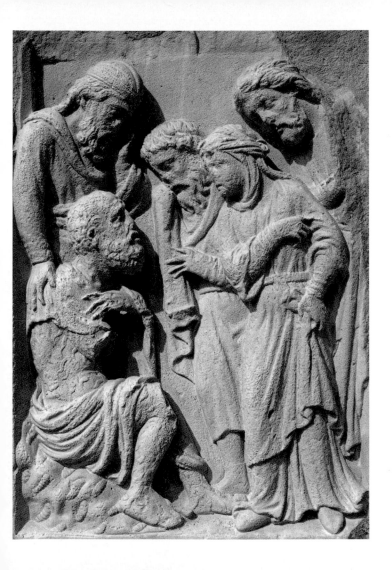

# Psalms

The Psalms are a collection of poems traditionally attributed to King David. In Hebrew they are called *tehillim*, meaning "lauds," and in Greek *psalmoi*, or "hymns." In fact, they are songs intended to be sung accompanied by music, and were often collected in separate books called psalters, where the verses were complemented by harmonic compositions from different musicians. Usually, Medieval psalters were enriched with splendid miniature illuminations that depict the subject matter of each laud. The Psalms were composed in different historical periods and tell the deeds of the people of Israel. Some of them are hymns of joy exalting the glory of the Lord, while others recount tragic events or are entreaties to God. They come in various lengths and styles. Psalms is the most frequently quoted Old Testament book. In his preaching, Jesus breathed new life into these prayers written by his ancestors.

Sano di Pietro
*Cleric Ringing the Bell*
miniature from a psalter
15th century
Museo dell'Opera del Duomo, Siena

Lleluia. Euoé.

Exultate. Euoé.

xultate deo
adiutori
nro: iubi
late deo ia
cob. Su
mite psal
mū ⁊ date
tumpanū: psalterium
iocunda cū cithara.
Bucinate i̇ neomenia tu
ba: i̇ insigni die sollenni
tatis vestre.

# Proverbs

Just as the Psalms are traditionally attributed to King David, the books of Proverbs, Ecclesiastes, and the Song of Songs have been associated with Solomon, the wise king. In the Hebrew Bible these texts were collected together in the *Kethuvim*, miscellaneous documents written after the Babylonian exile by a different school than the one from which the books of the Law and the Prophets are derived. The Proverbs are a collection of aphorisms handed down from century to century. They are short, deeply religious compositions that stress the unique traits of divine and human wisdom, a sort of manual of maxims and sayings. The central character is Wisdom herself, rendered as an actual historical figure. Generally, this allegorical figure has been depicted in art as sitting on a throne or in Heaven, endowed with powerful wings. Sometimes Wisdom carries in her left hand the Book of Knowledge and in her right the scales of justice (or the Cross), both symbols of divine wisdom.

Ambrogio Lorenzetti
*Justice*
detail from *Allegory of Good Government*
*c.* 1338–40
Palazzo Pubblico,
Sala della Pace, Siena

# *Ecclesiastes (Qoheleth)*

The protagonist of Ecclesiastes is a philosopher by the name of Qoheleth, who tries to convince the reader that all the things of this world are "vanity," thus casting serious doubts on the entire Torah tradition. Qoheleth meditates on how, in searching for the Lord, man ends by experiencing a deep sense of frustration because he cannot comprehend or make sense of God's actions. In essence, Qoheleth expressed the bitter disappointment of the people of Israel, who still could not achieve the longed-for era of peace in the Promised Land even after enduring so many trials. Still, although the author could not fathom God's design, his faith never wavered.

*Ecclesiastes*
miniature from the *Bible de Souvigny*
12th century
Bibliothèque Municipale, Moulins

iñe loquendi oms pariter audiam̃. Dm̃ time et
mandata illi obserua. hoc ẽ enī oīs homo. ⁊ cuncta
ta que fiunt ad ducer dś in iudiciū.p oīni erratu siue
bonū siue malū sit.

# EXPLICIT ; LIBER ; ECCLESIASTES ;

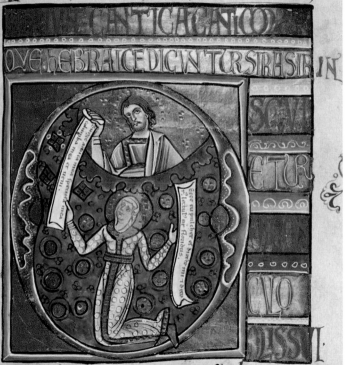

quia meliora sunt ubera tua uino. fragrantia un
guentis optimis. Oleū effusū nom̃ tuū. ideo adoles

# The Song of Solomon

The Song of Solomon is a love poem included in the *Kethuvim* because of its stylistic similarities with the book of Sirach. It celebrates the love that God has for His people, described as a union between a lover and his beloved. The Song of Solomon is a genuine literary work with strophes and refrains that carry recurring themes. The very first verse attributes authorship of the poem to King Solomon, though it was probably written just a few years after the Jews returned from the Babylonian exile. The author, in all likelihood, reprised ancestral verses, perhaps indeed from the time of Solomon. The subject is human love, a metaphor for expressing divine love. The image of a wedding with the Lord also recurs in prophets such as Hosea, Jeremiah, and Ezekiel. The verse "His left hand is under my head, and his right hand doth embrace me" (Song 2:6) has been seen as a prefiguration of the Church's bridal relationship with Christ, for in the New Testament Jesus is often called the "bridegroom."

Taddeo Crivelli and Franco de' Russi
*The Song of Songs*
miniature from the *Bible of Borso d'Este*
1455–61
Biblioteca Estense, Modena

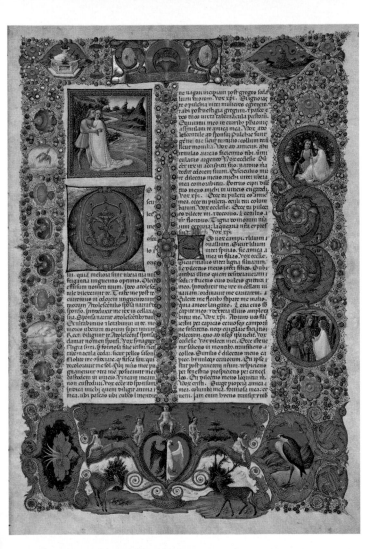

# *In Praise of the Bride's Beauty*

In the Song of Solomon the bride is the metaphorical image
of the Church. The poem seems to have been inspired by
a secular source that speaks of a youthful love filled with
almost erotic feelings of tenderness and intimacy. In reality,
it expresses the tension between the unity and totality that
is proper to God's love. For this reason, with the advent of
Christianity the bride of the Song took on characteristics of
the Madonna. In fact, Mary is a representation of the Church,
and many adjectives or attributes that describe the bride's
beauty have over time become associated with her. In par-
ticular, the verse "A garden enclosed is my sister, my spouse;
a spring shut up, a fountain sealed" (Song 4:12) has given rise
to a unique iconography as a metaphor of Mary's virginity.
In this painting, in fact, the Mother of God is sitting in an
enclosed "garden."

Stefano da Verona (attr.)
*The Virgin and Child with Angels in
a Garden with a Rose Hedge*
*c.* 1430
Worcester Art Museum, Worcester

# In Praise of the Bridegroom's Beauty

In the Song of Solomon, the relationship between the bride and the groom experiences a break, a moment of absence, of silence, and the dialogue must be rebuilt. But even the trying times of the spirit can be overcome by approaching the Lord anew. The Song tells of a love story where there is a search for the beloved, but also painful distance, bitter absence. Finally the woman finds her groom again, which in the Christian tradition has been identified with Jesus. The Song of Solomon also praises an ideal male beauty that in the Middle Ages would help build an image of Christ as a captivating young man: "My beloved is white and ruddy, the chiefest among ten thousand. His head is as the most fine gold, his locks are bushy, and black as a raven. His eyes are as the eyes of doves by the rivers of waters." (Song 5:10–12) The Fathers of the Church would be the first to strip away any carnal meaning from the Song and make comparisons between the Old and New Testaments, while modern artists have sometimes reemphasized the human aspect of the poem.

Domenico Morelli
*The Song of Songs*
1890
Galleria Nazionale d'Arte Moderna,
Rome

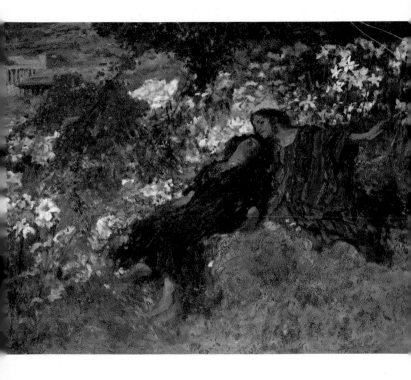

# *Wisdom*

In the ancient Near East, the wise men at court, often teachers or advisors, tended to consider reality an emanation of a divinely originated principle. The Hebrew sages called this *Hokhman*, or "Wisdom." This Old Testament book, written by a Jew of Alexandria around the first century BC, probably drew from very ancient traditions that originated in the East. He wrote for the Hebrews of Egypt, warning them not to fall into idolatry, and reminded them of the past errors of their ancestors, counseling them to always obey the Law and practice religion. Retracing the vicissitudes of the people of Israel, he stressed how human wisdom played a central role in the flight from Egypt. In the final part the just man is contrasted with the evildoer and the folly of idolatry with the wisdom of trusting in God. In this painting by Andrea Sacchi, Divine Wisdom sits on a throne and instructs Love and Fear. She is surrounded by the allegories of her attributes: Trinity holding a triangle in her hand; Eternity with the serpent; Purity with the swan; Understanding with the eagle; Beauty with Berenice's tresses; Sweetness with the lyre; Strength with the club; Charity with the ear of grain; Justice with the scales; and Nobility with the crown.

Andrea Sacchi
*Allegory of Divine Wisdom*
1630
Palazzo Barberini, Rome

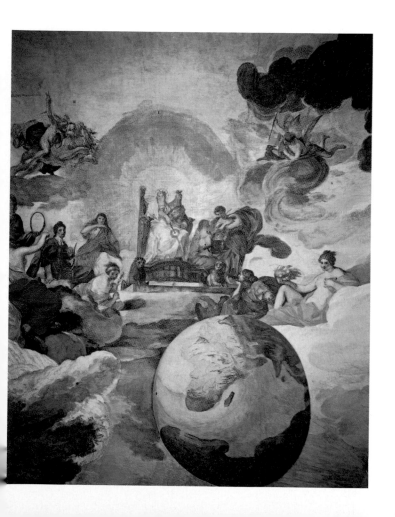

# Sirach (Ben Sira)

This book, also called Ecclesiasticus, perhaps because it has the tone of a manual, is known as Sirach, from the name of the author, Ben Sira, identified at the end of the book. The author's grandson, who probably lived in the second century BC, translated the original Hebrew text into Greek and added a prologue explaining that his grandfather had studied the Scriptures and decided to write this "manual" to help those wishing to acquire knowledge. The book contains no new information; it offers adages that are meant to give practical advice for leading a moral life, followed by a paean to Divine Wisdom and a canticle to God's mercy. Since this is a sort of instruction book about laws, rules, and regulations, visualizing it is not easy; it is, however, an aid for a more in-depth understanding of the events already recorded in the earlier Old Testament books.

*Sirach*
miniature from the Gutenberg Bible
*c.* 1455
Staatsbibliothek, Berlin

# The Prophetic Books

Isaiah
Jeremiah
Lamentations and Baruch
Ezekiel
Daniel
Hosea
Joel
Amos
Jonah
Micah
The Minor Prophets

These books are known as the "prophetic" books, from the Greek term *prophetes*, which means "to speak before," signifying the foretelling of future events. For this reason, they have been placed at the end of the Old Testament and lead into the Gospels.

# *Isaiah*

Although composed in a later period than the other prophetic writings, Isaiah has been placed first in the Old Testament section precisely because of the import of his revelations. Around 740 BC, Isaiah had a vision of Yahweh surrounded by the divine assembly: The Lord predicted that the countryside would be ravaged by the Assyrians and His people would be exiled. Thanks to the apparition, the prophet was confident, nor did he fear the enemy, for as long as Yahweh remained on His throne in the Temple of Jerusalem, the kingdom of Judah would be safe. Isaiah is usually depicted with a scroll to symbolize God's call to him. In art, the parchment roll or scroll sometimes replaces the book as the attribute of an author or a prophet.

Raffaello Sanzio,
known as Raphael
*The Prophet Isaiah*
1511–12
Sant'Agostino, Rome

# *"A Messiah Will Come"*

Among the most important of Isaiah's prophecies are the promises that God made to him to comfort His people during the dark years of the Assyrians' occupation of the northern territories. For Yahweh revealed to him the future birth of a royal heir of the Israelites: "Behold, a virgin shall conceive, and bear a son, and shall call his name Immanuel [God is with us]." (Is 7:14) Actually, the child that Isaiah referred to was Hezekiah, who would disappoint as a king, for although in 701 BC he was to lead an insurrection against the Assyrians, the outcome was the Assyrian destruction of Jerusalem and the countryside. With the New Testament, the prophecy took on another meaning: the coming of Jesus in Mary's womb. In reality, the term *almah* in Hebrew means "young girl" but has been translated as a word that in Greek could also mean "virgin," thus giving rise to the concept of Mary's chastity.

(Is 7:10–17)

Piero di Cosimo
*Incarnation of Christ*
*c.* 1505
Galleria degli Uffizi, Florence

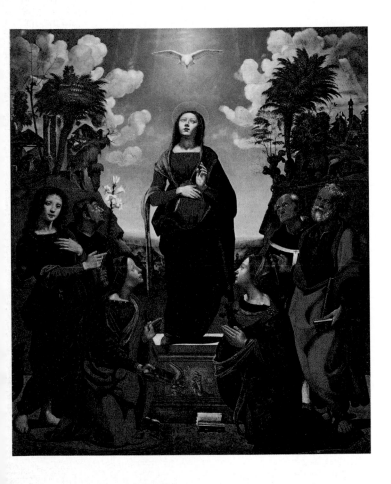

# *Jeremiah*

The prophet Jeremiah lived at the time of the Deuteronomic revolution, during the reign of Josiah. The Lord called upon him to announce the destruction of Jerusalem and of the kingdom of Judah. Jeremiah's prophecies frequently contain a strong critique of Judah's rulers, for which he was thrown in jail several times. When the tragedy he had foretold started to unfold, Jeremiah began to predict a future of hope and liberation. The prophet is a prefiguration of Jesus insofar as his life was one of challenges, persecution, and passion, forced as he was by the Lord to carry out a thankless mission that was, however, necessary for the salvation of his own people. In this masterful painting, Rembrandt has captured the depths of the prophet's spirituality as he despairs over the harsh future that awaits the Holy City: "When I would comfort myself against sorrow, my heart is faint in me." (Jer 8:18)

Rembrandt van Rijn
*Jeremiah Lamenting the Destruction of Jerusalem*
1630
Rijksmuseum, Amsterdam

# Lamentations and Baruch

The Lamentations consist of five elegies written to mourn the destruction of Jerusalem. Although composed by different authors, they were attributed to the prophet Jeremiah. The elegies express desolation and despair, but also hope and faith in a brighter future when Yahweh would forgive His people and cease His wrath. What is stressed in these poetic compositions is that the city was destroyed because of sin—because of the many offenses that the people, their priests in particular, had committed against the Lord. God's punishment is accepted as just and proper, and a means to reawaken the conscience of the people. Thus in this book human suffering, evil, and misfortune are divine tools meant to punish man and lead him back to the straight and narrow path of virtue. The Lamentations are followed by the book of Baruch, Jeremiah's secretary, who was sent by the prophet to Babylon. It consists of prayers, professions of faith, and a paean to wisdom and hope, all infused with profound doctrinal significance.

Donato di Niccolò di Betto Bardi,
known as Donatello
*Jeremiah*
1423–26
Museo dell'Opera del Duomo,
Florence

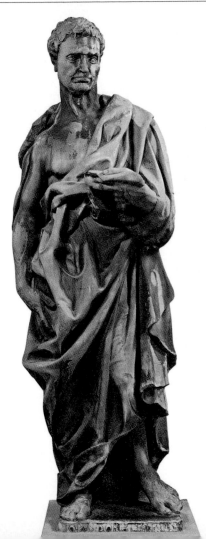

# Ezekiel

Ezekiel records the fall of Jerusalem from a different perspective than in Jeremiah. The prophet Ezekiel was exiled to Babylon when he began to experience visions. Before the fall of the Holy City, his prophecies warned the sinful, idolatrous Jews. After the devastation, he gave comfort to the exiles. His visions are always somewhat confused. In one well-known prophecy, Ezekiel saw himself carried by God in a valley covered with bones; he predicted a new life for them, because the divine spirit would be breathed into them. The bones then began to come together, gradually being covered with sinews, flesh, and skin until a spirit carried by four winds brought them back to life. This vision has been seen as a foreshadowing of the Resurrection of Christ, and of humankind after the Last Judgment.

(Ezek 37:1–14)

*Ezekiel*
1250
Saint-Etienne, Bourges

# The Vision of the Heavenly Chariot

In an important vision Ezekiel saw God arrive on a chariot and dwell with the Babylonian exiles after the destruction of Jerusalem. The Lord was surrounded by four beings, all of whom "had the face of a man, and the face of a lion, on the right side: and they four had the face of an ox on the left side; they four also had the face of an eagle." (Ezek 1:10) The Fathers of the Church interpreted the four animal faces as symbols of the four Evangelists. The vision continued with the prophet receiving a roll on which was written "lamentations, and mourning, and woe," and God's command that he eat the scroll. (Ezek 2:10–3:1) As soon as Ezekiel swallowed it, accepting the full suffering of the exiles, he found that in reality it was "as honey for sweetness." (Ezek 3:2–3) The exiled Jews relied on this prophecy to discard the idea of a new Temple and trust even more in the Scriptures (symbolized by the swallowed roll) and their interpretation, thus truly transforming their faith into "the religion of the Book."

(Ezek 1–3)

Raffaello Sanzio,
known as Raphael
*The Vision of Ezekiel*
1518
Galleria Palatina, Florence

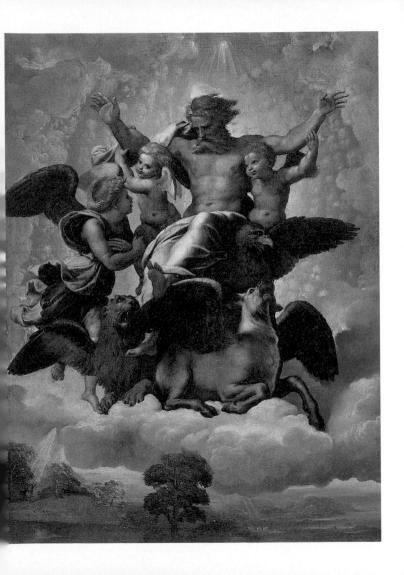

# Daniel

Daniel was written in Palestine in the second century BC, during the Maccabee rebellion. It records events from the time of the Babylonian exile. The book was composed in several phases. The first chapters were probably written before Antiochus desecrated the Temple of Jerusalem by introducing the worship of Hellenistic divinities. In this part of the book Daniel appears as a sage at Middle Eastern courts, a man endowed with the special gift of dream interpretation. The later chapters were probably written after the Temple was desecrated, but before the Maccabees' final victory; in this section the prophet is described as an exegete who is able to receive prophetic visions through his study of the Scriptures.

*Daniel*
13th century
Sainte-Marie-Madeleine, Vézelay

# Nebuchadnezzar's Dream

Daniel was deported to Babylon in 605 BC and became a page of Nebuchadnezzar. In the second year of his reign, the king had a dream. His court of wise men and astrologers could not decode its meaning and were all sentenced to death. Daniel asked God to reveal the dream and its meaning to him, and God granted his wish. Then Daniel went to the king and told him that he knew about the dream: the monarch had dreamed of a very large statue with a golden head, silver chest and arms, a bronze belly, iron legs, and partially clay feet. A stone struck the statue's feet, and the statue crumbled to pieces, while the stone became a mountain that filled the whole earth. Daniel revealed that the statue stood for his kingdom (the golden head); after him another kingdom would arise, inferior to his (the silver chest); then a kingdom that would rule over the entire earth (the bronze body). The last kingdom would be divided; one part would be strong as iron, but the other part brittle as clay. At that point, God would cause an invincible kingdom to arise—the stone that had struck the statue. After giving this explanation, Daniel earned the trust of the king, who made him his counselor.
(Dn 2)

Matthäus Merian
*The Dream of Nebuchadnezzar*
from the *Bible of Sieur du Royaumont*
1670
Private collection

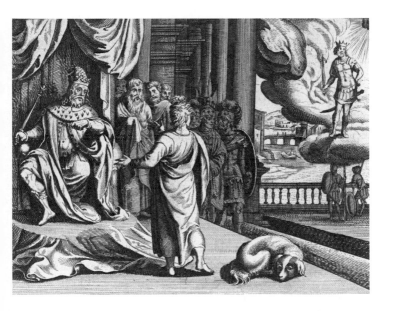

# The Lions' Den

Darius the Median was a king of Babylon. One day he
decided to divide the kingdom into three provinces and
entrust the government of one of them to Daniel, who in
time showed himself to excel over the other governors.
But the other two became envious and persuaded the king
to issue an edict that anyone who was seen praying to a god
or a man other than the king himself be thrown into the
lions' den. Daniel, who was in the habit of praying three times
a day, continued his custom, and for this was immediately
reported to the king, who regretfully had to obey his own law.
He hoped, however, that the prophet's God would save him.
Darius abstained and fasted for one day; on the following day,
he went to the lions' den to check if Daniel was still alive.
He was, and even reassured the king that an angel of the Lord
had shut the lions' jaws. Then the king freed Daniel and in his
place had the two governors who had slandered the prophet
thrown to the lions, who immediately devoured them. This
episode has been the subject of many works of art and some
artists, such as Rubens, even used real lions as models.

(Dn 6)

Pieter Paul Rubens
*Daniel in the Lions' Den*
c. 1615
The National Gallery of Art,
Washington

# Daniel's Visions

In his lifetime Daniel had a number of unsettling visions.
In one such experience he saw four powerful empires follow
upon each other, visualized as imaginary beasts, each one more
frightening than the other. One night, he saw a monster come
out of the sea: It had the body of a lion and eagle's wings; then
the wings came off and it stood upright like a man. The second
beast resembled a bear and held three ribs in its throat and
jaws. The third monster was a panther with four birdlike wings
and heads. The fourth one was truly terrifying: It had iron teeth
and ten horns, three of which came off and were replaced by
a new horn. This last monster was a symbol of the Seleucid
domination. Thus Daniel foresaw the worship of the Hellen-
istic deities in the Temple of Jerusalem, decreed by Antiochus.
But the prophet also saw that "one like the Son of man came
with the clouds of heaven" (Dn 7:13), a figure that refers to
the Maccabees but is also the prefiguration of Christ whose
"kingdom . . . shall not be destroyed." (Dn 7:14) This etching
by Gustave Doré perfectly renders the terrifying, visionary
atmosphere of the prophecy.

(Dn 7)

Gustave Doré
*The Vision of the Four Beasts*
1865
Private collection

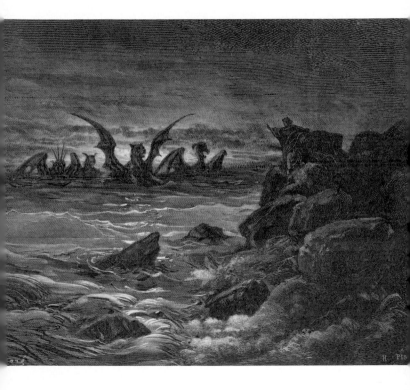

# Susannah and the Elders

Daniel closes with a historical appendix that records anecdotes from the prophet's youth. The most famous of them (quite popular with artists because of the juxtaposition of beauty and youth with ugliness and old age) is the episode of Susannah and the elders. Susannah, a God-fearing young woman, was married to a wealthy man who often received in his garden judges and people who were embroiled in lawsuits. Two old men who were among the guests became attracted to young Susannah and tried to catch her unawares. One afternoon, the woman decided to bathe and asked two maids to shut the garden and leave. When she was alone, she was accosted by the old men, who had been hiding nearby. They tried to force her to lie with them and when she refused they claimed to have come upon her as she lay with a young man, and thus succeeded in having her sentenced to death. Susannah prayed to God to reveal the truth, and her prayer was answered when the young Daniel questioned the old men separately and so unmasked their deceit, saving Susannah's life.

(Dn 13)

Lorenzo Lotto
*Susannah and the Elders*
1517
Galleria degli Uffizi, Florence

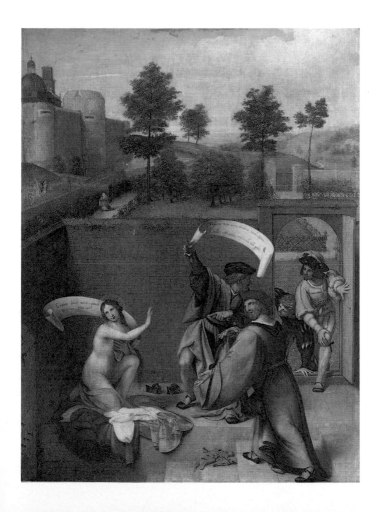

# Hosea

In the early eighth century BC Hosea, a prophet from the northern kingdom, struggled to make the Israelites worship only Yahweh. For while the people recognized the power of the Lord in war, they did not believe he was as successful in agricultural matters and so, to ensure a rich harvest, they preferred to practice the sexual fertility rite of Baal and his sister-bride, Anat, the local deities. Hosea compared the suffering that he had felt at the unfaithfulness of his wife, Gomer, who had served Baal as a sacred whore, to what Yahweh must feel at the idolatry of His people. Hence he tried to persuade his people that the Lord could satisfy all their needs. All the Lord required in turn was loyalty. But should the people persevere in their idolatry, the kingdom of Israel would be destroyed by the powerful Assyrian empire. The early Christian communities have associated the marital relationship between Yahweh and His people that Hosea describes to that of Jesus and the Church.

Duccio di Buoninsegna
*Hosea*
detail from the *Maestà*
1308–11
Museo dell'Opera del Duomo, Siena

EX EGI
PTO UC
CAUI
FILIU
MEU

# *Joel*

Joel records a natural disaster that devastated the kingdom of Judah: the locust plague, a catastrophe similar to what had struck Egypt before the Exodus. For this reason, a metaphorical meaning has often been assigned to this tale, as a symbol of the invasion of the Holy Land by pagan nations. But Joel also predicted the salvation of those who were filled with the Spirit of the Lord. For this reason Peter, in the Acts of the Apostles, cites this prophecy when he speaks of the descent of the Holy Spirit on Pentecost Day. (Joel 3:1–5; Acts 2:16–21) In art, Joel has been depicted with the locusts in the center of a parched landscape, alluding to the drought that followed the invasion. This work by Frederic James Shields, a model for a stained-glass window, is part of a portrait series of Old Testament prophets. The words above the portrait refer to a verse from *Te Deum Laudamus* ("We Praise Thee, O Lord"), the hymn usually sung on New Year's Eve, December 31: "Keep the words of the prophets in mind."

Frederic James Shields
*Joel*
c. 1910
Wolverhampton Art Gallery,
Wolverhampton

NVMERVS

JOEL

# *Amos*

Around the middle of the eighth century BC, the prophet
Amos revealed that the continued Assyrian assaults on the
lands of the kingdom of Israel were a punishment inflicted by
the Lord, as Hosea had predicted, because His people con-
tinued to be unfaithful. But unlike Hosea, Amos believed that
Yahweh had unleashed His wrath because the Israelites con-
tinued to offer ritual devotions to Him, rather than formal
worship, and He wanted justice in His kingdom. In repre-
senting prophets, artists have often associated the portrait
with their message. Many series simply portray them with a
scroll bearing some of their words, an attribute or two to
help identify them, or, in some cases, just their name. In the
stained-glass windows of the Auch Cathedral in France, Amos
is portrayed next to the sibyl Europa and the patriarch Joshua;
all the figures are dressed in sixteenth-century garb and are
recognizable only by the names that appear below.

*Amos* (detail)
1510
Auch, Sainte-Marie

# Jonah

The Lord had commanded the prophet Jonah to go to Nineveh, but wanting to dodge the mission, Jonah escaped on a ship. Yahweh sent a storm and Jonah, who had immediately understood the cause of the storm, confessed to his fellow travelers and asked to be cast into the sea so that they might be saved. They did so, and Jonah was swallowed by an enormous fish—perhaps a whale—and stayed inside it for three days and three nights until the monster vomited him up on a beach. Then the prophet believed and went on to Nineveh to preach the destruction of that city. The townspeople believed him, and repented, and received God's forgiveness. But instead of rejoicing, Jonah was upset because he feared that people might think he was a false prophet. So while he was resting, Yahweh put him again to the test and caused a castor oil plant to grow and give shade to the prophet. The following day the Lord caused the plant to shrivel up and die, and Jonah complained. The Lord pointed out that if all that was needed to upset him was a shriveled plant that he neither grew nor tended to, then clearly God could not avoid feeling compassion for the city of Nineveh. The story of Jonah is a frequent subject in art due to its facile narrative.

*The Story of Jonah*
miniature from a Bible
910
Bibliothèque Nationale, Paris

# *Micah*

Micah decries the injustices inflicted on the people by the political elite of the kingdom of Judah. It writes about a number of prophecies that foretell a united future for the Hebrew people, ending with a dialogue between God and Israel on the latter's unfaithfulness. This book is important because of the prophecy about the birth of the Messiah: "But thou, Bethlehem Ephratah, though thou be little among the thousands of Judah, yet out of thee shall he come forth unto me that is to be ruler in Israel. . . . And he shall stand and feed in the strength of the Lord, in the majesty of the name of the Lord his God." (Mic 5:2–4) This announcement would be reprised by Matthew in recounting the meeting between the Magi and Herod: "And when he had gathered all the chief priests and scribes of the people together, he [Herod] demanded of them where Christ should be born. And they said unto him, In Bethlehem of Judaea: for thus it is written by the prophet." (Mt 2:4–5) For this reason, the figure of Micah is often included in scenes depicting the coming of Christ, as in the panels of Jan van Eyck's *Ghent Altarpiece*, in which we see the prophet standing above the Virgin Annunciate.

Jan van Eyck
*Prophet Micheas*
from the *Ghent Altarpiece*
1432
Cathedral of Saint Bavo, Ghent

# The Minor Prophets

The minor prophets are Hosea, Joel, Amos, Obadiah, Jonah, Micah, Nahum, Habakkuk, Zephaniah, Haggai, Zechariah, and Malachi. They are called "minor" not because they are not important—some are treated separately precisely because their message and their revelations bear a special connection to the New Testament—but because their writings are very short. Their recurrent theme is a censure of the lavish life that the rulers of Israel and Judah led at the expense of the poor, conduct that would be chastised by God. Yet they predicted not just calamities, but also hope and the coming of a harmonious, peaceful future reign. This fundamental message shared by the prophets justifies their group treatment in art, where sometimes the painting or the sculpture has no details that might identify them.

*Prophets*
1275
Strasbourg, Notre-Dame

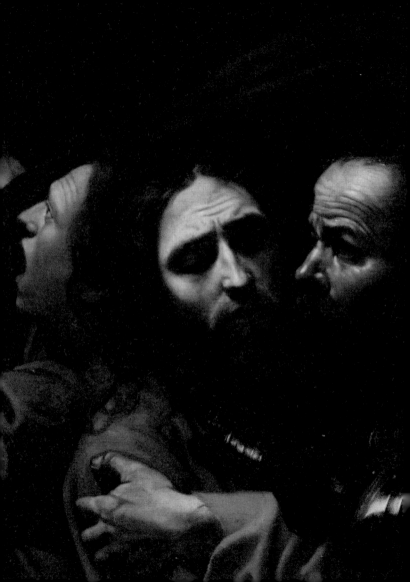

# The New Testament

The Gospels - The Acts of the Apostles
The Letters of the Apostles - Revelation

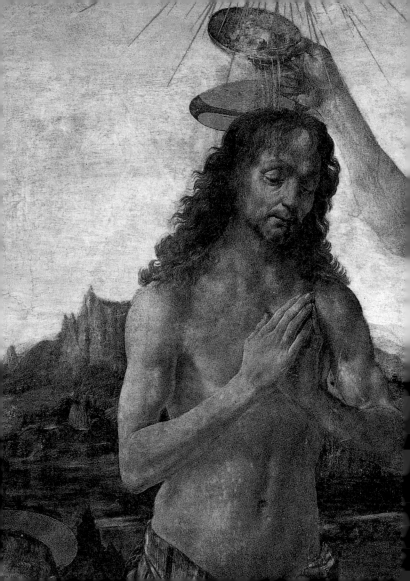

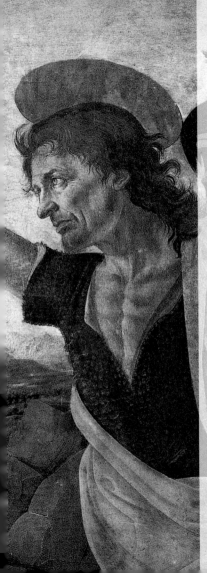

# The Gospels

Matthew
Mark
Luke
John

The Gospels recount the life
and the words of Jesus with
the intention of testifying to
the readers the mystery of
his divine nature and lead
them to accept the faith.

# Matthew

The first of the books to narrate the life and the message of Jesus, the Gospel of Saint Matthew opens the New Testament. Written in about AD 85–90, this Gospel is intended to comfort and encourage early Christian communities that suffered persecution at the hands of the Romans. The author to which this work is attributed was one of the twelve Apostles. A live witness to the events recorded in this book, Matthew must have later supplemented his recollections with passages and episodes from Saint Mark's text, which is the earliest of the four Gospels. Since Matthew was a Jew who had converted, there is general agreement that his intended audience were Jews who, like him, had converted to Christianity. A symbol has been traditionally attributed to each Evangelist, based on a vision from Revelation (Rev 4:7), which was itself inspired by the prophet Ezekiel (Ezek 1:5–12). Matthew is represented by a man or an angel because, more than the other three Evangelists, he insisted on the humanity of Jesus. In fact, he begins his narrative with the genealogy of Christ and his incarnation. Like many other artists, Caravaggio treated the symbol as inspiration: The intense exchange of looks between the Evangelist and the angel in this painting suggests that Matthew was writing under his direct dictation. The simple bench at which Matthew sits evokes his job as a tax collector.

Michelangelo Merisi da Caravaggio
*The Inspiration of Saint Matthew*
1602
Cappella Contarelli, San Luigi dei Francesi, Rome

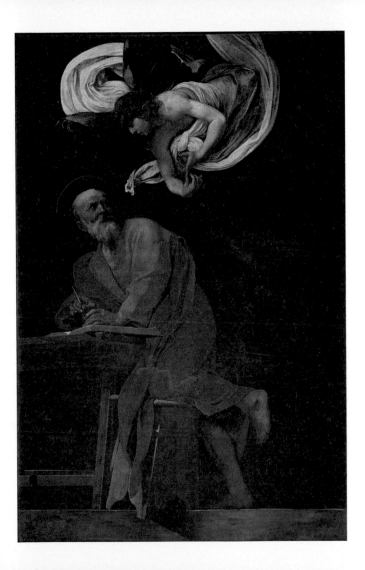

# *Mark*

The oldest and shortest of the four Gospels, Saint Mark's account is reputed to be the primary source for Matthew's and Luke's writings. The three are known as the "Synoptic" Gospels. Born in Jerusalem, in all likelihood Mark followed Peter to Rome and assisted him as his secretary. Although incontrovertible proof is lacking, the theory is sound if we consider the readers for whom the Evangelist most likely wrote—converted pagans. Some scholars believe that this Gospel was handed down to us in an incomplete form, for there is no mention in it of Christ's childhood. The atmosphere of lingering apprehension that pervades the final part of the book and its abrupt ending perhaps suggest the challenges faced by the infant Church that had just been devastated by Israel's war against Rome and had witnessed the Temple of Jerusalem destroyed (Mark was writing around AD 70, immediately after these events). The Evangelist is always represented with a lion at his side, presumably an allusion to the Resurrection of Jesus, the event that fills the central part of this Gospel. According to a legend, newborn lion cubs appear to be dead the first three days, then are brought back to consciousness by their father's breath.

Filippino Lippi (from a design of)
*Saint Mark*
late 15th century
San Martino, Lucca

# *Luke*

Saint Luke is considered the author of the third Gospel and of the Acts of the Apostles. Born in Antioch, he was a physician, and probably a painter as well. He knew Saint Paul and became his disciple. A widely read man (his Gospel is written in excellent Greek), Luke could presumably have known Mary, and it is said that he painted her first portrait (the only one painted from life). This would explain the profusion of details about Jesus' childhood years. Like the Acts, Saint Luke's Gospel is dedicated to a man named Theophilus and begins with a statement of purpose: Luke wrote it to set order among the many legends and witness accounts that circulated at the time about the figure of Christ. This Gospel contains many references to Mark's Gospel and has many sections in common with that of Matthew; it was written at about the same time as the latter. Luke draws an original image of Christ, whose life is recounted in concrete terms, leading scholars to believe that it was written for Christians who had converted from paganism. In the final chapters, the Evangelist focuses on the Passion and Resurrection of Christ, and perhaps because of this his symbol is a bull, the sacrificial animal of the burnt offering. In art, Luke has been represented holding a brush in his hands, an allusion to his activity and skill as a painter.

Bongiovanni Giovenale
*Saint Luke* (detail)
18th century
San Donato, Mondovì

# *John*

The fourth Gospel stands apart from the three Synoptic Gospels for the deep mysticism that pervades it; it has, in fact, been called the "spiritual Gospel." It is more interested in conveying Jesus's message than his actions. For this reason, the anecdotal, descriptive language of the other Gospels is missing. The author has traditionally been identified as John, the apostle whom Jesus loved, whom he called while he was fishing with his father, Zebedee, and his brother James the Elder, who also became an apostle. John was probably educated in a Hebrew environment that proclaimed the preexistence of divine knowledge, for in the prologue he refers to Christ as the Word—*logos*—of God incarnate. The Evangelist begins his narrative with the events of Jesus' public life. The intended readers of this work were probably the members of the Christian community of Ephesus, an important coastal city in Asia Minor. This Gospel is undoubtedly the one written last, probably as the first century AD was drawing to a close. Because his work soars spiritually, John is always represented with an eagle alighting on the sacred book.

Giovanni di Stefano
*Saint John*
15th century
Duomo, Siena

# The Tree of Jesse

"And there shall come forth a rod out of the stem of Jesse."
(Is 11:1) Starting from this prophecy of Isaiah, a tradition
developed that has Jesus descend from the genealogical tree
of Jesse, King David's father. Matthew and Luke account for
the lineage with one difference: While the former starts from
Abraham, the patriarch with whom the story of salvation
began, Luke goes back to Adam, thus underscoring the
redemptive nature of Christ for the entire human race.
Matthew goes back 42 generations, divided into three groups
of 14 generations each: from Abraham to David, from David
to Josiah and from Jeremiah to Joseph. Beginning with Adam,
Luke counts 76 generations. These genealogies have been
represented as a tree rising from the chest of the sleeping Jesse,
on whose branches are Jesus' ancestors. Jesus himself is in
Mary's arms at the top of the composition. The patristic
tradition added her to the genealogical tree because Joseph
was not Christ's biological father.

(Mt 1:1–17; Lk 3:23–28)

*The Tree of Jesse*
1610
Saint-Thégonnec, Notre-Dame

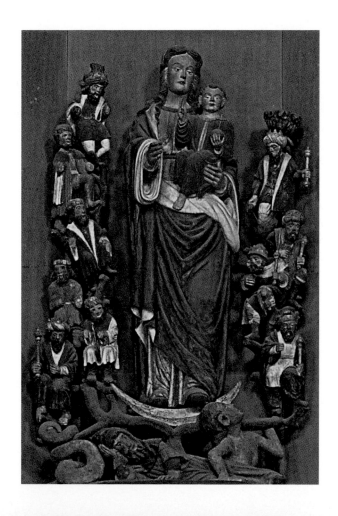

# The Angel Appears to Zacharias

Before announcing to Mary the coming of Jesus, the Archangel Gabriel was commanded by God to inform the priest Zacharias of his impending fatherhood, even though his wife, Elisabeth, who was Mary's cousin, was sterile and the couple were advanced in years. Zacharias was at the temple performing a sacrifice when the angel appeared announcing that a child would be born to him, who would be named John. Shocked at the news, the priest had his doubts and asked Gabriel for a confirmation. The angel, incensed by Zacharias's skepticism, replied: "And, behold, thou shalt be dumb, and not able to speak, until the day that these things shall be performed, because thou believest not my words, which shall be fulfilled in their season." (Lk 1:20) And Zacharias lost the power of speech; a short time later, his wife, Elisabeth, found out that she was with child. The miraculous encounter of Zacharias and the angel took place inside the temple; the locale's isolation has been marked by the artists with architectural devices that shut out the bystanders, who understand that a prodigy occurred only later, after the priest has lost his speech.

(Lk 1:5–25)

Jacopo della Quercia
*Zacharias in the Temple*
1428–29
Pieve di San Giovanni, Siena

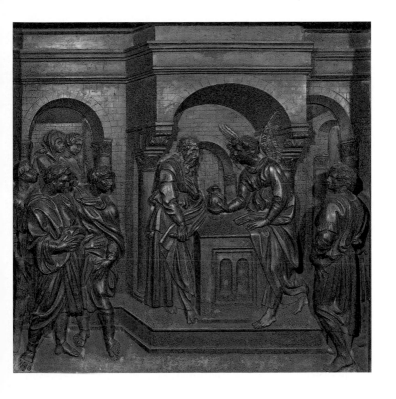

# The Annunciation

A highly lyrical passage in Luke tells of the annunciation of the coming of Jesus: "Hail, thou that art highly favoured, the Lord is with thee." (Lk 1:28) Gabriel began his announcement with these celebrated words, inviting Mary to rejoice. Although the young woman was still a virgin, through God's will she would conceive a son and name him Jesus. To impress God's omnipotence upon her, Gabriel told Mary that her cousin Elisabeth, although barren and elderly, was already six months pregnant. Mary received the news with joy, submitting herself to God's will: "Behold the handmaid of the Lord; be it unto me according to thy word." (Lk 1:38) Although the Bible mentions the city of Nazareth as this episode's location, it does not mention the context, leaving much to the artists' imaginations. The fundamental importance of this episode has led artists to imagine infinite variations in the setting and in the gestures or attributes of the two characters, such as the lily branch carried by the angel, a clear allusion to the Madonna's immaculate purity.

(Lk 1:26–38)

Giovanni Bellini
*Annunciation*
1489
Gallerie dell'Accademia, Venice

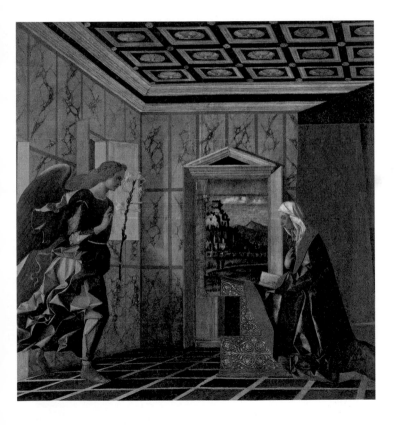

# The Visitation

Having learned from the Archangel Gabriel that Elisabeth was with child, Mary decided to pay her cousin a visit. As soon as Elisabeth heard Mary's greeting, the baby leapt in her womb. Understanding that Mary's motherhood was divine, Elisabeth exclaimed, "Blessed art thou among women, and blessed is the fruit of thy womb." (Lk 1:42) In this episode, as related in Luke's Gospel, there are only the two women whose miraculous motherhoods—one would give birth to John the Baptist, the other to Jesus Christ—have led artists to focus on their embrace and on the meeting of two pregnant bellies. Sometimes Zacharias is included in the scene and, more rarely—and with some poetic license—Joseph, although the Bible gives no hint that the two men were present.

(Lk 1:39–45)

Johann Friedrich Overbeck
*Visitation*
1867
Santuario della Madonna della
Stella, Spoleto

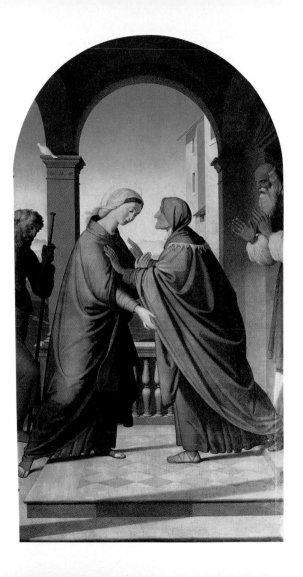

# *The* Magnificat

Upon Mary arriving at her cousin Elisabeth's home, she was greeted by the woman's blessing, for Elisabeth had understood that Mary's pregnancy was divine from the leap her own baby had made in the womb. The Madonna replied with the *Magnificat*, a prayer that takes its name from the first word of the Latin version of the hymn in the Vulgate: "My soul doth magnify the Lord, and my spirit hath rejoiced in God my Saviour." (Lk 1:46–47) Mary's song is one of joy and exultation for the mercy and omnipotence of God, whose most clear example she is. Finally, the work of salvation that God had foretold to the people of Israel was being realized. At the end of the canticle, Luke makes a point of noting that Mary stayed with her cousin for about three months before returning to Nazareth.

(Lk 1:46–56)

Master of the Madonna del Parto
*The Madonna del Parto*
*with Two Devotees*
late 14th century
Gallerie dell'Accademia, Venice

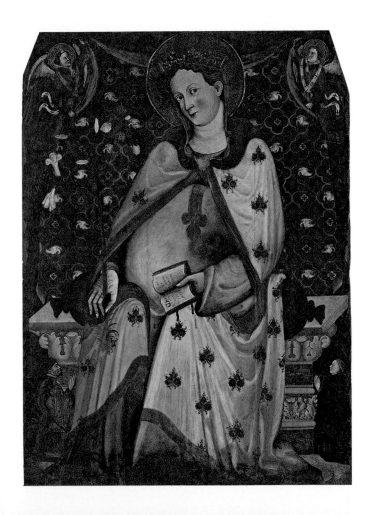

# The Birth of Saint John the Baptist

The birth of Saint John the Baptist has been often imagined as a simple delivery taking place in a modest home, with the mother surrounded by midwives, a normal, everyday event. The infant was assisted by his mother and the women, who ministered to him right away. Zacharias was a silent witness to the scene: because he had refused to believe the news of his impending fatherhood, God had made him a mute. Rejoicing with the elderly parents are kinfolk and friends who would have never believed that the old, barren Elisabeth would conceive, and who now understood the prodigious nature of this birth. Luke is the only Evangelist who recounts this episode in the first part of his Gospel, which is also known as the Gospel of the Infancy of Jesus.

(Lk 1:57–58)

Jacopo Robusti,
known as Tintoretto
*The Birth of John the Baptist*
*c.* 1554
Hermitage Museum,
Saint Petersburg

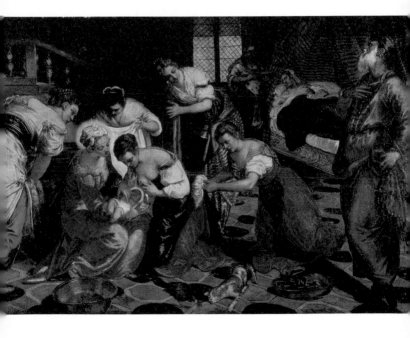

# The Giving of the Name to John

Following Jewish law, infant boys were circumcised on the eighth day of their birth. At that time the child was also given a name. The Archangel Gabriel had commanded Zacharias to name his future son John. Obeying the angel's words, Elisabeth declared that that would be the child's name, thus breaking with the custom of naming children with ancestral names from their family. The bystanders were surprised and turned to Zacharias, who still could not speak, and so wrote the name on a tablet. Luke's phrase "His name is John" (Lk 1:63) has been the subject of many works of art, in which the father expresses God's will by clearly indicating the name before an amazed crowd. At that very moment his tongue was miraculously loosed and Zacharias immediately sang a hymn to the Lord. The hymn, called *Benedictus* ("blessed"), thanks the Lord for His omnipotence and for the salvation that Jesus, whose prophet John the Baptist would be, was to bring to the people of Israel.

(Lk 1:59–80)

Riccardo Cessi
*Zacharias Names John the Baptist*
1892
Chiesa arcipretale, Pincara

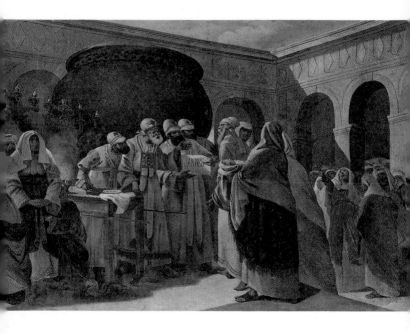

# *The Bethlehem Census*

The Bethlehem census recorded in the Gospel of Luke took place at the time of Quirinius, governor of Syria. A few pages before, the Evangelist had placed the Annunciation episode at the time of Herod the Great (Lk 1:5), clearly giving rise to a misunderstanding, for historical sources date the appointment of Quirinius to governor of Syria to AD 6, while Herod died in 4 BC. Taking these historical dates into account, Jesus would have been perhaps 12 years old at the time of the census. Nevertheless, Luke's clear mistake can perhaps be seen as an attempt to make the birth of Jesus coincide with an important, far-reaching historical event. Thus Joseph set out with the pregnant Mary from Nazareth to Bethlehem, from which his family originated, to have his name recorded in the registers of the general census of the Roman Empire. This scene has not been a frequent subject in art; in the rare cases when it has, it has been represented in an original, interesting manner. (Lk 2:1–5)

*Joseph at the Census in*
*Bethlehem* (detail)
1310
San Salvatore in Chora, Istanbul

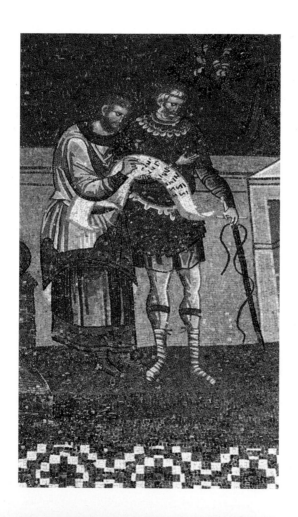

# *The Nativity*

The two canonical accounts of the Nativity (an event covered frequently, with rich details, in the apocryphal texts) are found in the Gospels of Matthew and Luke. The two Evangelists recounted the event from parallel but distinct points of view. Matthew focused the attention on Joseph's fears and worries, for upon discovering that Mary was with child, he had thought of repudiating her until an angel appeared informing him of the divine miracle that had taken place in the woman's womb. The childbirth itself is given in one line. Luke, on the contrary, focused the narrative on Mary, who gave birth to the Child, wrapped him in swaddling clothes, and laid him in a manger, for there was no room at the inn. In this narrative, Mary herself took care of the newborn under conditions of extreme hardship. The birth of Jesus is one of the most represented scenes in art: from simple settings with the Child lying on straw surrounded by his parents, to crowded compositions that include the Adoration of the shepherds and the visit of the Magi. The great wealth of details from the apocryphal texts has also inspired many works of art that stray from the canonical account, for example, by including two animals, the ox and the donkey, mentioned in neither Matthew nor Luke, to warm the Infant's body.
(Mt 1:18–25; Lk 2:6–7)

Federico Fiori Barocci
*The Nativity*
1597
Museo Nacional del Prado, Madrid

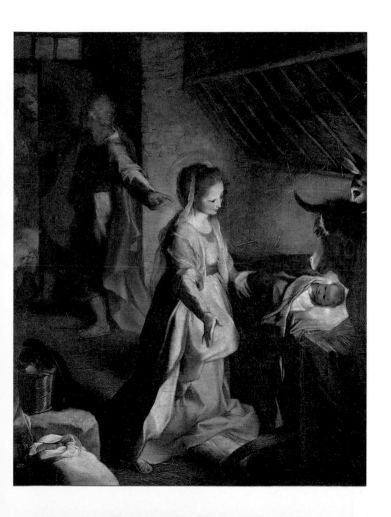

# The Adoration of the Shepherds

As soon as Jesus was born, a bright light awoke some shepherds who were sleeping in the fields. Among the shining rays an angel of God appeared who said to them, "For unto you is born this day in the city of David a Saviour, which is Christ the Lord. And this shall be a sign unto you; Ye shall find the babe wrapped in swaddling clothes, lying in a manger." (Lk 2:11–12) Then a myriad of young angels appeared and began to sing praises to the Lord. Hearing these words, the shepherds resolved to walk to Bethlehem to see God's Child. When they found him, they worshipped him and spread the good news. This episode is recounted only in Luke, while Matthew tells of the Magi's visit. Many works of art have included both scenes, the Announcement and the Adoration, together with the choir of angels in Heaven as a musical background to the deeply mystical scene.

(Lk 2:8–20)

Agnolo Bronzino
*Adoration of the Shepherds*
1535–40
Szépmûvészeti Múzeum,
Budapest

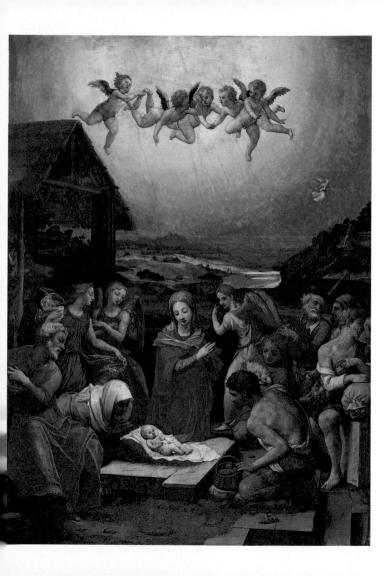

# The Adoration of the Magi

The Gospel of Matthew tells of some wise men from the East who, on the eve of the birth of Christ, following a star, reached Jerusalem, and were brought in the king's presence. They asked Herod: "Where is he that is born King of the Jews?" (Mt 2:2) After consulting his scribes, Herod directed them to Bethlehem and asked them to stop by the palace on their way back, for he too wanted to know where he could go to pay homage to the Messiah. Again guided by the star, the Magi found Jesus, worshipped him, and offered him gifts of gold, a symbol of royalty; frankincense, an emblem of the priesthood; and myrrh, a medicinal resin, symbolic of the Incarnation of Christ. Matthew's Gospel does not mention the Magi's identities, their exact origin, or their number. It was only later that they were identified as three kings, based on the gifts they had brought. In art, the three wise men were initially represented as white, but later came to symbolize the three continents (Europe, Asia, and Africa). After honoring the Child, they were warned by an angel in a dream not to go back to Herod's, and so they took a different route to make their way back to their country, which has been identified perhaps as Arabia or Persia.

(Mt 2:1–12)

Gentile da Fabriano
*Adoration of the Magi*
1423
Galleria degli Uffizi, Florence

352

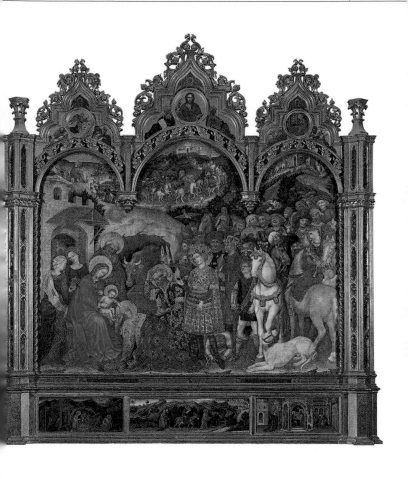

# *The Circumcision*

Following Jewish custom, Christ was circumcised on the eighth day after his birth, at which time he was named Jesus, which means "Savior." God had given the ritual of circumcision to Abraham as a tangible sign of the Covenant: "And he that is eight days old shall be circumcised among you, every man child in your generations." (Gn 17:12) When the foreskin was cut, the child was also given his name. This action also corresponds to the first blood flowing from the infant. In art, this scene has often been rendered realistically, even to the point of drawing the small knife or a frightened child clinging tightly to his mother's dress. Artists have given free rein to their imagination, sometimes creating richly detailed, up-to-date settings, such as this work by Mantegna. A young man carries a tray bearing scissors and a bandage. The setting is sumptuous and elaborate, decorated with inserts of colored, veined marble. References to Jewish history are found in the lunettes on top of the composition: One of them bears the scene of the sacrifice of Isaac; the other, shows Moses with the Tables of Law, symbolizing the continuity of the Covenant between God and the people of Israel.

(Lk 2:21)

Andrea Mantegna
*Circumcision*
from *The Uffizi Triptych*
1464–70
Galleria degli Uffizi, Florence

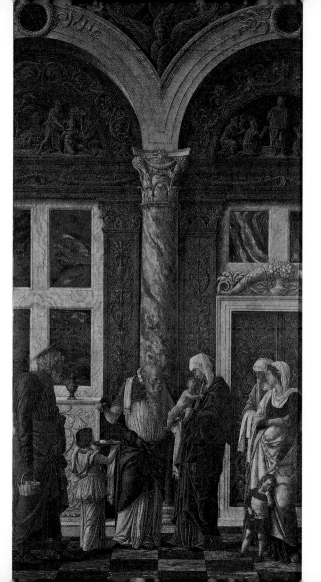

# The Presentation in the Temple

In addition to the circumcision, Jewish custom mandated that each firstborn son was to be consecrated to the Lord, in eternal remembrance of the release of the Hebrews from Egyptian slavery. Thus, Mary and Joseph went to the Temple of Jerusalem to offer Jesus to the Lord; in practice, the child would then be redeemed by making an offering: in the case of Mary and Joseph, two turtledoves. Anna, an old prophetess who was standing at the temple entrance, was the first to recognize Jesus's divinity, followed by Simeon, an old Israelite whom God had promised that he would see the Messiah before dying. The man praised the Child's holiness with the now famous prayer entitled *Nunc dimittis*, from the first words of the Latin version: "Lord, now lettest thou thy servant depart in peace, according to thy word: For mine eyes have seen thy salvation." (Lk 2:29–30) Simeon predicted to Mary her immense future sorrow. The figure of the just Simeon has inspired many artists to portray the scene when the old man takes the Child in his arms and proclaims his divine nature. Both the presentation in the Temple and the circumcision appear only in the Gospel of Luke.

(Lk 2:22–39)

Rogier van der Weyden
*Presentation at the Temple*
right panel of the *Saint Columba Altarpiece*
*c.* 1455
Alte Pinakothek, Munich

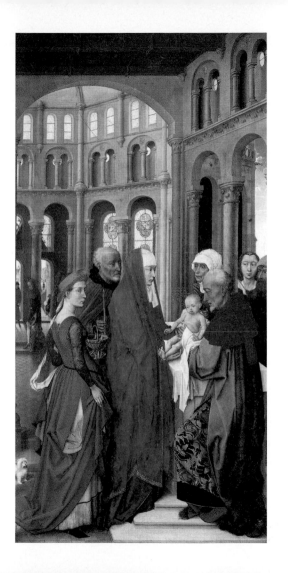

# Joseph's Dream

While the other Gospels make no mention of it, Matthew tells
of the angel's apparition to Joseph urging him to flee to Egypt
with his family, "for Herod will seek the young child to
destroy him." (Mt 2:13) Obeying the divine command, the
carpenter took Mary and the Son and escaped to Egypt,
where they lived until Herod died. Then the angel appeared
once more and instructed Joseph to return to Israel. During
the journey home there was another apparition, in which
the angel suggested that the Holy Family make their way to
Nazareth, a city in Galilee, instead of returning to Judaea, for
Archelaus, Herod's son, ruled there and was known to be a
violent, cruel man. The angelic apparitions to the sleeping
Joseph have been represented lyrically, in intimate compo-
sitions that contrast the shadow on the man's face with the
light of divine revelation that floods the divine messenger.
(Mt 2:13–23)

Georges de La Tour
*The Dream of Saint Joseph*
*c.* 1640
Musée des Beaux-Arts, Nantes

# The Flight into Egypt

The Gospel of Matthew recounts a popular episode in art
with just these words: "He . . . departed into Egypt." (Mt 2:14)
The many different iconographies are due for the most part to
the profusion of details one finds in the apocryphal writings,
which have led artists to subdivide the event into the journey
itself and the rest during the journey, pictured amid bucolic
scenes with the characters surrounded by lush landscapes very
much unlike the parched desert climate. The simplest repre-
sentations show Joseph barefoot leading a donkey on which
Mary and the Child are sitting.

(Mt 2:14)

Bartolomé Estéban Murillo
*Flight Into Egypt*
1645
Galleria di Palazzo Bianco, Genoa

# The Slaughter of the Innocents

As soon as the wise men brought Herod the news that a new king of the Jews had been born, he resolved to eliminate the claimant to the throne by ordering the killing of all infants younger than two years in Bethlehem and the surrounding area. This veritable slaughter gave rise to one of the most atrocious scenes of the New Testament: hordes of ruthless soldiers attacking innocent babies, tearing them from their mothers' arms, and slaughtering them. Catholic tradition considers the slain children to be the very first martyrs and commemorates them on December 28, three days after the birth of Jesus. Matthew links the episode to a prophecy of Jeremiah that recalls the grief that Rachel, Jacob's wife, had suffered when she lost her children at the hands of the Chaldaeans. Grief had become a recurring theme in the history of the people of Israel.

(Mt 2:16–18)

Pieter Bruegel the Elder
*The Massacre of the Innocents*
1565–67
Muzeul National de Artă al
României, Bucharest

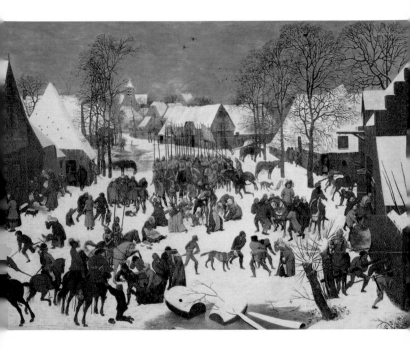

# Christ Among the Doctors of the Law

The dispute with the Doctors of the Law, recounted in Luke's Gospel, is the only episode of Jesus's adolescence to appear in the Bible. After a gap of several years, the story of Christ picks up again at the start of his ministry, when he is already thirty years old. Every year, Joseph and Mary went to the Temple of Jerusalem to celebrate Passover. When Jesus was 12 years old, he went on the pilgrimage with them. On the way home, Mary and Joseph realized that their son was missing, retraced their steps back to the city, and after searching for three days found him in the Temple deep in debate with the Doctors of the Law. When Mary gently reprimanded him, Jesus replied in a way that left his parents perplexed: "How is it that ye sought me? wist ye not that I must be about my Father's business?" (Lk 2:49) The paintings usually have captured Christ engaged in deep discussion with the wise men, suggested by the restless, knotty hands of the elderly juxtaposed with Jesus' calm gesture.

(Lk 2:41–52)

Albrecht Dürer
*Christ Among the Doctors*
1506
Museo Thyssen-Bornemisza,
Madrid

364

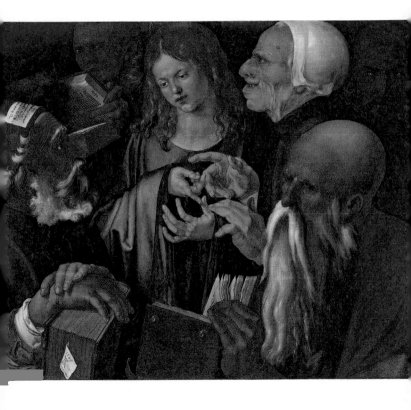

# The Proclamation of John the Baptist

All four canonical Gospels begin the account of Jesus' ministry with the imposing figure of his precursor and cousin John the Baptist, who lived as a Nazarite, a member of a monastic order whose rule included a ban on eating or drinking unclean foods and cutting one's hair and beard (another famous Nazarite was Samson)—a life of poverty and plain dressing. After withdrawing for a time to the desert, John began to preach the advent of the Kingdom of the Lord. He urged people to repent and introduced a new ritual for the remission of sins: the baptism, which required the immersion of the sinner in the waters of the river Jordan. Perhaps attracted by the force of his words—he referred to himself as "the voice of one crying in the wilderness" (Jn 1:23) —or by his unusual appearance, many began to follow him and convert. John announced the coming of the Christ, and for this he is considered Christ's forerunner: "He it is, who coming after me is preferred before me, whose shoe's latchet I am not worthy to unloose." (Jn 1:27) Tanned by the desert sun, animated by the news of an impending new era, and convinced of the need to repent, the Baptist is portrayed in art in the act of preaching. (Mt 3:1–12; Mk 1:1–8; Lk 3:1–18; Jn 1:19–27)

Adam Elsheimer
*Saint John the Baptist Preaching*
1602
Galleria Palatina, Florence

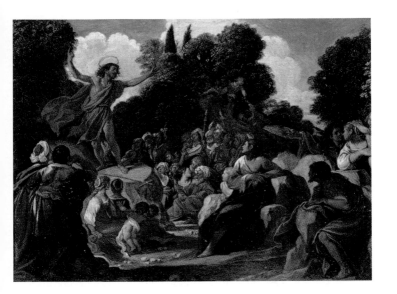

# The Baptism of Christ

"Behold the Lamb of God, which taketh away the sin of the world." (Jn 1:29) With these words John welcomed Jesus, who had come to the banks of the river Jordan. The account of the baptism of Jesus by the Baptist, reported in all the four canonical Gospels, is only a few verses long; as a result, the works of art on the subject are for the most part concise and tend toward uniformity. Matthew was the only one of the four Evangelists to report the exchange between the two figures, a simple dialogue that underscored John's reservations about his task. Having recognized Jesus as the one "Anointed by God," the sacrificial lamb that was to save humankind, the Baptist felt inadequate; it was Christ who should baptize him, not vice versa. After the purification ritual, the Baptist saw a dove descend from Heaven and heard these words: "This is my beloved Son, in whom I am well pleased." (Mt 3:17) While the Gospel of John tells the story indirectly through the testimony of the Baptist, Mark and Luke address the divine proclamation to Christ himself. Jesus, John, and the dove alighting on the Anointed One have been the subject of compositions that are as simple as they are filled with pathos. (Mt 3:13–17; Mk 1:9–13; Lk 3:21–22; Jn 1:29–34)

Leonardo da Vinci and Andrea di Michele
di Francesco de' Cioni, known as Verrocchio
*The Baptism of Christ*
1472–75
Galleria degli Uffizi, Florence

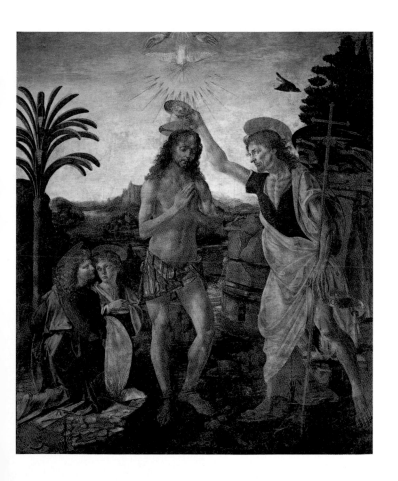

# The Temptations of Christ

After he was baptized, Jesus withdrew to the desert, where he prayed and fasted for 40 days. Here Satan came to tempt him, and here the angels ministered to him. While Mark mentions this episode only briefly, Matthew and Luke narrate the confrontation between Christ and the Devil in the form of three seductions. In the first, the one most represented in art, Satan incited Jesus, hungry after his prolonged fast, to turn some stones into loaves of bread. When Jesus refused, the Devil carried him atop the pinnacle of the Temple of Jerusalem, urging him to jump so that the angels could rescue him. Finally, he followed Jesus to the top of a tall mountain, where he promised to give him everything in his sight if he would only do him homage. The Messiah firmly resisted all these temptations, and after the third, the Devil, disappointed, left. After he overcame these diabolical challenges, the angels came to minister to Jesus in the desert, and then he began his public ministry. In depicting the showdown between Jesus and Satan, a symbol of the struggle between Good and Evil, artists have given free rein to their imaginations, rendering the Evil One sometimes as a monster, sometimes as a human being with the features of someone whom the artist disliked.

(Mt 4:1–11; Mk 1:12–13; Lk 4:1–13)

*The First Temptation of Christ*
miniature from a psalter
1222
Royal Library, Copenhagen

# The First Disciples

The four canonical Gospels give different versions of the time when Jesus called the first disciples to follow him. All four agree that the first two apostles were Andrew and his brother Simon, whom Jesus later rebaptized Peter. But the names of the other ten do not coincide perfectly. While John writes about Philip and Nathaniel, Luke only lists the names, putting the call to James the Elder and John before the call to Philip. The more detailed accounts are in Matthew and Mark, who both report that having reached Capernaum, a city in Galilee on the shores of Lake Tiberias (also known as the Sea of Galilee), Jesus saw two brothers—Andrew and Simon—throwing a net into the lake. He called to them with these words: "Follow me, and I will make you fishers of men." (Mt 4:19) And they left their nets to follow him. Then Jesus recruited two more apostles: John and James the Younger, the sons of Zebedee. With Andrew and Simon on each side, Jesus called the two new disciples: James bowed before the Messiah, while John brought his hand to his chest. The aquatic landscape that translates the fisherman's work into the heavenly call of gathering men is deeply meaningful. While Christ's choices are not really explained, the number of apostles, twelve, is a direct reference to the Twelve Tribes of Israel.

(Mt 4:18–22; Mk 1:17; Lk 6:12–16; Jn 1:43–50)

Marco Basaiti
*Call of the Sons of Zebedee*
1510
Gallerie dell'Accademia, Venice

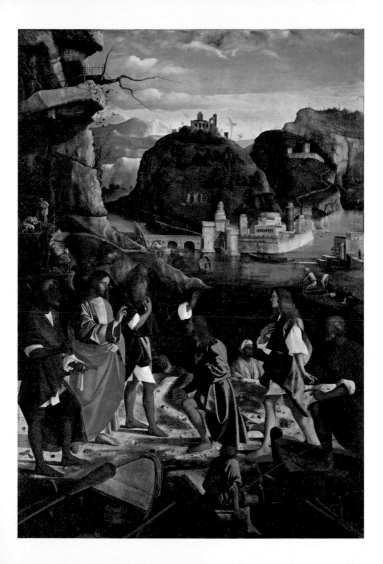

# The Sermon on the Mount

This episode recounts a speech that, according to Matthew and Luke, Jesus gave to a crowd shortly after gathering the apostles. The sermon opens with the famous nine beatitudes, the precepts that men must follow in order to enter the Kingdom of Heaven. Presumably, the speech was given on a mountain near the city of Capernaum. In most religions, the mount is the meeting point between Heaven and Earth, and in the Old Testament it is indeed the site of many divine revelations. The importance of the height is confirmed in the New Testament, not just in this passage but in the most salient hours of Jesus' life; for example, the night before his death Christ went to the Mount of Olives to pray. This work by Fra Angelico, created for a convent community, is simple and peaceful; the hill is more like a stylized rock, with Christ seated on top surrounded by his closest disciples.

(Mt 5:1–12; Lk 6:17–49)

Fra Angelico
*The Sermon on the Mount*
1438–46
Museo di San Marco, Florence

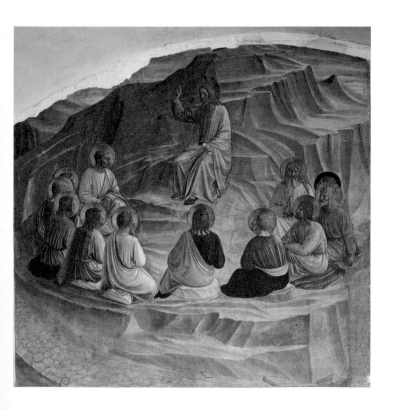

# The Good Samaritan

The parable of the Good Samaritan is one of best known and most commented Gospel passages. We find it only in Luke, who added many original episodes to his narrative. As Jesus was journeying toward Jerusalem, a lawyer referred to the commandment "Love thy neighbor as thyself" and asked him, "And who is my neighbor?" (Lk 10:29) And so Christ told of a Jew who, while traveling to Jerusalem, was assaulted by thieves, who robbed him and left him half-dead on the edge of the road. After a while, a priest and a Levite came down along the road, saw the wounded man, and passed him by. Finally a Samaritan (from Samaria, a land hostile to Judaea) saw the man and felt pity for him; he stopped and bandaged the man's wounds, pouring oil and wine on them. Then he lifted him onto his own mount and brought him to a nearby inn, where he looked after him. The following morning, he left him in the care of the innkeeper with twopence as advance payment for the expenses. The parable is very popular in art, two moments especially: the Samaritan giving first aid on the road, and the assistance at the inn.

(Lk 10:25–37)

Giuseppe Zannoni
*The Good Samaritan*
late 19th century
Galleria d'Arte Moderna, Verona

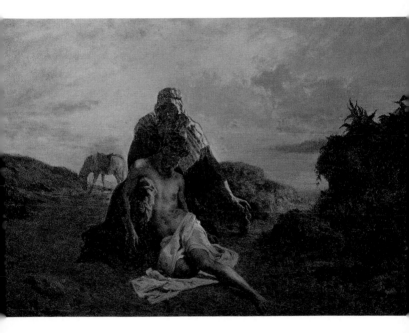

# The Lord's Prayer

The Lord's Prayer is the preeminent Christian prayer because it was received by Jesus himself; only the Gospels of Matthew and Luke have recorded the episode when Jesus himself taught his disciples how to pray. But while Matthew includes the episode in the Sermon on the Mount, Luke places it after the dinner at Martha's and Mary's house. The Evangelist begins with a generic phrase: "And it came to pass, that . . . he [Jesus] was praying in a certain place." (Lk 11:1) The prayer is important because it expresses the true relationship between God, Jesus, and the Holy Spirit; it is Christ's direct testimony of his union with the Trinity, an extremely difficult concept to grasp. This insufficiency of the human mind is transposed to art, where inevitably the Trinity is visualized as a God with the features of an old, bearded patriarch, a young Jesus on the Cross, and a dove; the latter is a symbol of the Holy Ghost, and we find it in a plethora of Old Testament passages as the bearer of messages from the Lord.

(Mt 6: 9–13; Lk 11: 1–4)

Robert Campin
*Trinity*
1430
Hermitage Museum, St. Petersburg

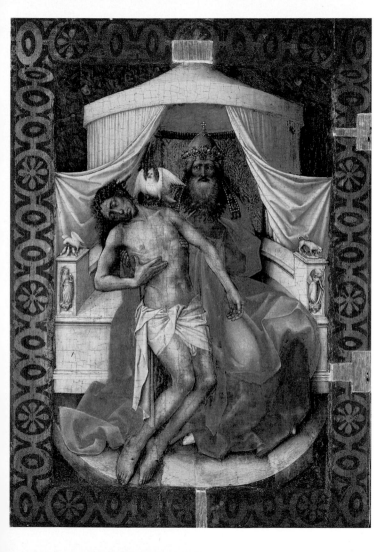

# Peter's Profession of Faith

Peter's profession of faith is recounted in the Synoptic Gospels. When Jesus was near the city of Caesarea, he asked the apostles who the people thought he was. Their answers laid bare the confusion that swirled around him: "And they answered, John the Baptist; but some say, Elias; and others, One of the prophets." (Mk 8:28) Then Christ asked them what they thought, and immediately Simon, whom Jesus had named Peter (*kephas*, which in Aramaic means "rock"), answered, "The Christ of God." (Lk 9:20) While Mark and Luke only mentioned Jesus' admonishment not to reveal his true identity, Matthew recorded the famous phrase with which the Messiah, employing a mean-ingful play on words, charged Peter: "And I say also unto thee, That thou art Peter, and upon this rock I will build my church; and the gates of hell shall not prevail against it. And I will give unto thee the keys of the kingdom of heaven: and whatsoever thou shalt bind on earth shall be bound in heaven: and what-soever thou shalt loose on earth shall be loosed in heaven." (Mt 16:18–19). With these words Christ gave Peter the power to forgive sin. Works of art depicting this scene have visualized Jesus handing to Peter a large set of keys.

(Mt 16:13–20; Mk 8: 27–30; Lk 9: 1–6)

Nicolas Poussin
*The Seven Sacraments: Ordination*
1636–40
Collection of the Duke of Rutland, Belvoir Castle

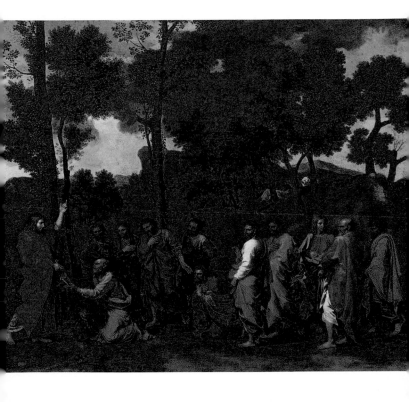

# The Wedding at Cana

This is the first miracle that Jesus performed during his public life. During a wedding banquet at Cana, a village near Nazareth, Mary informed Jesus that there was no more wine. His obscure reply hides the painful awareness of the fate that awaited him: "Woman, what have I to do with thee? mine hour is not yet come." (Jn 2:4) For his blood would be the last wine offered for the salvation of humanity. Nevertheless, Jesus indulged his mother and ordered the servants to fill six large stone jars with water and to have the banquet master taste it. As soon as he drank it, the banquet master turned to the bridegroom, congratulating him for having saved the best wine for last. All the guests were astonished. Thus in John's Gospel we see how Christ chose a festive occasion to work his first miracle; the banquet has been faithfully reproduced in the many works of art illustrating this scene, with the guests conversing happily among themselves as the servants pour the miraculous wine.

(Jn 2:1–11)

Gerard David
*The Marriage at Cana*
c. 1500–3
Musée du Louvre, Paris

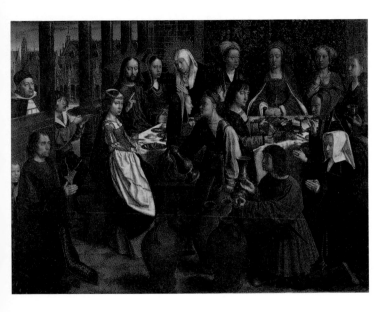

# Christ and the Samaritan Woman

As he was journeying from Judaea to Galilee, Jesus went through Samaria and stopped to rest at a well near the town of Sychar. Here a woman from Samaria, a nation traditionally hostile to the Judaeans, approached him and began a theological discussion. In fact, when Christ asked her for water, the woman was surprised at the request because their two nations were hostile. But Jesus replied, "If thou knewest the gift of God, and who it is that saith to thee, Give me to drink; thou wouldest have asked of him, and he would have given thee living water." (Jn 4:10) At the end of the discussion, the woman was converted. Convinced that the Messiah stood before her, she ran back into town announcing to everyone that the Savior had come. Not the easiest scene to reproduce visually, some artists have resorted to a sort of balloon in which they have written the most important quotations.

(Jn 4:1–42)

Lazzaro Bastiani
*Christ and the Samaritan Woman*
*c.* 1485
Gallerie dell'Accademia, Venice

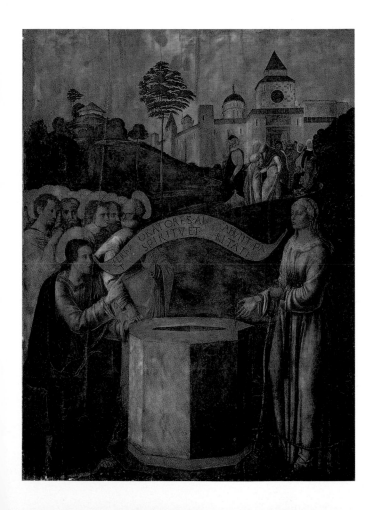

# The Healing of a Paralytic

The Evangelists used the same title to recount two separate episodes: the Synoptic Gospels describe Jesus' healing of a paralytic man in Capernaum during a sermon, while John reports a miracle performed near the Bethesda pool in Jerusalem. Both were harshly criticized by observant Jews.
In the first episode, having been accused of blasphemy, Christ replied, "Is it easier to say to the sick of the palsy, Thy sins be forgiven thee; or to say, Arise, and take up thy bed, and walk?" (Mk 2:9) To demonstrate the power of his words, the question turned into a command and the paralyzed man rose and began to walk. John placed the miracle near a pool famous for its waters that, being sometimes troubled by an angel of the Lord, healed the first person who stepped into them.
A paralytic was standing by the pool and, because he could not walk, he could never arrive first to bathe. Jesus invited the man to take up his bed and walk. Artists have used the two different settings to differentiate the two events; the room in a humble house is the setting for the first episode while a wide porch around the pool is used for the Bethesda miracle.
(Mt 9:1–8; Mk 2:1–12; Lk 5:17–26; Jn 5:1–16)

Giovanni Battista Tiepolo
*Healing of a Sick Man at the Pool of Bethesda*
1718–20
Gallerie dell'Accademia, Venice

# The Miracles of Loaves and Fishes

Throughout Christendom, artists have often portrayed Christ's miracles and prodigies with Jesus, variously rendered, as the focus of the compositions. This episode in particular, together with the Transfiguration of Christ and the resurrection of Lazarus, is premonitory of the suffering and glory of the Messiah and has been so interpreted in art. Usually, Jesus is depicted blessing the five loaves and the two fishes, mentioned by all four Evangelists, so that they will multiply to feed the crowd that has come to listen to his sermon. Sometimes only four loaves of bread are depicted, the fifth one being Christ, who was to sacrifice himself for humankind. The association between the miracle of loaves and fishes and the Passion is underscored especially by the fact that in the Gospels of Matthew and Mark the miracle was repeated (Mt 15:32–39; Mk 8:1–9) just before Jesus publicly announced for the first time his future suffering.

(Mt 14:13–21; 15:32–39; Mk 6:34–44; 8:1–9; Lk 9:12–17; Jn 6:1–15)

Juan de Flandes
*Miracle of the Loaves and Fishes*
1496–1505
Patrimonio Nacional, Madrid

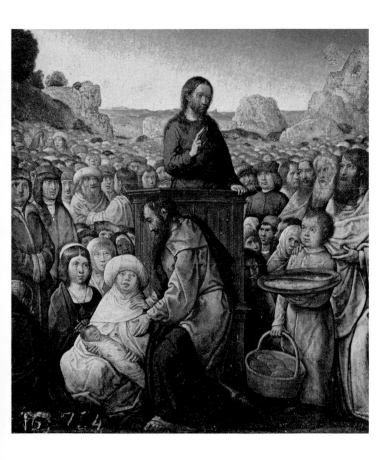

# Christ Walks on the Water

In the Gospels of Matthew, Mark, and John this episode immediately follows the multiplication of the loaves and the fishes. After the miracle, Jesus sent his disciples to the far side of the Sea of Galilee. Then he departed from the great crowd and walked up the mountain to pray. As the evening fell, the sea was troubled and the disciples saw Christ walking toward them on the waves. He put them at ease with these words, "It is I; be not afraid." (Mt 14:27) Unlike the other Evangelists, Matthew adds that Peter asked to approach Jesus, but as he started walking on the water he was frightened by the stormy wind and began to drown, and cried for help. Christ reached his hand out to him and rebuked him for having doubted the Lord. Artists have represented this incident often, sometimes confusing it with the call to the first disciples (in Luke, this incident is linked to a "miraculous catch" [Lk 5:1–11]) and the apparition on the Sea of Galilee that took place after the Resurrection (Jn 21:1–14).

(Mt 14:22–36; Mk 6:45–56; Jn 6:16–21)

François Boucher
*Saint Peter Invited to Walk on the Water*
1766
Saint-Louis, Versailles

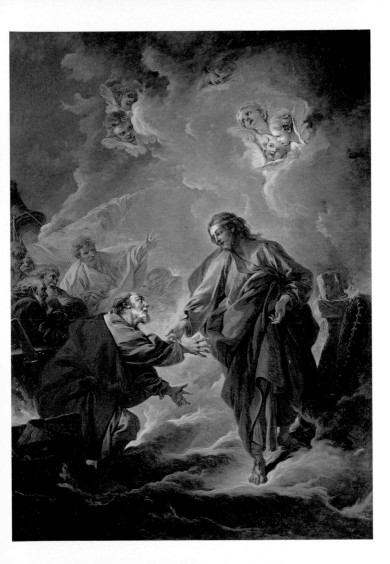

# The Healing of the Leper

Among the many healings that Jesus performed during his
public ministry is that of a leper who had turned to him
begging to be cleansed. Christ complied but commanded him
to immediately go to the priest without telling anyone, so that
he could properly observe the Law by submitting to the puri-
fication ritual, for a leper was barred from the community
until the religious authorities certified that he had been healed
after making an act of expiation and an offering to the Lord.
Still, while Matthew merely reports Jesus' advice, Mark and
Luke add that the cured leper did not heed the advice and
announced his miraculous healing, forcing Christ to move to
secluded places, away from the city, to avoid the great crowds
that were running to him from everywhere in order to be
cleansed. This episode is not a frequent subject in art; when it
has been represented, the man's sores have been reproduced
very realistically.

(Mt 8:1–4; Mk 1:40–45; Lk 5:12–16)

*The Healing of the Leper* (detail)
12th century
Santa Maria Nuova, Monreale

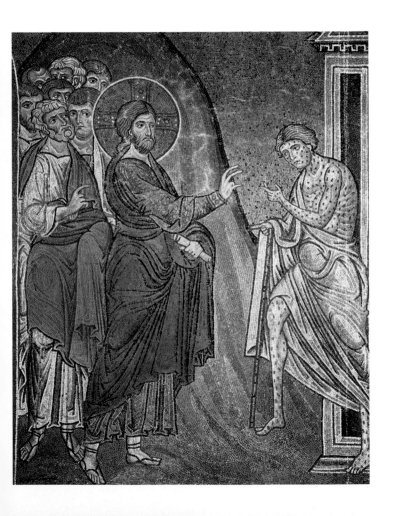

# The Healing of Peter's Mother-in-Law

Peter's mother-in-law lay in bed with a fever. Jesus went to her, touched her hand, and the woman immediately got up, her fever gone, and began to minister to him. These few lines from the Synoptic Gospels are meant to show that while Christ was always available to those in need, he never forgot his Father's mission. Having heard of the prodigy, many who were possessed by devils crowded around him, hoping to be healed. Jesus drove out the evil spirits, but as the crowds asking for help kept growing, he retired to a secluded place where he could pray. Followed by the multitude, Christ thus explained why he could not stay: "I must preach the kingdom of God to other cities also: for therefore am I sent." (Lk 4:43) Jesus never lost sight of the mission his Father had entrusted to him, even when his reputation as a miracle healer kept spreading. This particular episode is not represented often, artists having preferred other, more spectacular, miracles.

(Mt 8:14–17; Mk 1:29–39; Lk 4:38–44)

*Peter's Mother-in-Law* (detail)
1310
San Salvatore in Chora, Istanbul

# The Call of Matthew

Matthew received Jesus' call while he was sitting in the tax office, where he was a tax collector; these officers were hated by the people, who treated them as the worst of sinners. The simple command "Follow me!" uttered by Jesus is recorded in the Synoptic Gospels (Mt 9:9; Mk 2:14; Lk 5:27); artists have translated it in an eloquent gesture by Christ and a shocked Matthew, who reacts by bringing his hand to his chest. After the call, a banquet was held at the house of Matthew (who was also called Levi). There Jesus sat with other tax collectors, causing the scribes and the Pharisees to harshly criticize him. But Jesus replied thus to the accusations: "They that be whole need not a physician, but they that are sick. . . . I am not come to call the righteous, but sinners to repentance." (Mt 9:13)
In this painting, Caravaggio has set Matthew in a guardroom surrounded by shady figures; Peter's presence is an addition, for he is not mentioned in the Gospel passage; it is presumably an allusion to the Church's role in welcoming and converting sinners, since Peter symbolizes that role.
(Mt 9:9–13; Mk 2:13–17; Lk 5:27–32)

Michelangelo Merisi da Caravaggio
*The Calling of Saint Matthew*
1599–1600
Cappella Contarelli,
San Luigi dei Francesi, Rome

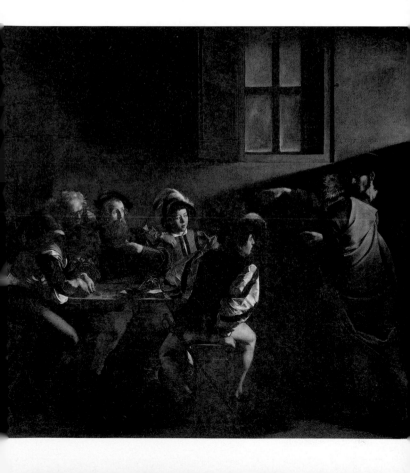

# *The Healing of the Woman with a Hemorrhage*

Most likely this episode took place in Capernaum as Jesus, followed by an immense crowd, was walking toward the house of Jairus, a ruler of the synagogue, to heal his daughter. Among the multitude pressing around the Messiah was a woman who had been hemorrhaging blood for 12 years. Being unclean, she was forbidden from touching anyone, but she thought that if she touched even just the hem of his garment she might be healed, so she went near him and pulled his cloak. According to Mark and Luke the healing was instantaneous. Feeling the pull, Jesus turned around, but could not see who it was, and so he asked. The woman came up, trembling with shame, and fell down before him, explaining why she had touched him, and that she had received the divine blessing. According to Matthew, feeling someone touch him, Christ turned around and, seeing the woman, told her: "Daughter, be of good comfort; thy faith hath made thee whole." (Mt 9:22) Hearing these words, the woman was healed.

(Mt 9:20–22; Mk 5:24–34; Lk 8:43–48)

*Healing of the Woman with a*
*Hemorrhage (detail)*
4th century
Catacombe dei Santi Pietro e
Marcellino, Rome

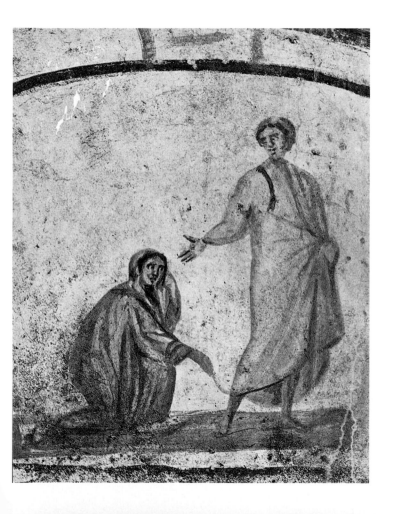

# The Calming of the Storm

In all likelihood this episode took place on the Sea of Galilee. It was night and Jesus and his disciples were crossing the lake on a boat when a raging storm broke out. The apostles were frightened for their lives, but Jesus kept sleeping, seemingly unaware. At the center of the boat a terrified Peter, his eyes wide open, was praying. When it seemed that all was lost against the raging forces of nature, the apostles awoke their Master. Their supplication has been recorded with almost the same exact words by the three Synoptic Gospels: "Master, carest thou not that we perish?" (Mk 4:38) Christ admonished them: "Why are ye fearful, O ye of little faith?" (Mt 8:26) At his command, the waters became still and the storm abated, leaving the apostles dismayed at the power of the Messiah. (Mt 8:23–27; Mk 4:35–41; Lk 8:22–25)

*The Calming of the Storm*
miniature from the Gospels of
the Abbess Hilda
11th century
Hessisches Landesbiblithek,
Darmstadt

# The Sign of Jonah

The scribes and the Pharisees having asked him for a sign, Jesus inveighed against the current "evil and adulterous generation." (Mt 12:39) The only sign he gave them was that of Jonah, which he used to announce his future Passion and death, as eternal comfort for the chosen. In fact, just as the prophet remained in the belly of the whale three days before seeing again the light of day, so Christ was to rise from death and ascend to the Kingdom of Heaven. Still, the part of the story of Jonah that has been highlighted the most is his rest under the castor oil tree, the tree that God had caused to grow to give shade and a peaceful rest to the prophet. The rest of Jonah's tale is compared to the prize that awaits those who live in the faith. It was a frequent subject of early Christian funerary art, as it decorated sarcophagi and the walls of catacombs and churches, suggesting the well-deserved peace that awaits the faithful.

(Mt 12:38–42; Lk 11:29–36)

*Jonah Resting under an Arbor*
(detail)
4th century
Santa Maria Assunta, Aquileia

# The Parable of the Sower

The good tidings brought by Jesus are efficiently expressed in
the parables, drawn-out metaphors that are at the core of the
preaching of the Messiah. That of the sower is particularly
famous: Christ explained to his disciples that there are many
ways of listening to God's word and used the image of the
seeds sown in different types of soil. The seeds that fall by the
wayside and are eaten by the birds are like those who hear
the news of the Heavenly Kingdom but do not understand it;
the seeds that fall on rocky ground and sprout right away, but
then shrivel and wither, are like those who joyfully hear God's
word but soon forget it. The seeds that fall in thorny bushes
and are choked by them are like those who lose the good
news amid the seductions of the world. He who hears God's
word, deeply understands it, and makes it bear fruit is like the
rich soil that sometimes yields 30, or 40, or 100 percent. The
difficulty in interpreting this parable also applies to its visual
representations, especially the difficulty of depicting various
types of soil.
(Mt 13:1–23; Mk 4:1–25; Lk 8:14–18)

Jacopo Bassano
*The Parable of the Sower*
1560
Museo Thyssen-Bornemisza, Madrid

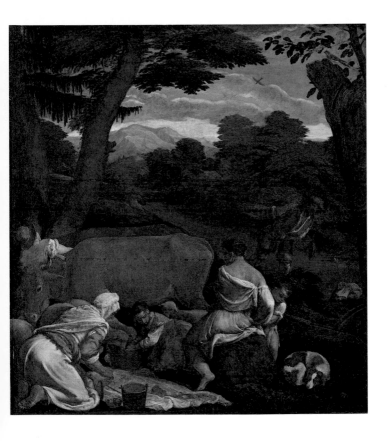

# Christ and the Adulterous Woman

One of the best-known episodes of Jesus' teaching and sermons, that of the adulteress, is in the Gospel of John. The Messiah's reply to the insinuations of the Pharisees is still one of his most famous precepts. While he was preaching in the Temple of Jerusalem, a group of Pharisees asked him what sentence should be meted out to a woman who had been caught in the act of adultery. They wanted to test Christ's observance of Jewish Law, which called for stoning the woman to death. At first Jesus did not reply but simply drew some words on the ground. But as the Pharisees insisted, he curtly replied, "He that is without sin among you, let him first cast a stone at her." (Jn 8:7) Speechless, the men left one by one until Jesus and the woman were alone. Then Christ asked her if someone had condemned her; she said no, and he simply told her to go and sin no more. Artists have interpreted this scene by expressing the ill-will of the Pharisees as they tried to lead Jesus into error, and Jesus' poise before the obvious trap.

(Jn 8:1–11)

Aert de Gelder
*Christ and the Adulteress* (detail)
1683
Museo Thyssen-Bornemisza, Madrid

# The Healing of the Blind Man

We know that the authors of the Gospels took these episodes seriously by the many instances of miraculous healings that they report. Mark and Luke give very similar versions of a healing in Jericho. When the blind man called to him, Jesus replied with a blessing that caused him to see. John sets the episode in Jerusalem and spends a whole chapter on it, describing the manner of the healing, with Christ spreading his own spittle and some mud on the man's eyes. The Evangelist also reports a discussion between some Pharisees and the healed man to show the importance of faith, and to help distinguish between the spiritual blindness of the Pharisees and physical blindness. In Mark, Jesus also spreads his spittle on the eyes of another blind man, this time in Bethsaida. Mark multiplies the number of the blind: two in Jericho and presumably two in Capernaum, all healed by the Messiah, who touched their eyes with his hands, a gesture reproduced in the works of art that depict this episode.

(Mt 9:27–29; 20:29–33; Mk 8:22–26; 10:46–52; Lk 18:35–43; Jn 9:1–41)

Doménikos Theotokópoulos,
known as El Greco
*Christ Healing the Blind*
1570–75
Galleria Nazionale, Parma

# Herod's Banquet

The preaching of John the Baptist aroused a fiery polemic among observant Jews; but one criticism he made of Herod Antipas, the son of Herod the Great, landed him in jail. Herod Antipas had taken as wife Herodias, the widow of his deceased brother; John had rebuked him thus: "It is not lawful for thee to have her." (Mt 14:4) The criticism had enraged the king, who had John thrown in a dungeon. While Luke's account is not more specific, Matthew and Mark have recorded the background that culminated in John's beheading. During a banquet, Herod was so enchanted by Salome's dance (her name is not mentioned in the Gospels; she was the daughter of Herodias) that he swore to give her whatever she asked for. After consulting with her mother, Salome asked that the head of the Baptist be brought to her. Most artistic renderings show the dance scene and the sacrifice together, with the lovely Salome carrying the platter with John's head on it. Other works of art have depicted the impending martyrdom, with the empty platter in the foreground.
(Mt 14:1–9; Mk 6:14–26; Lk 3:19–20)

Nikolaus Kirberger
*Herod's Banquet*
1521
Stiftsgalerie, Klosterneuburg

# The Martyrdom of Saint John the Baptist

Salome's request to have the head of John the Baptist brought to her on a silver platter left Herod disconcerted. According to Matthew, the king hesitated on account of the Baptist's immense popularity. Although he hated the Baptist deeply, the king also knew that sentencing to death a figure as well known and beloved by the masses as John could make him unpopular. On the contrary, according to Mark, the king was in awe of the prophet and was distressed by Salome's request. Still, he had to honor the oath he had made to the young girl. He therefore sent a soldier to the jail where the Baptist was chained. The prophet was decapitated and his head placed on a charger and brought to Salome. Artists of all eras have represented martyrdom scenes; beheadings in particular occur frequently in the Bible and have always aroused a sort of macabre interest in the artistic imagination.

(Mt 14:10–12; Mk 6:27–29)

Master of the Saint John the Baptist Frontal
*The Beheading of Saint John the Baptist*
detail from the Saint John the Baptist Frontal
late 13th century
Pinacoteca Nazionale, Siena

# Christ and the Canaanite Woman

Jesus also preached outside Israel, even reaching Phoenicia around Tyre and Sidon. Preceded by his fame, crowds of people went to meet him, asking him to heal them. Among them was a Canaanite woman who raised her voice in the crowd so that Jesus could hear her and beseeched him to take pity on her daughter, who was possessed by a demon (she was probably an epileptic). Christ answered her with a metaphor, that it was unfair to take bread from the children—the Israelite believers—and give it to the pups—the pagans. But the woman keenly replied, "Truth, Lord: yet the dogs eat of the crumbs which fall from their masters' table." (Mt 15:27) Surprised by the prompt retort, Jesus blessed the daughter, who was immediately made whole. Matthew's and Mark's accounts focus on the dialogue between Christ and the woman, which artists have represented by adding the simultaneous blessing gesture that heals the girl.
(Mt 15:21–28; Mk 7:24–30)

Jacopo Negretti,
known as Palma Vecchio
*Christ and the Canaanite Woman*
16th century
Gallerie dell'Accademia, Venice

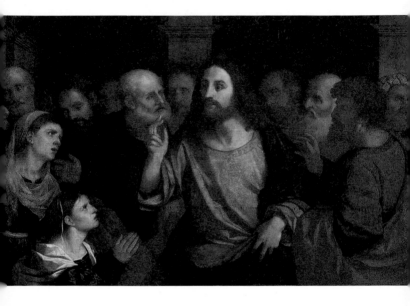

# Jesus at the Home of Martha and Mary

This episode narrated in Luke—the supper at the house of Martha and Mary, the sisters of Lazarus—hints at the importance that Jesus attached to the weaker social groups of his time, for in ancient Jewish society women were totally subordinate to men. Christ had stopped for supper at the home of the two women. Martha immediately set about with frenetic preparations for her guest. But Mary sat at Jesus' feet and was totally engrossed in the depth of his words. Seeing that Mary was of no help, Martha lost her temper and asked Jesus why he did not reprove her. Christ replied keenly, "Martha, Martha, thou art careful and troubled about many things. But one thing is needful: and Mary hath chosen that good part, which shall not be taken away from her" (Lk 10:41–42). With these words, Jesus was not belittling Martha's solicitude, but he did want to stress the importance of the Kingdom of God vis-à-vis human needs. The women are usually depicted surrounding Jesus; one sits at his feet and listens to him, while the other offers bread to the guest in a symbolic gesture.

(Lk 10:38–42)

Jan Vermeer
*Christ in the House of Martha and Mary*
c. 1656
National Gallery of Scotland, Edinburgh

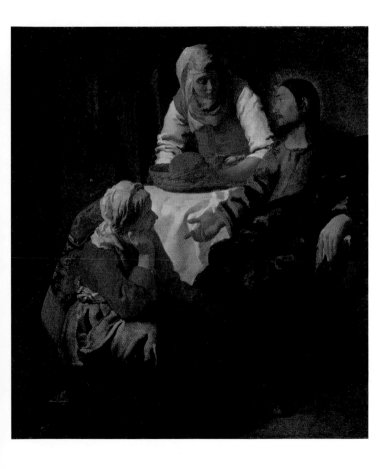

# *The Parable of the Prodigal Son*

This well-known parable is reported only by Luke, but the story is so long and detailed that it has become famous. Like Martha and Mary's story, it is unusual for its unexpected message. It is the tale of a son who decided to take his share of the family wealth and travel the world, squandering the money until he was left destitute and hungry, forced to eat the carobs fed to the pigs so as not to starve. Underfed and exhausted, he made his way home, where his father welcomed him with a lavish banquet. The brother, who always did his duty serving the family, aiding his parents and being close to them, bridled at all the festive preparations because he had never been treated so lovingly by his father. But his complaints were answered with a rebuke, for his father made him understand the importance of celebrating someone who had found again the straight path from which he had strayed. With this parable, Jesus wanted to convey the mercy of God to those who repent of their sins. Such feeling is perfectly captured by Rembrandt in this oil painting, where the father's attitude toward the prodigal son is made clear by his benevolent, kind, protecting embrace.
(Lk 15:11–32)

Rembrandt van Rijn
*The Return of the Prodigal Son*
*c.* 1669
Hermitage Museum,
St. Petersburg

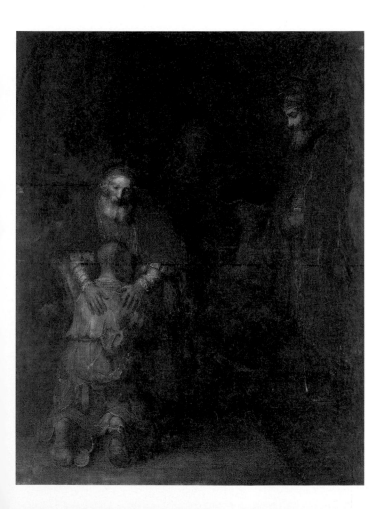

# The Resurrection of Lazarus

After he had risked being stoned, Jesus left Judaea and reached the eastern bank of the river Jordan. Here he learned that his friend Lazarus was mortally ill. Nevertheless, he tarried another two days by the river before returning to Judaea, even though his disciples were afraid. Arriving in Bethany, where Lazarus lived, he was received by Martha and Mary, who were mourning the death of their brother. For the first time, Jesus was also moved and broke out weeping. When he ordered that the gravestone be removed, Mary was repulsed because a four-day-old corpse would have a foul odor. But as the grave was unsealed, Jesus cried loudly, "Lazarus, come forth." (Jn 11:43) Immediately the dead man, wrapped in the burial clothes and with his face covered by a shroud, walked out of the sepulcher amid the consternation of the bystanders. The resurrection of Lazarus is the last, and the most important, of the seven miracles described by John. It is by far the most represented miracle in art. The miracle of the victory over death is a clear foreshadowing of Christ's own victory, and may be considered emblematic of the defeat of sin by faith.

(Jn 11:1–46)

Flemish Workshop
*The Resurrection of Lazarus*
(detail)
1515–20
Civiche Raccolte d'Arte del Castello
Sforzesco, Milan

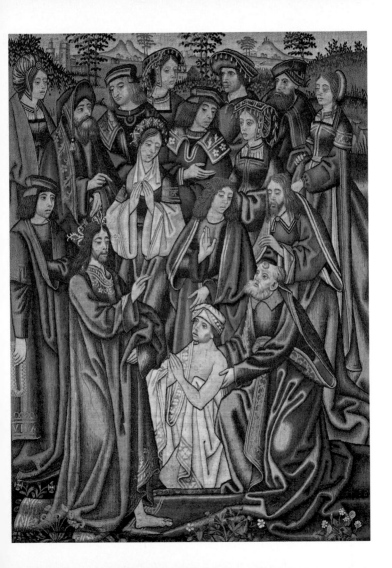

# The Transfiguration

The Transfiguration precedes and foreshadows with great clarity the Passion of Jesus. Escorted only by Peter, James, and John, Jesus walked to the top of a mountain—later traditionally identified as Mount Tabor—where he was transfigured: His face and clothes became as dazzling as light, and Moses and Elijah, representing the ancient Law and the Prophets respectively, appeared by his side. The two apparitions began a dialogue with Jesus about his imminent passing from the earthly to the heavenly life. Caught up in the ecstasy of the vision, Peter asked whether he could build three shelters, one for each. Suddenly, a bright cloud appeared and the disciples heard these words, the same that had been heard at the Baptism of Jesus: "This is my beloved Son: hear him." (Lk 9:35) The disciples were overcome with fear, but when they raised their eyes again, they saw Jesus alone. Warned by their master to keep silent about what they had seen, they came down the mountain. The great importance that Christian tradition attributes to this event lies in the acknowledgment of the divine nature of the Christ and in the prefiguration of his Passion and death on the Cross.

(Mt 17:1–13; Mk 9:1–13; Lk 9:28–36)

Lodovico Carracci
*The Transfiguration*
c. 1594–95
Pinacoteca Nazionale, Bologna

# The Parable of the Lost Sheep

In a celebrated passage from the Gospel of John, Jesus referred
to himself as "the good shepherd" who lays down his life for
his sheep. (Jn 10:11) This metaphor has given way to the image
of Christ the shepherd carrying a lamb on his shoulders. A
parable recounted in Matthew and Luke reinforces this image,
for according to Luke, Jesus told this parable to answer the
Pharisees' complaint that he consorted with tax collectors.
A shepherd had 100 sheep and lost one; so he left the other
99 in the desert to go after the missing one until he found it
and brought it back. Jesus compared his role to that of the
shepherd: "I say unto you, that likewise joy shall be in heaven
over one sinner that repenteth, more than over ninety and
nine just persons, which need no repentance." (Lk 15:7) Jesus'
role as a shepherd of souls proclaims the good news of the
coming of the Kingdom of God not just to the faithful, who
readily believe in it, but especially to those who have walked
down the path of sin.

(Mt 18:12–14; Lk 15:1–7)

*The Good Shepherd*
350
Vatican City, Musei Vaticani

# Jesus and the Children

The meeting of Jesus and the children took place in Judaea, on the other side of the river Jordan. A highly spiritual episode, it stresses simplicity, the quality for which God reveals his message to the "little ones," meaning all those groups and classes that the society of the time held in low esteem, including children. When the apostles rebuked the parents who were bringing children to Jesus, he replied, "Suffer little children to come unto me, and forbid them not: for of such is the kingdom of God." (Lk 18:16) Only those who approach God with an artless, trusting heart can enter the Kingdom of Heaven. The popularity of this passage has been mentioned, among other things, to promote church programs for children and teenagers, organized by the oratories of Saint John Bosco in the nineteenth century.

(Mt 19:13–15; Mk 10:13–16; Lk 18:15–17)

Emile Hirsch
*Jesus Blessing the Children* (detail)
1877
Saint-Severin, Paris

# The Payment of the Temple Tax

Jewish law required that every Jewish male over 20 years of age pay an annual tax of half a shekel for the upkeep of the temple. The Lord himself had given this rule to Moses (Ex 30:13–14) as an acknowledgment of God's authority and as a poll tax allowing access to worship freely in the sanctuary. As they were about to enter the temple in Capernaum, Jesus and his disciples were asked to pay the tribute. A doubtful Peter asked his master whether they should pay and how. Christ instructed him how to find the money, even though he felt that paying a tax to enter the house of the Father was unfair, just as a subject is not required to pay a tax to enter his own city (for kings levied entrance tolls only on foreigners). Still, Jesus asked Peter to go to the lake and cast a hook; he would find the tax coins in the mouth of his first catch. The episode has two phases: the meeting with the toll collector and Peter's miraculous catch made possible by Jesus' intercession. (Mt 17:24–27)

Tommaso Cassai,
known as Masaccio
*The Tribute Money*
1420s
Cappella Brancacci,
Santa Maria del Carmine, Florence

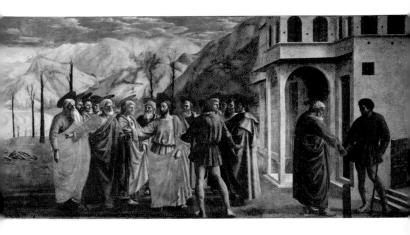

# *Christ Enters Jerusalem*

Christ entered the Holy City five days before he was to be crucified, on the day that Christians call Palm Sunday. Underscoring its importance, the four canonical Gospels all recorded the event. Having reached the outskirts of Jerusalem, Jesus himself told the apostles where they would find a donkey that he would mount to enter the city, and what to say in order to have the owner lend it to them. These explicit instructions to the disciples are reported in the Synoptic Gospels—Mark and Luke mention a male donkey; Matthew a she-ass with her colt (Lorenzetti, in this painting, followed Matthew's text). John merely writes that the disciples casually found the animal on the street. Matthew and John also link Christ's choice of the animal to a prophecy by Zechariah: "Rejoice . . . O daughter of Jerusalem: behold, thy King cometh unto thee: he is just, and having salvation; lowly, and riding upon an ass, and upon a colt the foal of an ass." (Zech 9:9) As Jesus entered the city he was received by a rejoicing crowd that sang hymns, laid their cloaks on the ground before the Messiah, and threw on the ground what Christian tradition would later identify as olive branches, the symbol of glory, but also an unmistakable sign of the impending martyrdom.

(Mt 21:1–11; Mk 11:1–11; Lk 19:28–44; Jn 12:12–19)

Pietro Lorenzetti
*Entry into Jerusalem*
1335–36
Lower Basilica of Saint Francis, Assisi

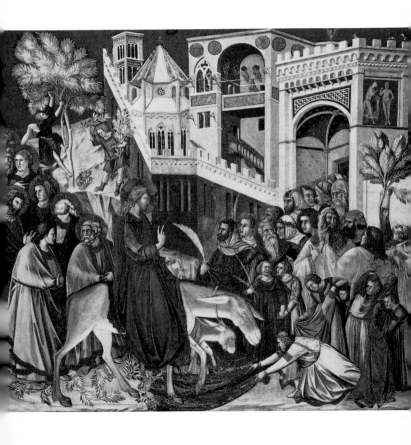

# The Expulsion of the Merchants from the Temple

The expulsion of the merchants from the Temple of Jerusalem is open to different interpretations, depending on the timeframe. While the Synoptic Gospels situate it right after Jesus' entrance into the Holy City, John puts it at the start of Jesus' ministry. In the former, the interpretation is historical, the Evangelists seeing in Christ's actions a possible cause for his arrest; in the latter, it is messianic, Jesus' promise to raise the Temple three days after its destruction a clear comparison between his body and the building. In truth, a flourishing market had grown in and around the Temple, where merchants sold cattle, sheep, and doves to pilgrims who needed to buy sacrificial animals, and money-changers exchanged currency for pilgrims. Jesus flew into a rage at this profanation: He cast out the merchants and their animals and knocked the money-changers' tables over. According to John, Jesus even used a whip made of cords to drive them out. The whip has been included in many works of art to heighten the theatricality of the gesture. All this drew the ire of the scribes and the Temple priests, who began to plot how to get rid of the troublesome prophet whom the people loved so much.

(Mt 21:12–17; Mk 11:15–18; Lk 19:45–48; Jn 2:13–25)

Jacob Jordaens
*Christ Driving the Merchants from the Temple*
c. 1650
Musée du Louvre, Paris

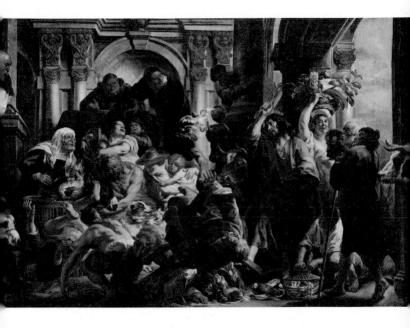

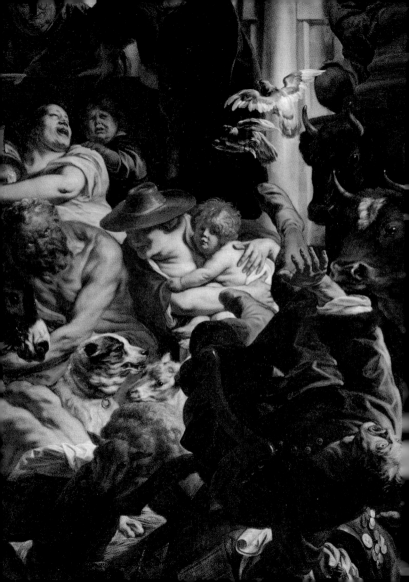

# The Parable of the Barren Fig Tree

The three Synoptic Gospels report this episode, which is very similar in Matthew and Mark, though Matthew places it right after the expulsion of the dealers from the Temple, Mark just before, and Luke during Jesus' journey toward Jerusalem. A hungry Christ saw a fig tree, but as he approached it he realized that it had no fruit, and so he cursed it: "Let no fruit grow on thee henceforward for ever." (Mt 21:19) The tree immediately withered. In Mark, the barren tree could allude to the lack of just, upright men in the Temple that Jesus was about to cleanse. In Luke, the protagonist is not Jesus but a man who, seeing that a fig tree in his vineyard never bore fruit, ordered that it be cut down, but was stopped by his farmer's words. The worker asked the master to wait one more year so that he could fertilize it properly and tend to it more carefully. Dedication to one's work is what leads the farmer to take good care of all the plants, including those that do not initially bear fruit.

(Mt 21:18–22; Mk 11:12–14; Lk 13:6–9)

Liberale da Verona
*The Parable of the Barren Fig Tree*
miniature from a book of religious music
late 15th century
Libreria Piccolomini, Siena

# On Tribute to Caesar

For centuries this passage has been cited in support of arguments over the illegitimacy of the temporal power of the Church. The narrative makes clear that the agents of the Jewish religious authorities were hostile to Jesus, asking him whether it was lawful to pay taxes to the Roman Empire, which at the time ruled Israel. Christ, who rightly mistrusted these people, asked them to bring him a *denarius*, the Roman currency at the time. Then, pointing to the coin, he asked: "Whose is this image and superscription?" They replied that it was the Caesar, the Roman emperor. And so Jesus retorted: "Render to Caesar the things that are Caesar's, and to God the things that are God's." (Mk 12:13–17) Christ did not suffer greediness and felt that faith in God ought to be completely detached from power and money. Several episodes in the Gospels, including the expulsion of the merchants from the Temple and Judas's betrayal, reflect this attitude. In this extraordinary painting by Titian, Christ is portrayed in all his holiness, calmly looking at the Roman coin that an ambiguous, hypocritical figure is showing to him with the same crafty look of the religious authorities described in the Bible.
(Mt 22:15–22; Mk 12:13–17; Lk 20:20–26)

Tiziano Vecellio, known as Titian
*The Tribute Money*
1516
Gemäldegalerie, Dresden

# The Destruction of Jerusalem

The Synoptic Gospels place Jesus' prediction of the destruction of Jerusalem and the end of times just before the Passion. Using a language reminiscent of apocalyptic literature, in a few lines Christ foretold the history of the early Church that was to labor under persecutions and internal crises, then predicted that the Gospel would spread throughout the world. The Temple of Jerusalem would be destroyed, the city devastated, and all the people of Judaea forced to flee for their lives. Certainly the three Evangelists, whose accounts are almost identical, must have reworked the words of the Messiah in light of the siege and destruction of Jerusalem wrought by the Roman army in AD 70. Many artists have been inspired by this event and have represented the conquest by concentrating on the destruction of its very symbol, the Temple, and the carrying away of the Ark of the Covenant, the most sacred Jewish relic, now become mere spoils of war.

(Mt 24:1–35; Mk 13:1–37; Lk 21:5–37)

Francesco Hayez
*The Destruction of the Temple
of Jerusalem*
1867
Galleria d'Arte Moderna, Venice

# The Parable of the Wise and the Foolish Virgins

This parable, a metaphor for the Kingdom of Heaven, appears only in the Gospel of Mark. Ten virgins, five of them sensible and five foolish, were waiting for the bridegroom. The first five took extra lamp oil with them while the others forgot. When the bridegroom was about to appear, the foolish five asked the wise virgins to lend them the extra oil but the latter refused because there was not enough to go around for everyone, and suggested that they go and buy the oil. In the meantime, the bridegroom arrived and the wise virgins went with him into the wedding hall and the door was shut. When the foolish virgins came back with the oil and asked to be admitted, the bridegroom pretended not to know them. The moral in this tale is that we should be careful and alert, for no one knows the day or the time when God will open His Kingdom. The lit lamp that the wise virgins hold aloft is a symbol of the light of God; it represents the caution we ought to exercise in choosing the right path.

(Mt 25:1–13)

Peter von Cornelius
*The Wise and Foolish Virgins*
1813
Museum Kunst Palast, Düsseldorf

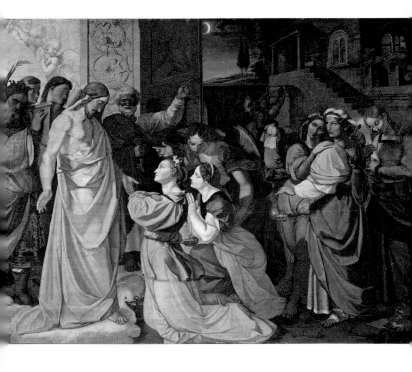

# The Parable of the Talents

Matthew and Luke tell the same parable with small variations. The main character is either a wealthy landowner or a nobleman who had to travel abroad. He summoned three of his servants and entrusted some talents with them. The number of servants is the same in both Gospels, but the amount of money varies. In Matthew they receive five, two, and one talent, while in Luke the nobleman gave one mina to each servant. Upon his return, the master summoned the three men and asked for an account of the money. The first servant had doubled the principal (in Luke, he had increased it tenfold); the second servant, who had received two talents, had also doubled it (in Luke, he had increased it fivefold). The third returned the one coin he had received, which he had jealously kept wrapped in a napkin (or, according to Matthew, buried). After praising the first two men, the master grew angry at the third because instead of making the money yield, he had simply stored it away. The meaning of the parable is clear: Christ invites the faithful to use the gifts that the Lord has bestowed upon them, each one based on their ability.

(Mt 25:14–30; Lk 19:11–27)

Matthäus Merian
*The Parable of the Talents*
from the *Bible of Sieur du Royaumont*
1670
Private collection

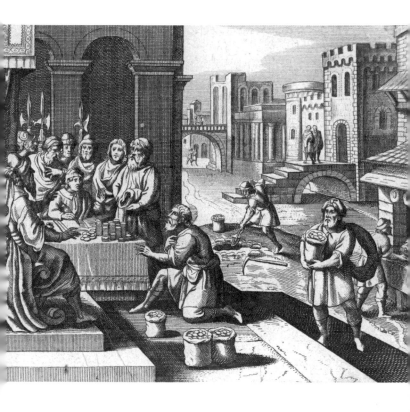

# The Supper at the Home of the Pharisee

Matthew, Mark, and John place the supper at the home of Simon, the Pharisee, before the Passion (in John, the venue is the home of Martha and Mary, Lazarus's sisters). Only Luke located the episode at the center of Jesus' ministry. A woman approached the Messiah with an alabaster jar full of costly ointment and poured it on his head (in Matthew and Mark) or, in the version that has enjoyed more popularity in art, on his feet, which she then wiped with her own hair. Seeing this, the disciples were indignant because the unguent was very costly, but Jesus soothed them, saying, "For in that she hath poured this ointment on my body, she did it for my burial." (Mt 26:12) Then he forgave her sins, increasing the murmurings, for the bystanders were asking each other, "Who is this that forgiveth sins also?" (Lk 7:49) The apocryphal tradition identifies the repentant sinner with Mary Magdalene.
(Mt 26:6–13; Mk 14:3–9; Lk 7:36–50; Jn 12:1–11)

Alessandro Bonvicino,
known as Moretto da Brescia
*Supper at the Home of the Pharisee*
*c.* 1550
Santa Maria in Calchera, Brescia

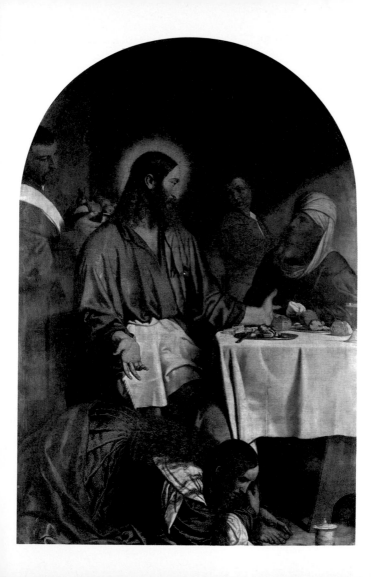

# The Betrayal of Judas

In the Gospels of Matthew, Mark, and Luke, the apostle Judas—called Iscariot perhaps because he came from Cariot (a hotbed of radical zealots who resisted Roman occupation)—voluntarily approached the chief priests and offered to hand Jesus over to them. They paid him 30 silver pieces. John does not record this episode; he makes no reference to the monetary agreement between Judas and the priests, although he recounts that Jesus revealed the traitor's betrayal at the Last Supper. The shameful deal between Judas and the Jewish authorities and the events leading to the death of Jesus were the foundation of Christian anti-Semitism. Over time, the responsibility for the death of Christ was unjustly extended to the entire Jewish people, and for this reason the Jews have been often portrayed grotesquely. For example, the figure sitting at the left in this miniature has a double chin and a very large nose.

(Mt 26:14–16; Mk 14:10–11; Lk 22:1–6)

Giovanni Pietro Birago
*Judas Is Paid*
miniature from the *Sforza Hours*
c. 1490
British Library, London

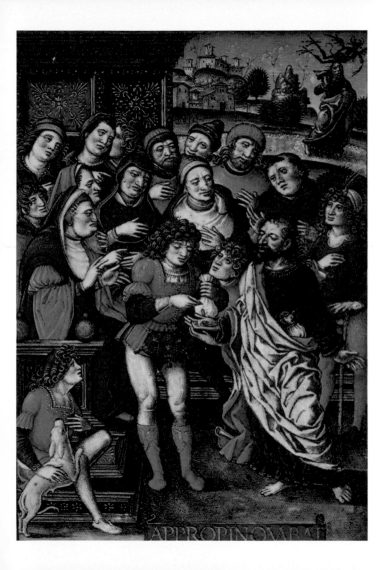

# The Washing of Feet

The episode of the washing of feet appears only in John, where it takes place at the beginning of the Last Supper, and for this reason both episodes have sometimes been represented together. When the scene stands alone, artists have depicted the dismay of the apostles as Christ knelt to perform a task usually reserved for slaves. For Jesus, it was one more teaching occasion, as he explained that if he, the "Lord and Master," washed their feet, they also must wash each other's feet. (Jn 13:14) Peter has usually been portrayed as embarrassed and reluctant to have his Lord humble himself before him. In the Gospel, Christ calmly explained that he would understand the gesture later, but Peter continued to insist, and so the Messiah replied that by so doing the disciple would be able to "have share" with him. (Jn 13:8)

(Jn 13:1–20)

Giovanni Agostino da Lodi
*Washing of the Feet*
1500
Gallerie dell'Accademia, Venice

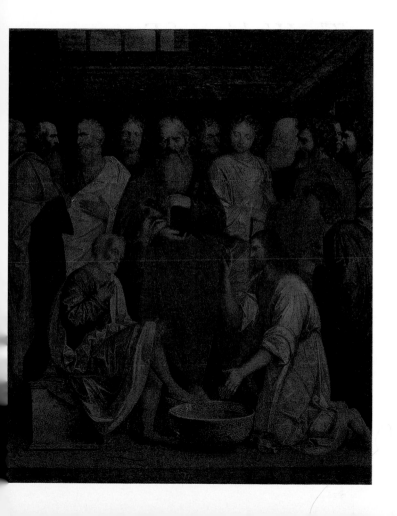

# The Last Supper

Like all good Jews, on "the first day of Unleavened Bread," which that year fell on a Thursday, Jesus wanted to sit down at dinner with his disciples and partake in the sacrifice of the Paschal lamb. (Mk 14:12) Aware that his earthly life was coming to an end, on the evening before he died Christ sat at the table with his friends, took bread and wine, blessed them, and proclaimed that they were his body and his blood. All the Evangelists, with the exception of John, have recorded the origin of the sacrament of the Eucharist. Generally, the scene has been rendered with Jesus seated at the center of the table, blessing a loaf of bread or the Eucharistic host held above a chalice, priestlike. But the best-known moment, and the one most represented in art, is Christ's warning, "One of you shall betray me." (Jn 13:21) Leonardo da Vinci has masterfully interpreted the apostles' different, all too human reactions, including that of Judas, who in earlier paintings was portrayed as isolated, sitting on the other side of the table or leaving the cenacle. (Mt 26:17–29; Mk 14:12–25; Lk 22:7–23; Jn 13:21–30)

Leonardo da Vinci
*The Last Supper*
1498
Santa Maria delle Grazie, Milan

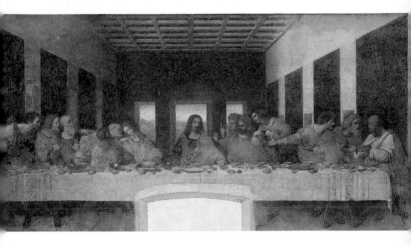

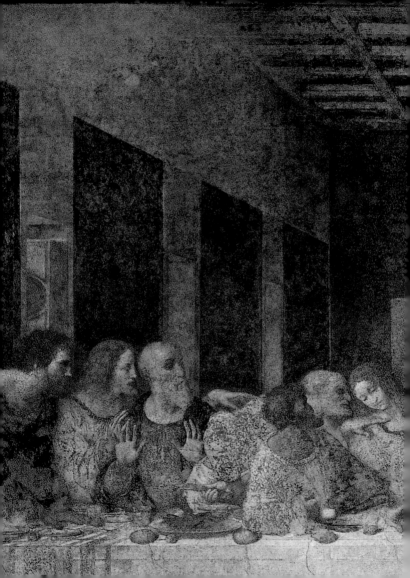

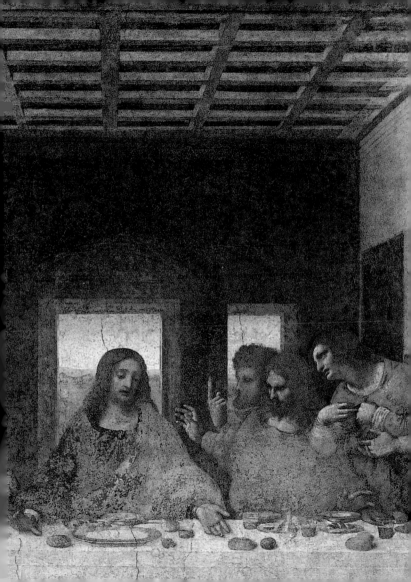

# The Prayer in the Garden of Gethsemane

Immediately after expressing his profound awareness of the ordeal that awaited him at the Last Supper, Jesus revealed his humanity as he experienced a spiritual crisis. Anguished and sorrowful, he retired to the Mount of Olives with his disciples Peter, James, and John. Withdrawing from them, he asked God to allow him to avoid death. But immediately his inner strength came back and he submitted gloriously to God's will. Walking back to his companions, he found them asleep. He awoke them and asked them to stand watch, that they might not be tempted. The hour of his capture was at hand. In this painting by Giovanni Bellini, the rocky, desolate background mirrors the lonely soul of Jesus in this extremely sad moment, deserted by the apostles, who have fallen asleep. Before him appears the angel of the Lord who, according to Luke, came down from Heaven to give him strength.

(Mt 26:36–46; Mk 14:32–42; Lk 22:39–46)

Giovanni Bellini
*Agony in the Garden*
*c.* 1465
National Gallery, London

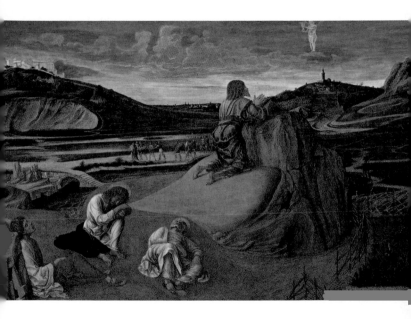

# Christ Is Arrested

As Jesus was talking to his disciples on the Mount of Olives, the guards sent by the chief priests and led by Judas Iscariot appeared. While the Synoptic Gospels report that the traitor helped the guards recognize Christ by kissing him, according to John it was Jesus who came forward and identified himself. The kiss, which is described explicitly in Matthew, is surely what has most inspired artists in depicting this scene. This masterpiece by Caravaggio highlights Judah's aggressive gesture in the foreground and is filled with important details, such as the flight of the frightened apostles. But the painting has left out the angry Peter, who reacted by drawing a sword and cutting off the ear of one of the soldiers. Jesus rebuked him and asked him to place the sword back in its sheath.

(Mt 26:47–56; Mk 14:43–52; Lk 22:47–53; Jn 18:10–11)

Michelangelo Merisi da Caravaggio
*Taking of Christ*
*c.* 1598
National Gallery of Ireland, Dublin

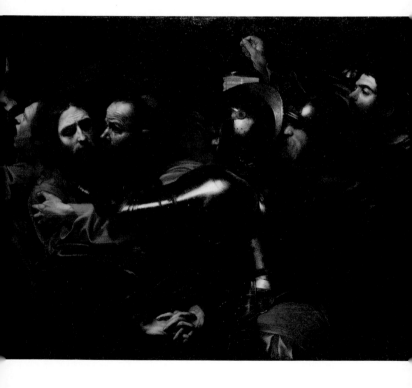

# Christ Before Annas

After his arrest, Jesus was brought to the Sanhedrin, where the priests and the elders assembled, in order to be tried. Only John explicitly reports that Jesus was first led before Annas, the former High Priest and father-in-law to Caiaphas, who was High Priest that year. Annas was a feared, influential figure in Israel; it was thanks to him that Caiaphas had succeeded him to the High Priest's chair. Among other things, Annas hated Jesus because he was hostile to the Pharisees, who hypo-critically showed intransigence on matters of faith and of Hebrew Law but were loose in their application. Annas him-self had made the pact with Judas for Christ's capture. Out of respect for his father-in-law, Caiaphas preferred that Jesus be brought before Annas first, before trying him.

(Jn 18:12–24)

Duccio di Buoninsegna
*Christ Before Annas*
detail from the *Maestà*
1308–11
Museo dell'Opera del Duomo, Siena

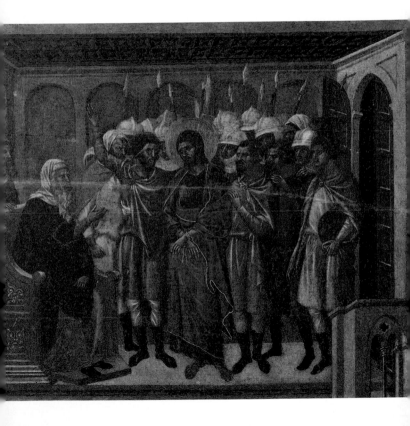

# *Christ Before Caiaphas*

As Jerusalem's High Priest, it was Caiaphas's responsibility to preserve the delicate balance between the religious needs of the more radical groups and the mood of the Roman occupiers. One action by Jesus—the expulsion of the money-changers and merchants from the Temple—is what perhaps had caused the balance to teeter. Still, the Gospels suggest that there was no real offense to prompt Christ's arrest; but Caiaphas was a good dialectician and led Jesus to admit that he was God, thus uttering what the Jews considered blasphemy. In art, this episode is sometimes interchangeable with the earlier appearance before Annas, for in both cases artists have portrayed a man sitting on a throne, wearing a headdress that identifies him as a priest, with the bound Jesus standing before him surrounded by armed guards, like a dangerous criminal. (Mt 26:57–68; Mk 14:53–65; Lk 22:66–71; Jn 18:24)

*Christ Before Caiaphas*
detail from the *Calvary*
1602
Plougastel-Daoulas

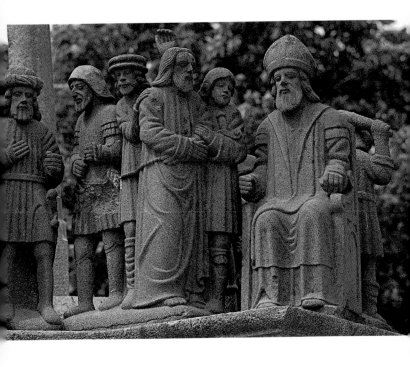

# Peter's Denials

At the Last Supper, when Jesus revealed to his disciples that there was a traitor among them, he also told them that he would be with them only for a short while yet. At that point Peter asked to follow him wherever he went, but Christ explained that for the time being Peter must let him go, in order to follow him later. The apostle insisted that he would give his life for Jesus, and the latter replied that before the cock crowed, Peter would disown him not once, but thrice. After Jesus was seized, the disciple followed from afar the armed escort toward the Sanhedrin. During the "trial" a woman insisted that she had noticed Peter among Jesus' apostles, but Peter denied it three times. When he heard the cock crow, he remembered the words of his master, repented, and wept bitterly. This painting by Georges de La Tour portrays Peter's tears. The cock on the table merely serves to identify the figure; the true protagonist is the apostle's repentance, his human emotions.

(Mt 26:69–75; Mk 14:66–72; Lk 22:54–62; Jn 18:15–27)

Georges de La Tour
*Saint Peter Repentant*
1645
Cleveland Museum of Art, Cleveland

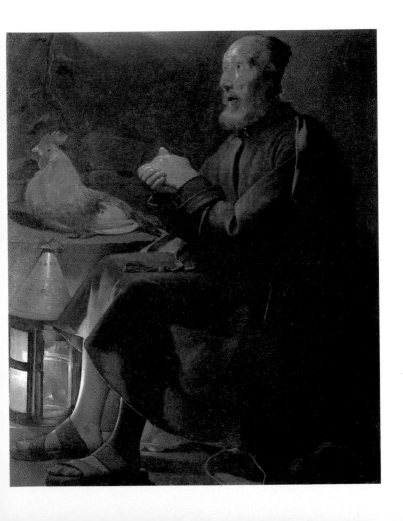

# Judah's Repentance

Perhaps out of a desire to totally erase from memory Christ's betrayer, except for a brief mention in the Acts of the Apostles, only the Gospel of Matthew reports this episode. When he saw Jesus sentenced to death, Judas was filled with remorse and flung the silver pieces he had received at the chief priests, then hanged himself. To Christians, suicide is a more sacrilegious sin even than betrayal, for man has no right to take the life that God has given him. For this reason, although he repented, Judas has been portrayed surrounded by devils who help him hang himself so they can carry his soul to Hell. After his death, the chief priests realized that they could not put Judas's money into the Temple treasury, for those coins were "the price of blood" (Mt 27:6), and so they decided to use it to buy a field as a graveyard for foreigners. Perhaps for this reason, starting in the sixth century, in addition to being a religious sin, suicide also became a criminal offense. The body of a suicide could not be buried in a consecrated Christian cemetery, a requirement for entrance to Heaven. Fortunately, in the spirit of Christ, this rule is no longer applied strictly today, and in many cases funerals are allowed for those who have taken their own lives.

(Mt 27:1–10)

*Judas's Suicide*
1140
Saint-Lazare, Autun

# Christ Before Pilate

After he was tried by Caiaphas, Christ was brought before Pontius Pilate, the Roman governor of Israel who, around the year AD 30, was in Jerusalem (his headquarters were in Caesarea) for the Jewish Passover. Around that time, various radical religious groups were threatening to riot, and thus it was necessary to have the army standing by. When Jesus was brought before him, Pilate thought he was a rebel, but finding no fault with him tried to shift the responsibility to Herod, who had jurisdiction over Galilee, Jesus' homeland. In this case also, artists have treated this episode like other interrogations of Jesus before authorities.

(Mt 27:11–14; Mk 15:1–10; Lk 23:1–7; Jn 18:28–31)

Giovanni Francesco delle Croci
*Christ Before Pilate*
1501
Tesoro di San Francesco, Brescia

# Christ Before Herod

Herod Antipas, king of Galilee, was the son of Herod the Great. He was glad to receive Jesus because he thought he might witness a miracle or two. He knew him by reputation, for the people spoke about him, John the Baptist in particular, whom he had beheaded to satisfy a young woman's whim. He questioned Jesus but received no reply. Spurred on by the chief priests, after mocking and deriding Jesus, Herod "arrayed him in a gorgeous robe" and sent him back to Pilate, for he too had found no reason to condemn him. This episode is reported only in Luke's Gospel. The scene is usually represented with Jesus standing like a prisoner before the king seated on a throne.

(Lk 23:8–12)

Andrea Schiavone
*Christ Before Herod*
*c.* 1550
Museo Nazionale di Capodimonte,
Naples

# The Scourging

Piero della Francesca has set the scourging scene in daylight, in the courtyard of the Praetorian Palace. Tied to a column topped by a Roman idol, Jesus is whipped by three villains before Pontius Pilate, who looks on from the left. In the Bible, the episode is not described; only a brief sentence refers to it. The artist therefore used his imagination. Justice was not to prevail, and Jesus would be sentenced to death. This work by Piero della Francesca expresses the immense injustice of this torture by relegating it to the background so that Christ's physical suffering is not visible; a hieratic figure, he seems to stoically bear the lashes. What the artist has brought to life is the indifference to this violence, symbolized by the three mysterious figures in the foreground (many theories have been put forward about their identity) who seem unmoved by the momentous event unfolding nearby. The painting can be seen as a metaphor of how politics and power can unjustly sacrifice human lives in order to restore "law and order."

(Mt 27:26; Mk 15:15; Lk 23:13–16; Jn 19:1)

Piero della Francesca
*The Flagellation*
*c.* 1455
Galleria Nazionale delle Marche,
Urbino

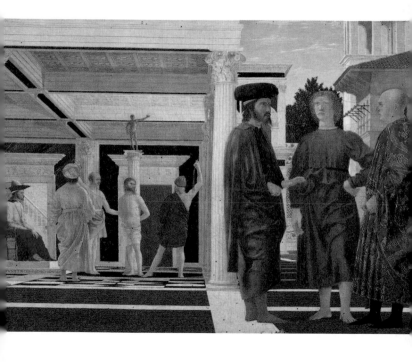

# *Barabbas*

It was customary to pardon and release a prisoner for the Passover festival. Searching for a way to exculpate Jesus, Pilate thought of asking the crowd if they wanted to free him. Unexpectedly, however, they called for the release of another prisoner, Barabbas, who had been jailed on charges of sedition and murder. Both Matthew and Mark explain the reason for this choice as the pressure that the elders and the chief priests exerted on the crowd to ask for the murderer's release. This particular painting by Daumier has a contemporary political significance; it is the image of a people who neither resist nor react to power, but rather submit to being led without realizing it.

(Mt 27:15–23; Mk 15:9–15; Lk 23:16–21; Jn 18:38–40)

Honoré Daumier
*We Want Barabbas*
1850
Folkwang-Museum, Essen

# *Pilate Washes His Hands*

The multitude was pressuring Pontius Pilate, vociferously demanding that Jesus be crucified, but all along Pilate realized that he had no grounds to sentence him to die. He was also reflecting about his wife's warning: "Have thou nothing to do with that just man." (Mt 27:19) For she had a dream that predicted misfortune from this. Still, to ward off a riot, the governor gave in to the crowd's demands. So he took some water and washed his hands, saying: "I am innocent of the blood of this just person: see ye to it." (Mt 27:24) From his gesture comes the expression "to wash one's hands of something," to signify not taking a position but leaving a decision to others. And so Pilate released Barabbas and delivered Jesus to the crowd. The most frequent rendering of this scene, also used by Dürer, has the governor standing with a servant holding a pitcher and pouring water on his hands. On the right is Christ being led away by soldiers.

(Mt 27:24–26)

Albrecht Dürer
*Small Passion: Pilate Washing His Hands*
1511
Galleria degli Uffizi, Florence

# Christ Is Crowned with Thorns

The soldiers continued to mock Jesus. They led him into the courtyard of the Praetorian Palace where he had probably just been scourged. They dressed him in a scarlet cloak and put a crown of thorns on his head. The men were mocking him because he had neither denied (nor confirmed) to Pilate that he was the king of the Jews. They struck his head with a reed, spit on him, and worshipped him on their knees. The villains are usually represented placing the crown of thorns on his head, using sticks to avoid being pricked. In this painting by Bosch, one villain even holds the crown of thorns with a metal glove. Here Jesus is not dressed in the scarlet cloak of kings, but in a white tunic that recalls the Holy Shroud, the sheet in which his body would be wrapped after his death. The thorns from the crown are an extremely important relic in Italy to this day.

(Mt 27:27–29; Mk 15:16–19; Jn 19:1–3)

Hieronymus Bosch
*Christ Mocked (Crowning with Thorns)*
1495–1500
National Gallery, London

# "Ecce Homo"
# (*"Behold the man"*)

The *Ecce Homo* is a specific iconography of Christ whose title comes from the words that Pontius Pilate spoke to the Jews as he showed them the scourged Messiah: "Behold the man!" (Jn 19:5) It is Christ covered by welts and bleeding wounds: not the king of the Jews, but the man whom the multitude wanted punished even without justification. With these words, the Roman governor unwillingly pointed to the truth of the double nature—human and divine—of Jesus. This masterpiece by Antonello da Messina highlights the human reality of Christ's suffering and despair, with the tears streaking down his mournful, indignant face. The dark background heightens the face of Jesus that seems to rise from the depths of the wood panel.

(Jn 19:5)

Antonello da Messina
*Ecce Homo*
1474
Galleria Nazionale di Palazzo
Spinola, Genoa

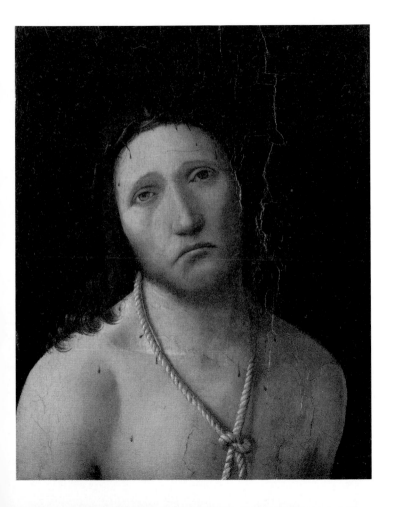

# The Way to Calvary

After the judgment, Jesus was forced to carry his own Cross up Mount Golgotha (the Greek name is from the Aramaic *Gulgotha*; it is also known as Calvary, from the Latin *Calvaria*, "the place of the skull") with only the help of Simon of Cyrene. They offered him "vinegar to drink mingled with gall" (Mt 27:34), the drink that was given to those about to die because it reduced sensation to pain, but he refused. The Gospels simply record that he reached the top of the hill; only Luke writes that some women along the way "also bewailed and lamented him." (Lk 23:27) But Jesus berated them not to weep for him, for he was going to his Father in Heaven. The ritual of the Way of the Cross and all the artistic renderings of the subject are drawn from devotional, nonbiblical tradition. Here Raphael has portrayed the Redeemer falling on the way to Calvary and looking at his mother, who is held up by Mary Magdalene and the pious women.

(Mt 27: 32–34; Mk 15:20–23; Lk 23:26–32; Jn 19:17)

Raffaello Sanzio,
known as Raphael
*Christ Falls on the Way to Calvary*
1517
Museo Nacional del Prado, Madrid

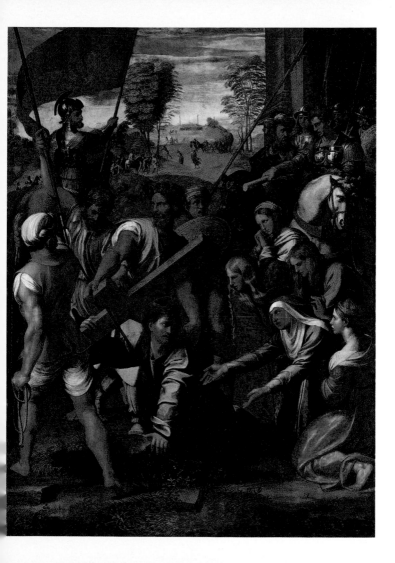

# *The Crucifixion*

The cross was not a Christian symbol at first. Its adoption as a meditation on Christ's agony developed in the early Middle Ages, after the Germanic populations invaded the Roman Empire. Later, the word "compassion"—from the Latin *cum passione*—was coined, where *passio* indicated, in the liturgical glossary, the Passion of the Christ. Symbolism became very important in portraits of the Crucifixion; in this painting by Bramantino, for example, Jesus is between the Old and New Testaments, symbolized by the Moon and the Sun. At the foot of the Cross is a skull, symbolizing not just Mount Calvary but also Adam, for according to a legend, he was buried in the exact spot where the Cross was erected. Thus Christ's sacrifice finally redeemed human sin.

(Mt 27:32–34; Mk 15:20–23; Lk 23:26–32; Jn 19:17)

Bartolomeo Suardi,
known as Bramantino
*Crucifixion*
c. 1515
Pinacoteca di Brera, Milan

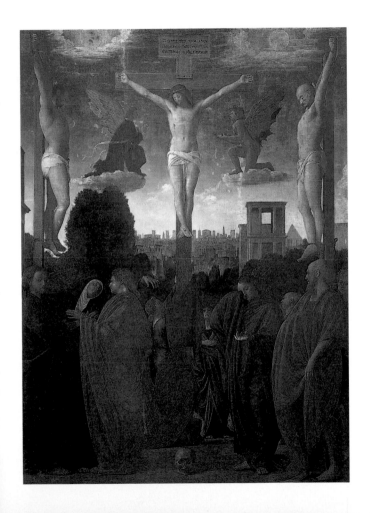

# The Parting of the Garments

The Evangelists seem to have been inspired by the Psalms in reporting some aspects of the Crucifixion of Jesus, such as the parting of Jesus' garments, for which the Roman soldiers cast lots under the Cross. Some verses from Psalm 22, such as the prayer of a just man who is about to die, seem to prophesy the event: "They pierced my hands and my feet. I may tell all my bones: they look and stare upon me. They part my garments among them, and cast lots upon my vesture." (Ps 22:16–18) This outrageous act has sometimes been included in the background of Crucifixion scenes. Sitting on the ground, the soldiers cast lots without being troubled or feeling pity for the men who are dying next to them. They all hope to win the scarlet tunic (an allusion to the blood that is being shed), the quality and fabric of which they admire so much. (Mt 27:35; Mk 15:24; Lk 23:34; Jn 19:23–24)

Andrea Mantegna
*Crucifixion* (detail)
1457–59
Musée du Louvre, Paris

# Jesus and the Good Thief

On Calvary with Jesus two common criminals were also crucified. Only Luke recounts how, as the crowd was mocking Christ, one of the thieves hanging from the cross also began to jeer at him: "If thou be Christ, save thyself and us." (Lk 23:39) But the other wrongdoer spoke up and rebuked him, pointing out that they deserved their punishment and were to fear God's judgment, while Christ had done nothing wrong. Then he turned to Jesus, asking him to remember him when he came into the Kingdom of Heaven. The Messiah promised that they would be together in Paradise on that very day. Many iconographies of the Crucifixion have the three crosses with the good and the bad thief recognizable from their facial expressions. This work by Titian focuses on Christ and just one of the thieves, who is unidentifiable, though presumed to be the one defending Jesus; for his part, Jesus wears a sad, suffering expression and does not reply to the nasty comments. (Lk 23:33–43)

Tiziano Vecellio, known as Titian
*Christ and the Good Thief*
*c.* 1566
Pinacoteca Nazionale, Bologna

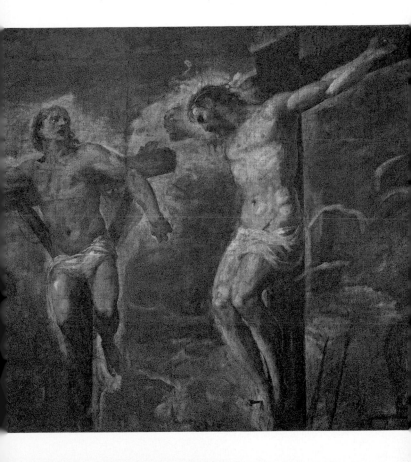

# *"Behold Thy Mother!"*

When Jesus was crucified, they nailed a sarcastic inscription above his head: "This is Jesus the King of the Jews." (Mt 27:37) Paintings or sculptures of this scene often include a scroll with the initials "INRI," which stand for the Latin words *Iesus Nazarenus Rex Iudaeorum* (Jesus Nazarene King of the Jews). John is the only Evangelist who paid any attention to Mary, the Mother of Jesus. For she despairingly stood below the Cross with Jesus' dearest apostle, John the Evangelist himself, who was a direct witness to the event. Christ addressed his last thoughts to the two people he loved, asking them to take care of each other. For this reason many Crucifixions, especially more intimate, devotional works, depict only Mary and John without the crowd or the soldiers, thus highlighting Jesus' human, merciful qualities.

(Jn 19:25–27)

Carlo Crivelli
*Crucifix with the Virgin and
Saint John the Evangelist*
1486
Pinacoteca di Brera, Milan

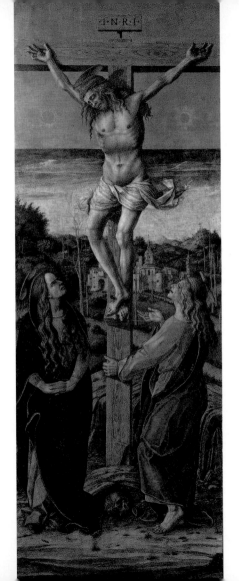

# *The Sponge Soaked in Vinegar and the Spear in the Side*

Like the parting of the garments, another Crucifixion scene seems to have been inspired by a Psalm: the offer to the thirsty Jesus of a sponge soaked in vinegar. Psalm 69 expresses a mortal agony: "They gave me also gall for my meat; and in my thirst they gave me vinegar to drink." (Ps 69:21) Even the words that Jesus spoke to God just before expiring are reminiscent of the Psalms. In the Gospels of Matthew and Mark, Christ cried out: "My God, my God, why hast thou forsaken me?" (Mt 27:46), which is the opening verse of Psalm 22. According to Luke, he cried out, "Father, into thy hands I commend my spirit" (Lk 23:46), which is a verse from Psalm 31. Only John noted that, since it was the day before Passover, the bodies of the crucified could not hang overnight on the crosses. Therefore the soldiers were ordered to break their legs to hasten their death. But because Jesus was already lifeless, a soldier pierced his side with a lance and blood flowed out mixed with water, verifying that he had indeed died. For immediately after death, blood continues to flow together with the water released by the torn flesh.

(Mt 27:48–56; Mk 15:33–41; Lk 23:44–49; Jn 19:28–37)

*The Crucifixion*
miniature from *The Prayer Book of Jeanne de Laval*
16th century
Bibliothèque Municipale, Poitiers

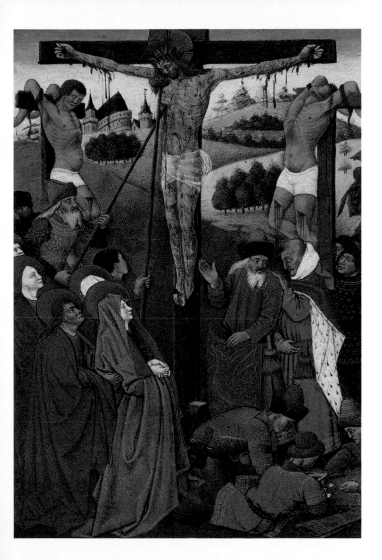

# The Deposition in the Tomb

After Jesus died, a man named Joseph from Arimathaea, a city in Judaea that is difficult to identify, appeared before Pilate asking permission to remove the body. Pilate granted it, so Joseph and Nicodemus wrapped the body of Jesus in a shroud and laid it in the tomb that Joseph had had built for himself. Each of the four Gospels approaches these men differently. Only John mentions Nicodemus, who was a Pharisee and a Jewish leader who had visited Jesus soon after he had come to Jerusalem, accepting him as the Son of God (Jn 3:1–3), but all four Gospels mention Joseph of Arimathaea: Mark and Luke note that he was a member of the Sanhedrin, while in Matthew and John he was simply a wealthy man. The Gospels also speak of the presence of the women (Lk 23:55–56): Mary of Magdala and the other Mary (Mt 27:61), whom Mark identifies as Joseph's mother (Mk 15:47). Artists have often portrayed the "other Mary" mentioned in Matthew as the Mother of God, not of Joseph, as Mark had specified, probably because it is difficult to believe that a mother would not want to stay by her son until he breathed his very last.

(Mt 27:57–61; Mk 15:42–47; Lk 23:50–56; Jn 19:38–42)

Pieter Paul Rubens
*The Deposition*
1602
Galleria Borghese, Rome

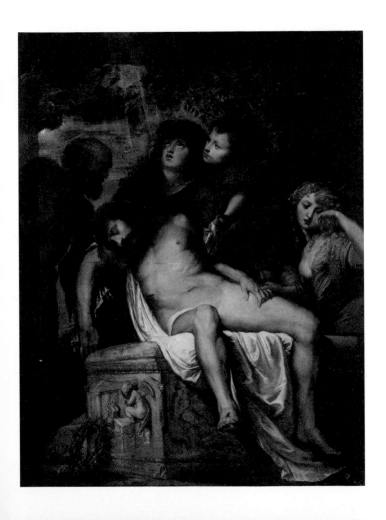

# The Resurrection

The Resurrection of Christ has fascinated artists since the early Christian era. In addition to the literary description, which we find only in Matthew, of the frightened soldiers who seem to have fainted, and the accounts of the other Evangelists who recorded in detail the women's shock before the empty tomb, a very effective iconography developed over time to symbolically render the event. Starting in the fourteenth century, we have representations of a Jesus in glory, whose aspect is "like lightning" (Mt 28:3) floating over the open, empty tomb. The etymological meaning of the Greek *anastasis*, which has been translated as "resurrection," is neutral in the sense that it means to rise, to get up, to awaken, just like the rising sun that surrounds Jesus in this splendid painting by Grünewald.

(Mt 28:1–15; Mk 16:1–13; Lk 24:1–12; Jn 20:1–10)

Matthias Grünewald
*Resurrection*
detail from the *Isenheim Altarpiece*
1509–12
Musée d'Unterlinden, Colmar

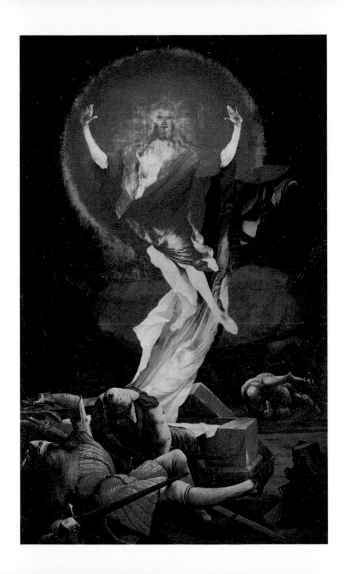

# Noli me tangere
## *("Touch me not")*

In the Gospel of John, after coming upon the empty tomb, Mary Magdalene immediately told Peter and "the other disciple, whom Jesus loved" (Jn 20:2), i.e., the Evangelist himself. The two apostles ran to the tomb, but only saw the linen cloths and the shroud rolled up in a corner, and so they decided to return home. But the woman who stayed behind met the resurrected Jesus, who asked her to go to the disciples to tell them that he was ascending to the Kingdom of Heaven. Mary Magdalene obeyed, and thus became the first messenger of the Resurrection. Mark also mentions this episode, though more summarily (Mk 16:9–10). The title of this scene and its visualization highlight the words that Jesus addressed to the woman who had recognized him: "Touch me not; for I am not yet ascended to my Father." (Jn 20:17) To increase the pathos, many artists have portrayed an ecstatic Mary Magdalene about to embrace her master.

(Jn 20:11–18)

Denis Calvaert
*Noli me tangere*
1619
Pinacoteca Nazionale, Bologna

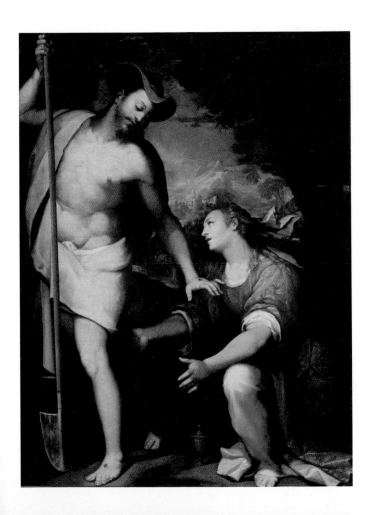

# The Women at the Tomb

On the first day after the Passover Sabbath, the pious women went to visit the tomb and prepare Jesus' body in accordance with Jewish custom. While John does not mention other women in addition to Mary Magdalene, the other Evangelists do. In Matthew, there was Mary Magdalene and "another" unidentified Mary; in Mark, in addition to the Magdalene there was Mary the mother of James and Salome; in Luke, the Magdalene was accompanied by Joanna, Mary the mother of James, and other women. Thus the importance of the women as witnesses to the extraordinary event was unanimously recognized. We note, incidentally, that in Jewish and in Greco-Roman antiquity, the legal value of women's testimony was very low. Interestingly, Jesus' first disciples were criticized on this account, because they championed "the weakest," in particular, women and children.

(Mt 28:1–10; Mk 16:1–8; Lk 24:1–12; Jn 20:1–18)

Bartolomeo Schedoni
*The Two Marys at the Tomb*
1613
Galleria Nazionale, Parma

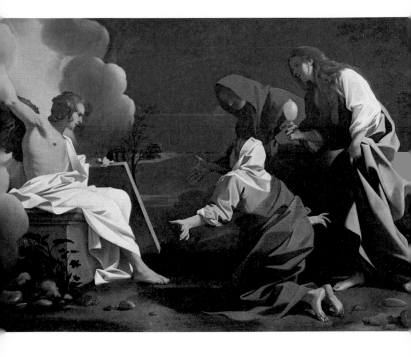

# The Supper at Emmaus

Only the Gospel of Luke records the episode of two disciples who were on their way to Emmaus, a village about ten kilometers from Jerusalem. While they walked, the men were commenting on the recent events surrounding Jesus. A foreigner drew alongside them and joined in the discussion, explaining to them the relationship between Jesus and the Scriptures. Excited about their new acquaintance, the disciples invited him to supper. When they were seated at the table, the guest broke the bread using the same ritual that he had instituted at the Last Supper. Then the disciples recognized Christ, but he had already vanished. The men decided to return forthwith to Jerusalem to inform the others of what they had seen. Representations of this scene usually center around Jesus' blessing of the bread, as the image of his resurrected body. (Lk 24:13–35)

Jacopo Carucci,
known as Pontormo
*Supper at Emmaus*
1525
Galleria degli Uffizi, Florence

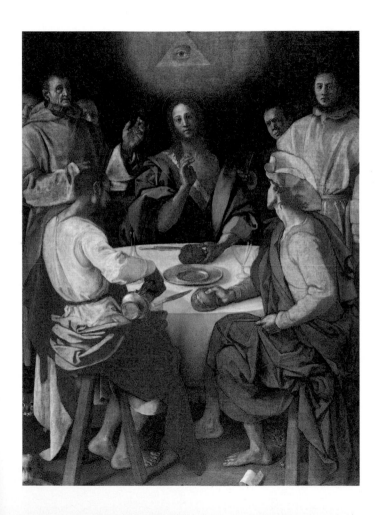

# The Mission of the Apostles

While the four Evangelists all recount Christ's apparition to the apostles, they differ about the places where the extraordinary event took place. Mark and Matthew write that after their master's death, the disciples went to Galilee; according to Luke and John, they stayed in Jerusalem. Still, the message in the four versions is the same in that Christ upbraided them for not believing the women's announcement. And he gave them an important task: "Go ye into all the world, and preach the gospel to every creature." (Mk 16:15) From this command that Christ gave to his disciples originated what the apostles themselves never dreamed that they could create: Christianity.

(Mt 28:16–20; Mk 16:12–17; Lk 24:36–49; Jn 20:19–23)

Tommaso Minardi
*The Mission of the Apostles*
1848–58
Palazzo del Quirinale, Rome

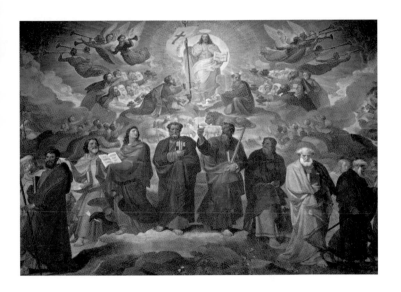

# The Doubting Thomas

When Jesus appeared for the first time to the apostles gathered together, Thomas, who was also called Didymus ("the Twin"), was not there and did not believe his companions. He said to them, "Except I shall see in his hands the print of the nails, and put my finger into the print of the nails, and thrust my hand into his side, I will not believe." (Jn 20:25) Eight days later, when the apostles were all together again, Christ appeared to them and spoke thus to Thomas: "Reach hither thy finger, and behold my hands; and reach hither thy hand, and thrust it into my side: and be not faithless, but believing. . . . Blessed are they that have not seen, and yet have believed." (Jn 20:27–29) This episode, a metaphor for all the Christians who believe in Jesus and his Word though they have never seen him, has been the subject of some macabre works of art, with Thomas literally thrusting his finger in Christ's wound; some sculptures in particular, have a classical, hieratic quality, which is at the same time all too physically human. (Jn 20:24–29)

Andrea di Michele di Francesco de' Cioni,
known as Verrocchio
*Christ and Saint Thomas*
1467–83
Orsanmichele, Florence

# The Ascension

The Ascension of Christ to Heaven is mentioned in Luke and in Mark. It is also described in the Acts of the Apostles, from which artists have derived most of the elements for their iconographies, such as the site (the Mount of Olives) and the two white-clothed men (the angels). Other elements, such as the footprints Jesus left on the ground or the presence of Mary his mother, are inventions, suppositions, or imagination. This work by Tintoretto depicts Jesus ascending to Heaven escorted by the angels, as the apostles and the women look at the clouds from the ground below.

(Mk 16:19–20; Lk 24:50–53; Acts 1:1–11)

Jacopo Robusti,
known as Tintoretto
*The Ascension*
1579–81
Scuola Grande di San Rocco,
Venice

# The Acts of the Apostles

The Acts of the Apostles is the history of the origins of the Church; it narrates how the disciples of Jesus endeavored to preach and spread the Word. The Acts begin at the Ascension and the Pentecost and end with the arrest and incarceration of Saint Paul.

# The Acts of the Apostles

The first book on the history of Christianity as a religion, Acts is dedicated to one Theophilus. The book has been generally attributed to Luke the Evangelist; it recounts the life of the apostles and their mission to testify and evangelize. The first part concentrates on Peter's activity in Jerusalem, then turns to Paul's ministry in Judaea and Samaria and the slow flowering of the idea of spreading Christianity to the entire world. The second part reports on the conflict over whether or not to circumcise men upon conversion, and on Paul's missions to Asia Minor and Greece, ending with his arrest and transfer to Rome.

Andrea Mantegna
*San Luca Altarpiece*
1453
Pinacoteca di Brera, Milan

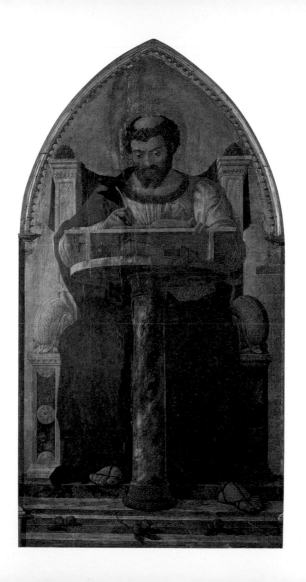

# The Pentecost

Christian doctrine considers the Pentecost (also known as Whitsunday) the birth of Christianity. The only words in the Gospels that suggest Jesus' intention of founding a religion are in Mark and Matthew: "Go ye into all the world, and preach the gospel to every creature" (Mk 16:15); "Thou art Peter, and upon this rock I will build my church." (Mt 16:18–19) Fifty days after Christ's death, the Holy Spirit descended first as a wind, then as tongues of fire that came to rest on the head of the apostles and the Madonna, who were gathered together. By adapting the original Hebrew meaning of the Pentecost, a feast that celebrated the first harvest and God's revelation to Moses on Mount Sinai, on this day Christians celebrate the new Law that God gave to His faithful. Representations of the Pentecost are often used to symbolize the assembled community of believers, with the Madonna at the center as the prefiguration of the Church.

(Acts 2:1–13)

Luca Signorelli
*Pentecost*
1494
Galleria Nazionale delle Marche,
Urbino

# Peter's Ministry

The Holy Spirit that filled the apostles endowed them with the gift of speaking all the languages of the world, thus putting an end to the chaos that had erupted with the construction of the Tower of Babel. Peter addressed the Jews of Jerusalem, who were perplexed by the linguistic powers of the Twelve (for the apostles had elected a twelfth, Matthias, to replace Judas Iscariot), reassuring them and explaining that from that time on, thanks to the Holy Spirit, the apostles would also be able to work prodigies. He urged the Israelites to repent and receive baptism for the forgiveness of their sins, in order to gain eternal salvation. This painting by Fra Angelico, made for the monks of Saint Mark's Convent in Florence, seems to be set in a fifteenth-century Tuscan city rather than in Jerusalem, precisely because Peter's message to Christians must always be contemporary and universal.

(Acts 2:14–40)

Fra Angelico,
*Saint Peter Preaching in the Presence of Saint Mark*
from the *Linaiuoli Altarpiece*
*c.* 1433
Museo di San Marco, Florence

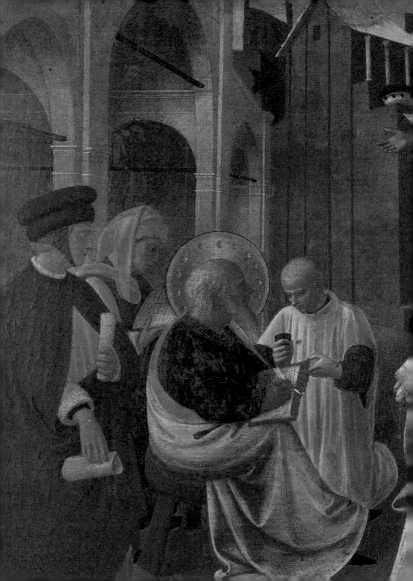

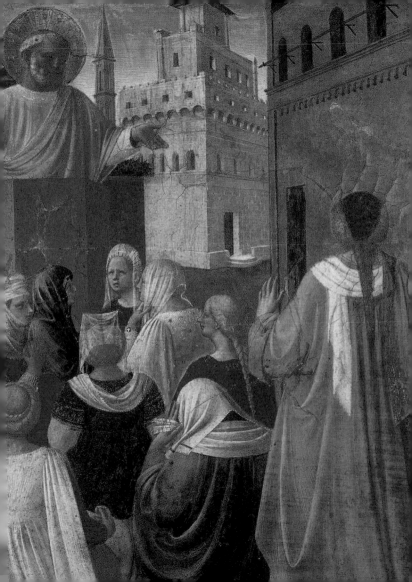

# Peter Heals a Lame Man

Peter was the first apostle to perform a miracle. One day as he walked with John to the Temple, he met a man who had been crippled from birth begging for alms. Peter had "neither silver nor gold" (Acts 3:6) to offer him, but instead he healed the man, who regained the full use of his legs. In this rendering of the episode by Simone Cantarini, the chief priests are huddled to one side in the background, plotting against the apostles. The artist has included autobiographical elements such as his own city, Pesaro, in the background; one glimpses Villa Mirafiore, a symbol of the power of the Dukes Della Rovere, and the Church of San Giovanni.

(Acts 3:1–11)

Simone Cantarini
*Saint Peter Healing the Cripple*
1639
Pinacoteca Civica, Fano

# Peter Heals the Sick with His Shadow

As the apostles began to work miracles, their followers increased. The sick thronged the streets waiting to be made whole by Peter, whose shadow healed anyone who crossed its path. Crowds came to Jerusalem from nearby cities. No one was denied healing. In this splendid work by Masaccio, Peter's resolute expression contrasts vividly with the suppliant looks of the sick. Whether leaning on a stick or kneeling, they all look to the saint, hoping for an imminent, miraculous cure. (Acts 5:12–16)

Tommaso Cassai,
known as Masaccio
*Saint Peter Healing the Sick*
*with His Shadow*
1426–27
Cappella Brancacci,
Santa Maria del Carmine, Florence

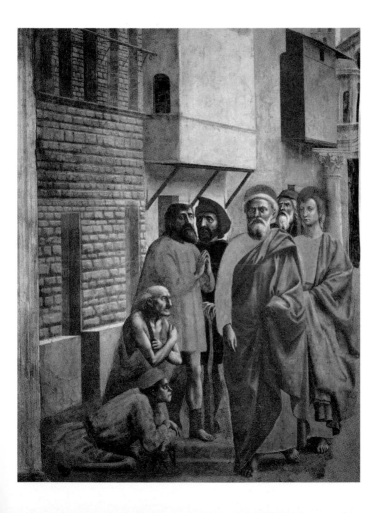

# Stephen's Ministry

In the first Christian community in Jerusalem, tensions were rising between the converts from Judaism and those who came from a Hellenistic culture. The latter accused the former of handling charity work poorly. Thus an assembly was called that voted to appoint deacons, including Stephen, who was charged with taking care of the indigent. The newly chosen deacons also began to preach and work miracles. In this painting by Carpaccio, Stephen is dressed in a priestly habit and sits at the base of a statue, a clear allusion to his death and the proclamation of his sainthood. Around him are figures dressed in styles from different parts of the world, some sumptuous, some plain, to signify the universality of Christianity, which embraces everyone, rich and poor, from all nations.

(Acts 6; 7:1–53)

Vittore Carpaccio
*The Sermon of Saint Stephen*
1514
Musée du Louvre, Paris

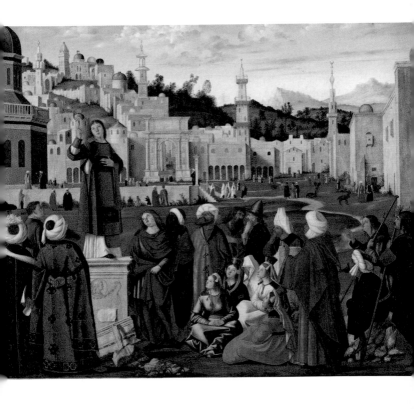

# The Martyrdom of Stephen

The tensions brewing in the early Christian communities led to lynchings. The first victim was Stephen, stoned to death by a crowd. As he lay dying, the deacon cried to God to forgive his executioners just as Christ had done on the Cross. For this reason, he has been called a protomartyr. After the stoning, the crowd dropped the saint's clothes at the feet of a young man, Saul, who approved of Stephen's killing and became a relentless persecutor of Christians. This detail has been included in this work by Dosso Dossi, who set the scene of the killing in a clearing. Stephen wears his priestly robe but there is no crowd, only three villains, a clear allusion to iconographies of the scourging of Christ.

(Acts 7:54–60; 8:1–3)

Giovanni di Niccolò de Luteri,
known as Dosso Dossi
*The Stoning of Saint Stephen*
c. 1525
Museo Thyssen-Bornemisza, Madrid

# Simon Magus

The Acts of the Apostles also records the first Christian heresy. One Simon, who had been practicing the magic arts, was converted by the apostle Philip's preaching and was baptized. Later, having learned that Peter had the power of transmitting the Holy Spirit through the simple laying-on of hands, he had the perverse idea of offering him money in exchange for that power. But the apostle flew into a rage and cursed him because he "thought that the gift of God [could] be purchased with money." (Acts 8:20) From this attempt to buy sacred things the word "simony" is derived, from the name of the offender. Representations of the altercation between Simon and Peter have been usually inspired by apocryphal sources that speak of how Simon fell and died in a vain attempt to show that he could float in the air. Artists have associated his fall with that of the rebel angels, another apocryphal tale that tries to explain the origin of Hell. In this splendid Medieval capital Peter is identifiable by the key and Simon, who is falling headlong, has been given the deformed features of a demon. (Acts 8:9–25)

*The Fall of Simon Magus*
1130
Saint-Lazare, Autun

# The Conversion of Saul

Saul was a Greek-speaking Jew born in Tarsus, Cilicia. He had never met Christ and, as the stoning of Saint Stephen reveals, he was hostile to Christians. He joined the Church three years after Jesus' death. During a trip, he had a vision that totally upset his life. Suddenly he was surrounded by a light, and as he fell to the ground he heard a voice: "Saul, Saul, why persecutest thou me? . . . I am Jesus whom thou persecutest. . . . Arise, and go into the city, and it shall be told thee what thou must do." (Acts 9:3–5) And so Saul was converted and came to believe that Christ had chosen him to be an apostle to the Gentiles, meaning those who were not of the Jewish faith. In both the Acts and his letters, Saul is called Paul because in the Roman Empire Jews often adopted a Greco-Latin name, sometimes chosen because of its assonance with their birth name. In art Paul is always depicted falling from a horse, though the Scriptures do not specify how he was traveling from Jerusalem to Damascus.

(Acts 8:1–3; 9:1–9)

Bartolomé Estéban Murillo
*The Conversion of Saint Paul*
1675
Museo Nacional del Prado, Madrid

# The Baptism of Saul

Saul was blinded by the divine vision experienced while traveling from Jerusalem to Damascus; a man named Ananias, sent to him by God, restored his sight by the laying-on of hands upon his eyes. The Acts briefly mention Paul's baptism, and it is generally believed that he received it from Ananias. A Medieval mosaic in Palermo's Cappella Palatina reproduces this scene by setting the ceremony in a courtyard, before a temple, with Paul's body completely immersed in the baptismal font. Ananias blesses him, and a bystander stands behind holding a candle. The scene depicts the baptismal ritual that is still in effect today. The hand of God imparting His blessing, from which a beam of light radiates tracing the path of the dove of the Holy Spirit, is a splendid detail.

(Acts 9:10–22)

*The Baptism of Saul*
12th century
Cappella Palatina,
Palazzo dei Normanni, Palermo

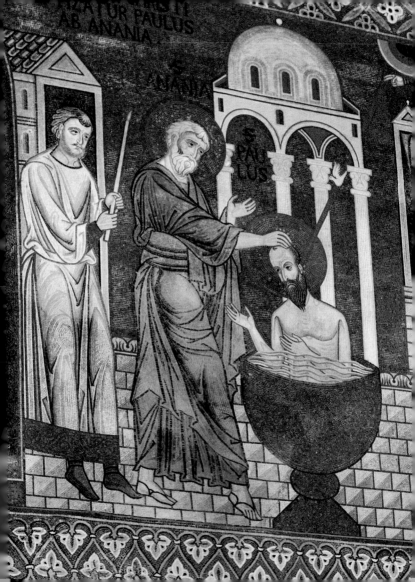

# The Resurrection of Tabitha

After his conversion, Paul initially withdrew to the desert, then began to travel far and wide to spread the Gospel, founding communities in Syria, Asia Minor, and Greece. The apostles also successfully expanded their ministry. It happened that Peter was visiting the Christian community of Lydda when he was asked to go on to Jaffa, a city nearby where a disciple, Tabitha, had just died. The apostle entered the room where the woman's lifeless body lay and ordered her to get up. Tabitha came back to life and sat up on the bed. After the miracle, she resumed her normal life with her family.
(Acts 9:36–42)

Henri Testelin
*Saint Peter Resurrecting
the Widow Tabitha*
1652
Musée des Beaux-Arts, Arras

# The Martyrdom of James

The apostle James was one of the sons of Zebedee and one of Jesus' first disciples. He had witnessed all the events of the Messiah's public life until his death and Resurrection, and had become a leader of the Christian community of Jerusalem. Several nonbiblical traditions claim that James brought his ministry to Spain, where, in fact, an ancient shrine, Santiago de Compostela, is dedicated to him. If in fact he traveled to Spain, he nevertheless returned to Judaea, where in the early AD 40s he was among those persecuted by Herod Agrippa. James was the first apostle to be martyred. Because the Acts mention the martyrdom only too briefly, artists have drawn from hagiographies, including Jacopo da Varagine's *Legenda Aurea* (The Golden Legend).

(Acts 12:1–3)

Jacopo Avanzi
*The Martyrdom of Saint James*
from *Stories of Saint James*
1370s
Basilica di Sant'Antonio, Padua

# Peter's Arrest and Deliverance

Peter was among the first Christians persecuted by Herod Agrippa, who threw him in jail and assigned four teams of four soldiers each to guard him. The night before he was to be executed, an angel of the Lord appeared to the apostle. He broke the chains that bound him, urged him to put on his cloak, belt, and sandals, and led him out of jail unbeknownst to the guards. At first Peter was incredulous and thought that he was having a vision, but once he was in the street he understood the miraculous event. In this work by Gerritt van Honthorst, the angel appears, surrounded by a light that, while faithful to the biblical text, is also an artistic device that lights up the darkness of the dungeon.

(Acts 12:1–19)

Gerrit van Honthorst
*The Liberation of Saint Peter*
1616–18
Staatliche Museen, Berlin

# Paul and Barnabas in Lystra

In many of his travels Paul was accompanied by the disciple Barnabas, a Greek-speaking Jew from Cyprus who had preached in Antioch, the city where for the first time those who believed that Jesus was the *Messiah* (in Greek, *Christos*, the "Anointed" of God) were called "Christians." It happened that the two preachers went to the city of Lystra, where their miraculous healings convinced the people that they were the gods Jupiter and Hermes. The pagan priest wanted to make a burnt offering in thanksgiving to them. Paul and Barnabas passionately tried to explain that they were men, not gods, and that their mission specifically dealt with highlighting the futility of heathen beliefs. This splendid painting by Peterzano, who was Caravaggio's teacher, has set the scene outside the city walls, creating a perfect harmony between the landscape and the crowd that witnesses the scene.

(Acts 14:8–20)

Simone Peterzano
*Paul and Barnabas at Listra*
1572–73
Chiesa del Paolo e Barnabas, Milan

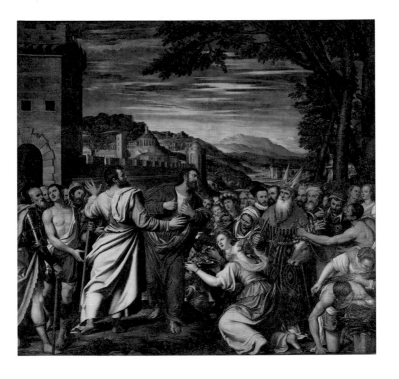

# Paul Is Arrested

After traveling for ten years among the Christian communities of the Aegean Sea, Paul resolved to return to Jerusalem. As soon as he reached the Holy City, the authorities arrested him and charged him with disturbing the peace, the same charge that probably led to Jesus' Crucifixion. As *civis romanus*—for although a Jew, Paul was a Roman citizen—Paul requested to be transferred to Rome to be tried before the emperor. He was thus put on board a ship for a trip that included a shipwreck on the island of Malta. When he finally reached Rome, he was allowed to live under house arrest. Paul did not give up his mission but continued to preach, receiving people at home. In this Rembrandt painting, Paul is in jail in the act of writing letters to the Christian communities that he had founded around the world.

(Acts 21–28)

Rembrandt van Rijn
*Saint Paul in Prison*
1627
Staatsgalerie, Stuttgart

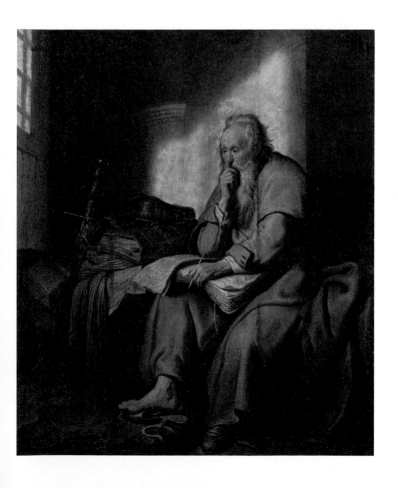

# The Letters
# of the Apostles

The Pauline Epistles
James
Peter
John
Jude

The letters of the apostles
were addressed to the infant
Christian communities; they
are messages of exhortation
to persevere in the faith and
to carry out the message of
Jesus Christ.

# *The Letters of the Apostles*

The arrangement of the letters in the Bible has been determined primarily by their length and their theological import. The first 14 are attributed to Paul, though only 7 are now believed to be autograph letters. The other seven are called "catholic," from the Greek *katholikos*, meaning "universal," because unlike Paul's autograph epistles, they are not addressed to a specific Church or city. Though no one knows for sure their authorship, they have been attributed to other disciples. In general, since they are mostly sermons, the letters do not contain scenes suitable to artistic representation. Mostly the illustrations consist in a portrait of the presumed author.

*Initial "P"*
miniature from *The Letters of Paul*
1506
British Library, London

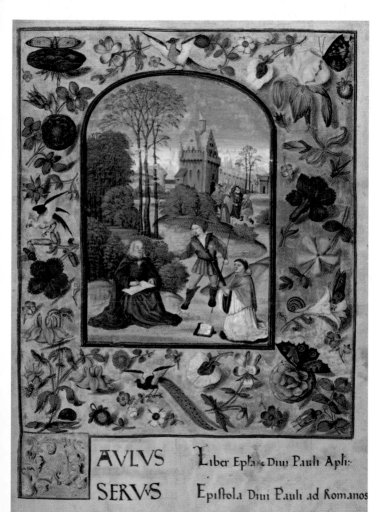

AVLVS
SERVS

Liber Epła Diui Pauli Apli:

Epistola Diui Pauli ad Romanos

# The Pauline Epistles

In his letters, Paul addressed all the people that he converted, answered questions that the Christian communities posed to him, and explained the mysteries of the faith. His letters to the Romans, the Corinthians, the Galatians, the Philippians, and the Thessalonians were saved by other Christian authors who tried to imitate him by composing other letters under his name, addressed to the Ephesians and the Colossians. The letters addressed to Titus and Timothy, Paul's companions, were probably written after Paul's death in the early AD 60s. The author of the letter to the Hebrews, the last one bearing the apostle's name, tries to comfort the disheartened community and vigorously defends the revolution that Christ has brought to the history of the people of Israel.

Bongiovanni Giovenale
*Saint Paul* (detail)
18th century
San Donato, Mondovì

# *James*

After Paul's, the remaining letters are grouped under the term "catholic." Rather than epistles, they are sermons or catechism lessons addressed to some Christian communities. The first one was written by James. It is not clear whether the author was James the Elder—the son of Zebedee, and John's brother—or James the Younger, whom the Gospels call the "brother of the Lord," meaning that he was from Jesus' kin. As is often the case with the Bible, the author's identity is less important than the message being communicated. Among the many teachings of this letter is a particular reference to how to pray for the sick, which became an important justification at the Council of Trent for instituting the sacrament of anointing the sick.

Giovanni di Paolo di Grazia
*San Giacomo*
1430
Tesoro di San Francesco, Assisi

# Peter

The two letters attributed to Peter differ greatly from each other. While the first is addressed to the Christians of Asia Minor, the second is more like a spiritual last will and testament intended to put the readers on their guard against false prophets. Most scholars believe that the first letter was composed in the last quarter of the first century, probably after Peter's death (AD 64). It was most likely written in Rome, which is metaphorically referred to in the letter as Babylon, recalling ancient Hebrew history. The second letter also seems to be posthumous. It is in a different style than the first, and bears similarities with the later letter of Jude.

Francesco del Cossa
*Saint Peter*
from the *Griffoni Polyptych*
1473
Pinacoteca di Brera, Milan

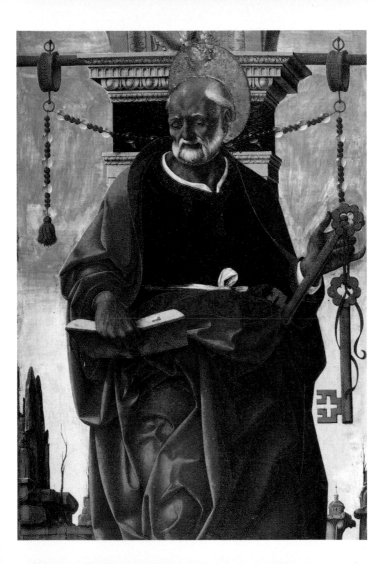

# *John*

The attribution of some letters to John is partially due to the fact that they exhibit many stylistic similarities with the Gospel of John. They probably date to the end of the first century AD, when John was in Ephesus, and were most likely addressed to the pagans of Asia Minor. Like Peter, John also warned against false teachers and heretics. These letters stand out for the use of the word "Antichrist," which appears here for the first time. The author used the term to characterize the false prophets and their heretical teachings, which denied the unity of Father and Son and preached that they are two distinct beings.

Luigi Miradori, known as Genovesino
*Saint John the Evangelist*
17th century
Museo Civico Ala Ponzone, Cremona

# *Jude*

The first line of the last letter in this book mentions "Jude, the servant of Jesus Christ and brother of John," a reference to the apostle whom the Gospels of Matthew and Mark call Thaddeus. Some scholars have put forth the theory that he might have been one of Jesus' brothers. The letter probably dates to around AD 70; like the others, it warns of the danger of falling victim to impostors. The latter would in due time be punished, as the Old Testament teaches. Finally, the letter urges Christians to keep their faith in the Lord as they await the coming of Jesus Christ.

Doménikos Theotokópoulos,
known as El Greco
*Apostle Saint Thaddeus (Jude)*
1610
Museo de El Greco, Toledo

# Revelation

A visionary book filled
with symbolic language,
Revelation speaks about the
end of times. It closes the
Bible with the triumph of
Christ and of the Kingdom
of God over the forces of
Evil, the advent of the
Heavenly Jerusalem, and the
resurrection of the dead.

# *Revelation*

The last book of the Bible is Revelation, or Apocalypse (from the Greek *apocalypsis*, which means "revelation"); it is the truth that Jesus revealed to the apostle John during his exile on the Island of Patmos around the year AD 95. This is the prevailing theory, although some doubts still exist. John received a revelation from Jesus about the end of times, a revelation that was to be communicated to seven churches of Asia Minor as a spur to overcome their internal crises and continue to resist persecution. Thus the announcement is one of hope, expressed through symbolic visions and images whose meanings are not immediately perceptible, for this is the nature of apocalyptic literature, a popular genre at the time. The text is presented as a prophecy, that is, a foretelling of the end of times through the interpretation of God's actions in history. Therefore, the catastrophes of history must be seen as the work of the forces of Evil, which in the end shall be defeated by Jesus with the advent of the Heavenly Jerusalem and the wedding of the Christ to a redeemed human race. Precisely because of its visionary, symbolic qualities, Revelation has been profusely illustrated throughout Christian history, and artists have concentrated especially on the fantastic, visionary images.

*Episodes from Revelation*
miniature from a Dutch Bible
*c.* 1400
Bibliothèque Nationale, Paris

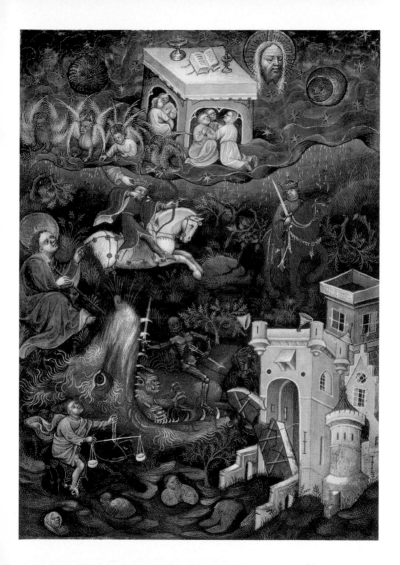

# The Seven Stars and the Seven Candlesticks

Saint John writes that he had fallen into a rapture when he heard a powerful voice telling him to write down in a book all that he saw and relay it to the seven churches of Ephesus, Smyrna, Pergamum, Thyatira, Sardis, Philadelphia, and Laodicea. The Evangelist saw seven candlesticks surrounding the Son of Man, with long, white hair and burning eyes, feet like burning brass, and a voice like "the sound of many waters." (Rev 1:15) The man wore a long robe and held seven stars in his right hand. Out of his shining mouth came a sharp, double-edged sword. Seeing that John was disturbed, the vision reassured him thus: "I am the first and the last: I am he that liveth" (Rev 1:17–18), meaning he who was resuscitated after death. He was Jesus; the attributes of the vision allude to his omniscience (the flaming eyes), his indestructible personhood (the feet like "brass burned in a furnace" [Rev 1:15]), and the justice of his Word, which judges both the just and the sinners. Christ himself explained the meaning of the stars and the candlesticks: "The seven stars are the angels of the seven churches: and the seven candlesticks which thou sawest are the seven churches." (Rev 1:20)

(Rev 1–3)

*The Seven Stars and the Seven Candlesticks*
1250
Saint-Etienne, Bourges

# The Throne Surrounded by Elders

Seized by rapture, John was taken to Heaven, where he saw an emerald rainbow surrounding a throne on which sat the Lord, in the text called simply "the One" (Rev 4:2) due to the inadequacy of language to define God's majesty. It was in turn surrounded by 24 thrones—the 12 Tribes of Israel and the 12 apostles—on which sat 24 elders dressed in white robes, with golden crowns on their heads. The elders represent the chosen of the Lord who will share in the new Heavenly Kingdom. The elders paid homage to the Lord by throwing their crowns at his feet, symbolizing the submission of their power to the higher, divine One. Reminiscent of Old Testament visions, surrounding God's throne the Evangelist also saw four living creatures resembling a lion, a bull, one with man's features, and an eagle—all with open eyes in front and back to symbolize omniscience; these symbols would be later attributed to the four Evangelists. In art, the elders have sometimes been portrayed as angels, or included in images of the heavenly court. (Rev 4:1–11)

*Christ as Judge of the World*
1120
Saint-Pierre, Moissac

# The Mystical Lamb

The likening of Jesus to a lamb can be traced back to Exodus, when God, before releasing the Israelites from their Egyptian captivity, ordered Moses to instruct his people to sacrifice a lamb for each family and to smear its blood on the doorposts of their homes, so that the last of the ten plagues of Egypt— the killing of the firstborn sons—would pass over them. In the New Testament, when John the Baptist saw the Messiah, he cried, "Behold the Lamb of God." (Jn 1:29) The shedding of his blood washed away the sins of the world and gave eternal salvation to humankind. The image of the lamb returns in Revelation: Before the divine throne surrounded by the elders, "stood a Lamb as it had been slain, having seven horns and seven eyes" (Rev 5:6), which are the seven spirits that God sent forth on the earth. Only the Lamb is worthy of opening the book wherein the destiny of man is written.
(Rev 5:1–6)

*The Lamb of the Apocalypse*
13th century
Santa Maria, Anagni

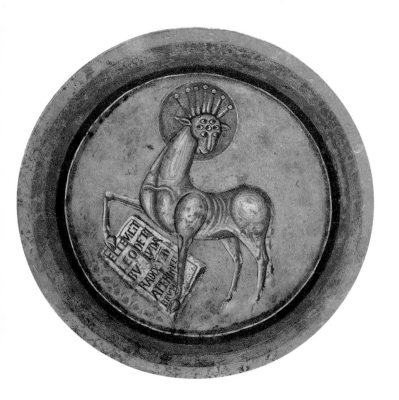

# The Seven Seals

Saint John's vision of the heavenly court with the 24 elders enthroned around the divine seat culminated in the apparition of the Lamb. The scroll, which the Father holds in His right hand, is closed with seven seals that no one but the Lamb is worthy of breaking. In fact, at first John cried and wept bitterly because he could not read the scroll and thus understand the meaning of history, for man is lost and distressed when confronted with his inability to understand events. But one of the elders comforted John, announcing to him the coming of the Christ: "Weep not: behold, the Lion of the tribe of Judah, the Root of David, hath prevailed to open the book, and to loose the seven seals thereof." (Rev 5:5) Thereupon the Lamb, who is the image of Christ and the ancestor of King David, appeared and took the book from the right hand of the Father, as illustrated in some rare images, mostly found in illuminated Revelations.

(Rev 5:1–14)

French School
*Vision of the Lamb with Seven Horns*
13th century
Lambeth Palace Library, London

issue tecors. par le plurer ples mutaines ke il ne seit
eimr iohan: est signefie troue. e si aim il eun vort e
nesmes tco ke par le crier ses oilz ouerez: eissi morut
en la croiz qil i ala char. e qil i ala tertre uiueit

IO m dit seint iohan: een mi = les maiurs im
le est ws en mile chro aignel estreant aussi cu
e een mi les quatre bestes eris e auent ses cornes e ser

# The Horsemen of the Apocalypse

The best-known vision in Revelation, the one that has been illustrated most often and has truly engaged artists' imaginations, is the breaking of the first four seals. As each seal of the book was opened, a mounted horse appeared. The first horse was white and its rider held a bow and wore a crown; he came not to destroy, but to go from victory to victory, symbolizing Christ's supremacy over the forces of Evil. The second horse was red and mounted by a rider with a sword, symbolizing the shedding of blood; this rider was empowered to steal peace from Earth. The third horse was black and its rider held a pair of scales to symbolize famine and dearth of food. The last horse was a pale, greenish color and its rider was Death, followed by Hell. The text points out that God had given the four riders "power . . . over the fourth part of the earth, to kill with sword, and with hunger, and with death, and with the beasts of the earth." (Rev 6:8) When the fifth seal was broken, the multitude of martyrs appeared. The opening of the sixth seal caused violent earthquakes on Earth, interrupted only by the angels who marked the foreheads of all those who lived justly and thus would be spared. They numbered 144,000, or 12,000 for each Tribe of Israel.

(Rev 6–7)

Arnold Böcklin
*War*
1896
Staatliche Kunstsammlungen, Dresden

# Supplements

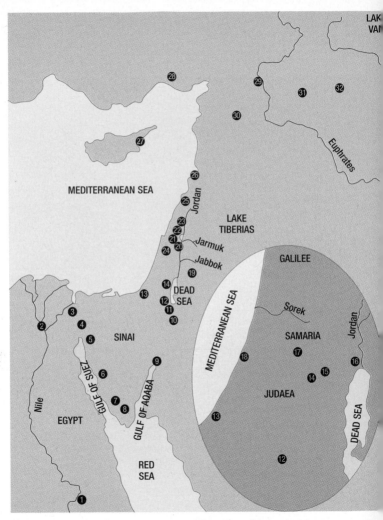

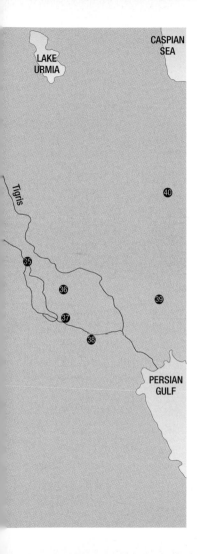

## Principal Biblical Places

1 Thebes
2 Memphis
3 Succoth
4 Etham
5 Marah
6 Elim
7 Rephidim
8 Mount Sinai
9 Elath
10 Sodom
11 Gomorrah
12 Beer Sheba
13 Gaza
14 Jerusalem
15 Bethany
16 Jericho
17 Emmaus
18 Azotus
19 Mount Neboh
20 Mount Tabor
21 Nazareth
22 Cana
23 Capernaum
24 Caesarea
25 Tyre
26 Sidon
27 Salamis
28 Tarsus
29 Carchemish
30 Aleppo
31 Harran
32 Nisibis
33 Nineveh
34 Assur
35 Babylon
36 Nippur
37 Uruk
38 Ur
39 Susa
40 Ecbatana

**18th–15th century BC**
Time of the patriarchs, from Abraham to Jacob, and the story of Joseph.

*c.* **1250–20 BC**
Exodus from Egypt and arrival in the Promised Land.

*c.* **1220–1200 BC**
Joshua's conquests. Time of the Twelve Tribes.

*c.* **1200–1030 BC**
Time of the judges.

*c.* **1030 BC**
Founding of the monarchy.

*c.* **1030–10 BC**
Saul is the first king of Israel.

*c.* **1010–970 BC**
Reign of King David.

*c.* **970–30 BC**
Reign of King Solomon, who builds the Temple on Mount Zion in Jerusalem.

*c.* **930 BC**
The monarchy is split in two: the kingdom of Judah to the south and that of Israel to the north.

*c.* **722 BC**
The Assyrians take over the kingdom of Israel.

*c.* **701 BC**
Hezekiah, king of Judah, guides the rebellion against the Assyrians, ending with the destruction of Jerusalem.

*c.* **687–42 BC**
Under Manasseh, the kingdom of Judah becomes vassal to the Assyrians.

*c.* **622 BC**
Josiah begins to rebuild the Temple of Solomon. During the construction, the Book of the Law is found.

*c.* **597 BC**
The Babylonians seize Jerusalem for the first time and deport the Jews to Babylon.

*c.* **586 BC**
The Babylonian king Nebuchadnezzar destroys the Temple of Jerusalem; second deportation of the Jews to Babylon.

*c.* **539 BC**
End of the exile decreed by the liberation edict of Cyrus, king of Persia.

*c.* **520–15 BC**
Construction of the new Temple of Jerusalem.

*c.* **333 BC**
Alexander the Great conquers the Persian Empire.

**late 4th–2nd century BC**
Rule of the Diadochi, successors of Alexander the Great.

*c.* **167 BC**
Antiochus Epiphanes, ruler of the Seleucid empire in Palestine and Mesopotamia, desecrates the Temple of Jerusalem by introducing the worship of Hellenistic deities.

*c.* **164 BC**
The Maccabees expel the Greeks from the Temple of Jerusalem and reestablish Jewish worship.

*c.* **143 BC**
The Maccabees force the overthrow of Seleucid rule and reestablish the Kingdom of Judah as an independent nation ruled by the Hasmoneans.

**63 BC**
The Roman general Pompey conquers Palestine.

**37–4 BC**
Herod the Great, appointed king of Judaea by the Romans, rebuilds the Temple of Jerusalem.

**31 BC–AD 14**
Octavian Augustus is the Roman emperor. Jesus is born during his reign.

***C.* AD 27**
John the Baptist begins his ministry.

***C.* AD 30**
Jesus is executed under the Roman governor Pontius Pilate.

***C.* AD 36**
Martyrdom of Saint Stephen and conversion of Saul on the road to Damascus.

***C.* AD 64–67**
Martyrdom of Peter in Rome. Last incarceration and martyrdom of Paul.

***C.* AD 66–70**
The Roman emperors Vespasian and Titus set siege to Jerusalem. During the war, the Dead Sea Scrolls are hidden in the Qumran caves. They would be found in 1947.

**AD 70**
Titus destroys the Temple. Conventionally, this date marks the beginning of the Diaspora of the Jews.

# Index of Episodes

# Index of Artists

# List of Abbreviations

**Acts**: The Acts of the Apostles
**Am**: Amos
**Bar**: Baruch
**1 Ch**: Chronicles I
**2 Ch**: Chronicles II
**1 Co**: The First Letter to the Corinthians
**2 Co**: The Second Letter to the Corinthians
**Col**: The Letter to the Colossians
**Dn**: Daniel
**Dt**: Deuteronomy
**Ec**: Ecclesiastes (Qoheleth)
**Eph**: The Letter to the Ephesians
**Esth**: Esther
**Ex**: Exodus
**Ezek**: Ezekiel
**Ezr**: Ezra
**Ga**: The Letter to the Galatians
**Gn**: Genesis
**Hab**: Habakkuk
**Heb**: The Letter to the Hebrews
**Hg**: Haggai
**Ho**: Hosea
**Is**: Isaiah
**Jb**: Job

**Jdt**: Judith
**Jer**: Jeremiah
**Jg**: Judges
**Jl**: Joel
**Jm**: The Letter of James
**Jn**: The Gospel of John
**1 Jn**: The First Letter of John
**2 Jn**: The Second Letter of John
**3 Jn**: The Third Letter of John
**Jon**: Jonah
**Jos**: Joshua
**Jude**: The Letter of Jude
**1 Kgs**: Kings I
**2 Kgs**: Kings I
**Lam**: Lamentations
**Lk**: The Gospel of Luke
**Lv**: Leviticus
**1 Macc**: Maccabees I
**2 Macc**: Maccabees II
**Mic**: Micah
**Mk**: The Gospel of Mark
**Ml**: Malachi
**Mt**: The Gospel of Matthew
**Na**: Nahum
**Nb**: Numbers
**Ne**: Nehemiah
**Ob**: Obadiah

**1 Pe**: The First Letter of Peter
**2 Pe**: The Second Letter of Peter
**Phm**: The Letter to Philemon
**Php**: The Letter to the Philippians
**Pr**: Proverbs
**Ps**: Psalms
**Rev**: Revelation
**Rm**: The Letter to the Romans
**Rt**: Ruth
**1 Sam**: Samuel I
**2 Sam**: Samuel II
**Sir**: Sirach or Ben Sira
**Song**: The Song of Solomon
**Tb**: Tobit
**1 Th**: The First Letter to the Thessalonians
**2 Th**: The Second Letter to the Thessalonians
**1 Tim**: The First Letter to Timothy
**2 Tim**: The Second Letter to Timothy
**Tit**: The Letter to Titus
**Wis**: Wisdom
**Zech**: Zechariah
**Zp**: Zephaniah

# Photographic Credits